THE
CALIFORNIA
MISSIONS

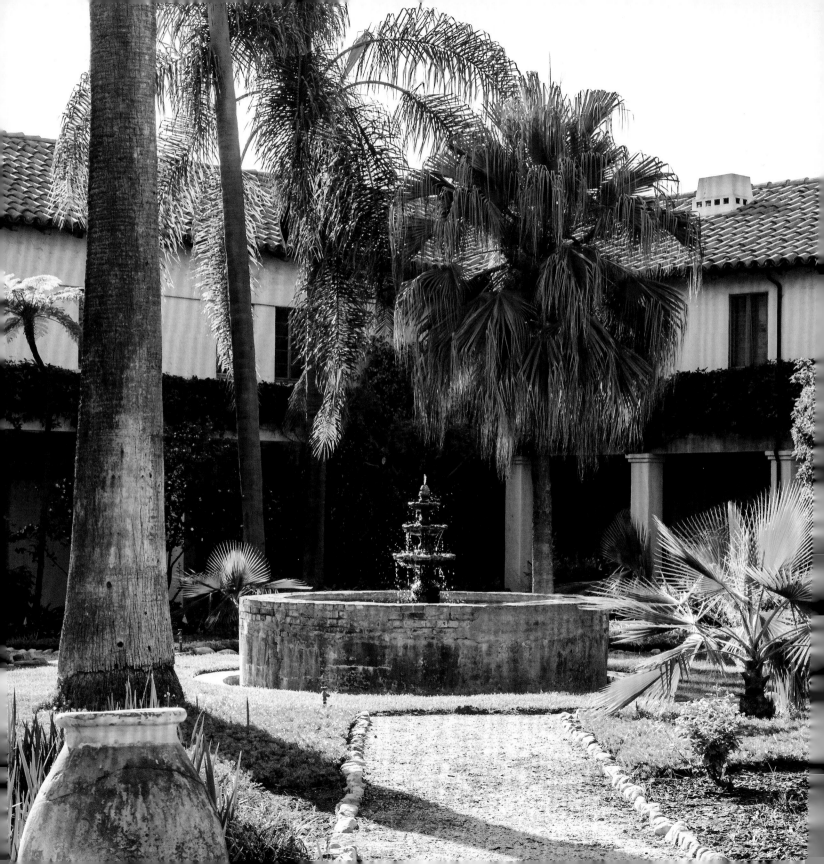

THE CALIFORNIA MISSIONS

Text by Rubén G. Mendoza
Photography by Melba Levick

RIZZOLI
NEW YORK

New York · Paris · London · Milan

Dedicated to California mission scholar Mardith Schuetz-Miller and conservator Sir Richard Joseph Menn, and warmly inscribed to my loving wife, Linda, and beautiful daughters, Natalie and Maya—R. G. M.

For my loving son, Bret, my daughter-in-law, Shaunti, and my granddaughter, Bowie—who have brought so much joy to my life—M. L.

First published in the United States of America in 2018 by
RIZZOLI INTERNATIONAL PUBLICATIONS, INC.
300 Park Avenue South, New York, NY 10010
www.rizzoliusa.com

ISBN-13: 978-0-8478-6151-4
Library of Congress Control Number: 2017956527

Distributed to the U.S. Trade by Random House, New York

Designed by Douglas Curran

Page 2: Lush planted garden at Mission Santa Bárbara (p. 130)
Pages 6–7: Detail from Mission San Carlos Borromeo (Carmel, p. 46)

Printed and bound in China

2018 2019 2020 2021 2022 / 10 9 8 7 6 5 4 3 2 1

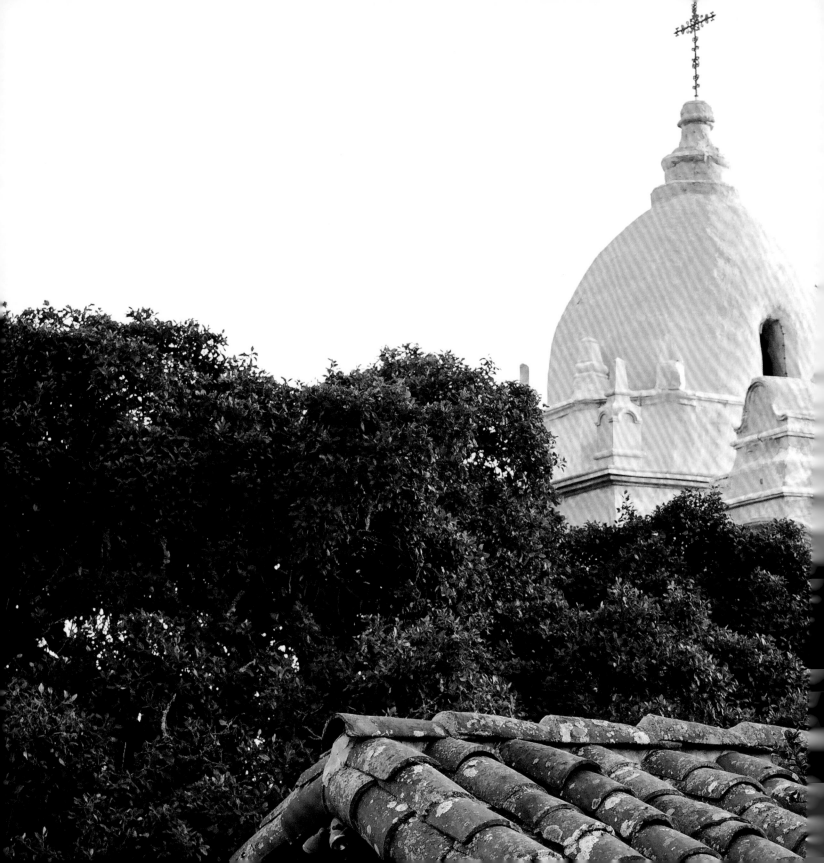

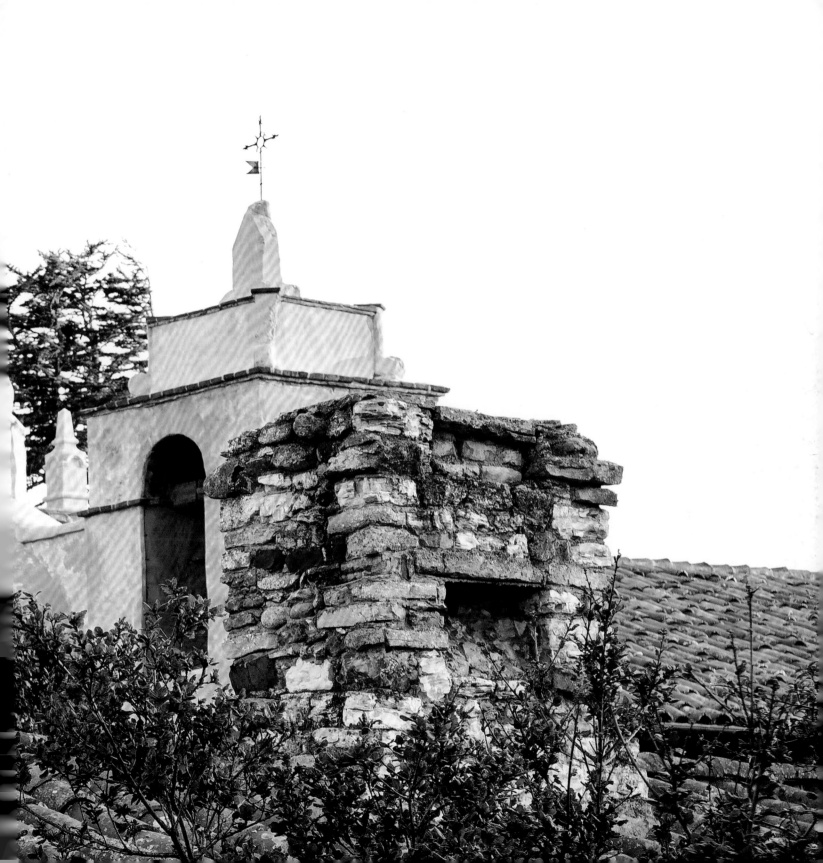

INTRODUCTION

My interest in history, and thereby archaeology, began with a 4th grade field trip from Fresno to the Spanish mission of San Juan Bautista, California. In the spring of 1965, I discovered my love of early California and the West while standing amidst the vast open plaza that fronts the old mission. While clouds of dust swirled about in that largely abandoned and decrepit historic village, my thoughts were of Indians and Cowboys, and the early to mid-nineteenth century Mexican adobes and early American clapboard buildings that lined that space. As enchanting as it all was for a nine-year-old boy, one building in particular left me awestruck with the prospect of learning more about the town's early inhabitants. As it turned out, the building had seen its share of history, ranging from its original use as an 1820s *monjerio* or dormitory for unmarried Costanoan Indian women through to its conversion into a fandango dance parlor and civic building identified with Plaza Hall. Over the course of several decades, each time I visited San Juan Bautista, that building beckoned to me, inviting me to learn more about this Spanish and Indian mission community. Even so, a host of questions loomed large in my curiosity, and these centered on why such an immense building was constructed in the late-eighteenth-century Spanish frontier of Alta California?

Thus, I found myself fascinated with the old West, and the hundreds of indigenous tribal communities that once populated the length and breadth of the early California frontier. This fueled an early passion for history, books, and the study of my indigenous ancestors. Soon I took to crafting a visual narrative of California history with my trusty Kodak Brownie Box Camera and visits to Kern County's Pioneer Village in Bakersfield, California. However, my interest in history was transformed into one centered on archaeology and architectural history after a fortuitous visit to the ancient metropolis of Teotihuacan, Mexico. I have since maintained an intense interest in Precolumbian and Spanish colonial architecture, art, and culture. This evolved into my work as an archaeologist and professor specializing in the study of the Spanish missions, presidios or garrisons, and pueblo towns of early California. With a professional base at the California State University, Monterey Bay, I have undertaken large-scale archaeological and historical investigations at missions San Juan Bautista, San Carlos Borromeo, Nuestra Señora de la Soledad, and San Miguel Arcángel. These studies led to a major archaeological investigation of the late-eighteenth-century Spanish garrison at the Real Presidio de San Carlos de Monterey. In 2008, the Monterey investigation in turn led to the recovery of the buried foundation footings of the earliest Christian house of worship on the U. S. West Coast, that of the Founding Father of the early missions of Alta California, Fray Junípero Serra (November 24, 1713, to August 28, 1784) of the Order of Friars Minor (OFM).

About this Book

In December 2014, I was contacted by internationally renowned photographer Melba Levick about the prospects of collaborating on a book project regarding the Franciscan missions of California. Melba informed me that she had been referred by mutual acquaintance and anthropologist Paula Cruz-Takash. Melba and I met soon thereafter in Salinas, California, to discuss the proposed project. At

that time she shared a sampling of her work and I was impressed into working on this project with an acclaimed photographic talent. Melba's interests in architecture, and her many award-winning publications depicting architecture from around the world won me over. With some 60 books spanning California ranches through Islamic, Indian, and European architectural traditions, decor, gardens, and travel, I jumped at the opportunity to collaborate with Melba. Moreover, given Melba's exhibitions in Paris, New York, Barcelona, Ibiza, and Washington, D. C., I knew that our collaboration would prove an invaluable learning experience under the tutelage of a master photographic talent.

With 21 California missions with which to contend, and a multitude of origin stories associated with each, we narrowed our scope to first foundings, and thereby sought to highlight the challenges and architectural histories that distinguished each respective site. Significantly, Melba's many years of experience in the Balearic Islands long ago honed her interest, passion, and appreciation for the Mallorcan and Catalan architectural traditions that formed the basis for that of the California missions, presidios, and pueblos of the earliest colonies. With Melba's previous publications as a guide, I revisited much of that research that I had already completed for the study of California and U. S. Southwest mission architecture. However, Melba's insistence on weaving together architecture and the individual identities of each respective mission, and the momentous events of the coming months, led us down a very different path than that originally envisioned.

In January 2015, Pope Francis announced the impending canonization of the founding Father and Father President of the California missions, Fray Junípero Serra, OFM (Order of Friars Minor). Despite a tumultuous several decades of often contentious debates regarding Serra's place in the history of the Church, and the indigenous communities that he sought to evangelize, Serra's beatification by Pope John Paul II in 1989 constituted a key turning point in the debate. Needless to say, the papal announcement instantaneously reopened old wounds, and the debates intensified for and against Serra's canonization as a saint of the Catholic Church. From January through September of 2015, Serra was both the subject and target of international media coverage. In the wake of a March 2015 interview for a television documentary on the life of Serra, I was summoned as an expert witness for an April 2015 Vatican symposium exclusively devoted to an interrogation of the life of the holy man. Afterwards, participants were invited to join Pope Francis for the Serra mass at the Pontifical North American College in Vatican City. With world attention focused on Serra, Pope Francis subsequently convened the first ever canonization ceremony on American soil in Washington, D. C., on September 23, 2015. Since that day, Serra has come to be known as San Junípero, with both the renewed scrutiny and homage that that entails.

Serra's Mission
In order to address the question of why this renewed interest in the Franciscan missions of California has recently come to the fore, one must first address the who of Serra and the Order of Friars Minor. Born Miquel Josep Serra i Ferrer

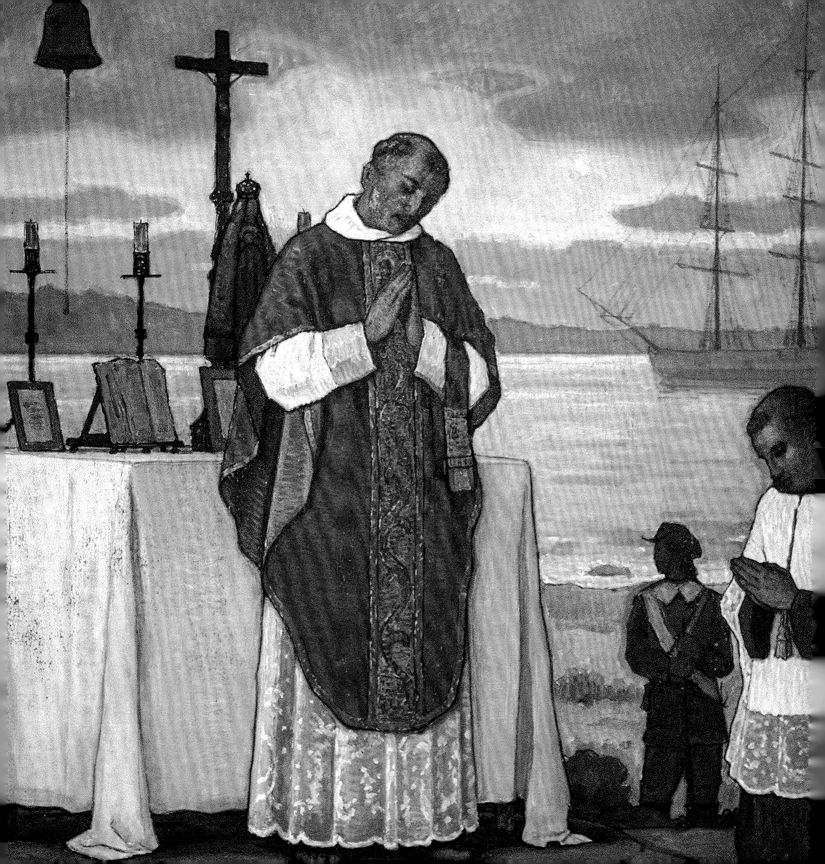

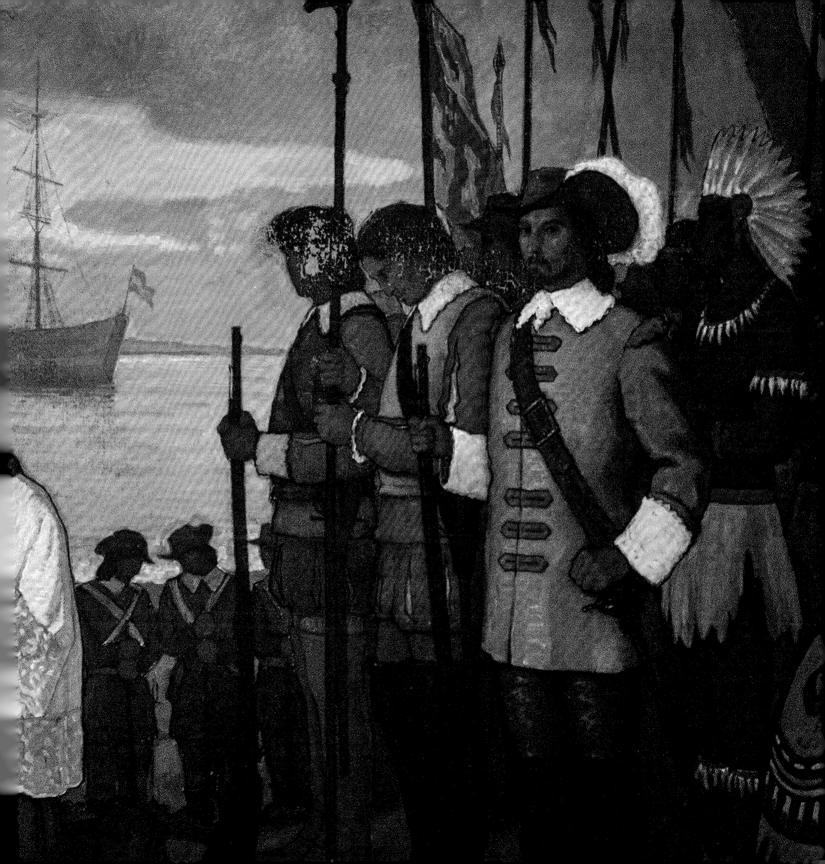

in Petra on the Balearic Isle of Mallorca, Spain, on November 24, 1713, Serra took the religious name of Brother Juniper, an early thirteenth-century follower of St. Francis who was known as both the "Servant of the Lord" and as the "renowned jester of the Lord." As the third child born to Antoní Nadal Serra and Margarita Rosa Ferrer, Serra was raised in the shadow of his parents loss of their first two children in infancy. By age seven, Serra took to working the family's wheat and bean fields with his father, who owned and cared for six relatively small parcels located on the outskirts of Petra. Serra's real interests were with the Petra parish church and friary of San Bernardino. His devotion to liturgical song, particularly Gregorian chant, was cultivated at the Franciscan friary of San Bernardino, and by age 15, Serra's parents sent him to the Franciscan monastery of San Francisco in Palma, Mallorca. There he assisted with the administration of classes, and was matriculated in the philosophy program of the Franciscans.

On November 14, 1730, he advanced to the status of novice in the Order of Friars Minor (OFM) in the Convento de Jesús in Palma. On the following day, Serra made his profession to the order, and chose the name Junípero. Serra was then subject to the rigors of the novitiate and some seven years passed before he became an ordained Catholic priest in December 1738. Appointed librarian of the friary, Serra held that position from 1739 through 1740, and for the following three years held a lectureship in philosophy at the Monastery of San Francisco. It was there that Serra's students included Fray Francisco Palóu, OFM (January 22, 1723, to April 6, 1789), and Fray Juan Crespí, OFM (March 1, 1721, to January 1, 1782), who both emerged as lifelong companions, colleagues, and fellow missionaries in New Spain. In 1742, Serra completed doctoral studies in theology at Lullian University in Palma de Mallorca, where he attained preeminent status as the Duns Scotus chair of theology and professor by 1744. Despite his widely acclaimed status, Serra resigned in January 1749 to give his life over to an Indian ministry as a mendicant friar and missionary in the Americas.

Serra departed Palma for the Iberian peninsula in the company of Palóu on April 13, 1749. They traveled to the mainland at Málaga and onward to the port of departure at Cádiz, Spain. In August, Serra and Palóu embarked on a harrowing ninety-nine day sea voyage to Veracruz by way of San Juan, Puerto Rico. Upon arriving at the port of Veracruz on December 7, 1749, Serra and another companion opted to travel the 250 miles to Mexico City on foot. Unlike other friars departing the port that day on horseback, Serra declined such offers of assistance. Ultimately, Serra reached the Franciscan regional headquarters in Mexico City, the Colegio Apostólico de Propaganda Fide de San Fernando, on the first of January 1750. The evening prior to his arrival was spent at the pilgrimage mecca identified with the Santuario de Nuestra Señora Santa María de Guadalupe. Shortly thereafter, Serra and Palóu volunteered for service in the Pame Indian missions of the rugged Sierra Gorda at Jalpan, Querétaro, Mexico. Serra once again opted to walk the 175-mile distance to Jalpan despite a seriously infected insect bite sustained on his journey from Veracruz to Mexico City some six months prior.

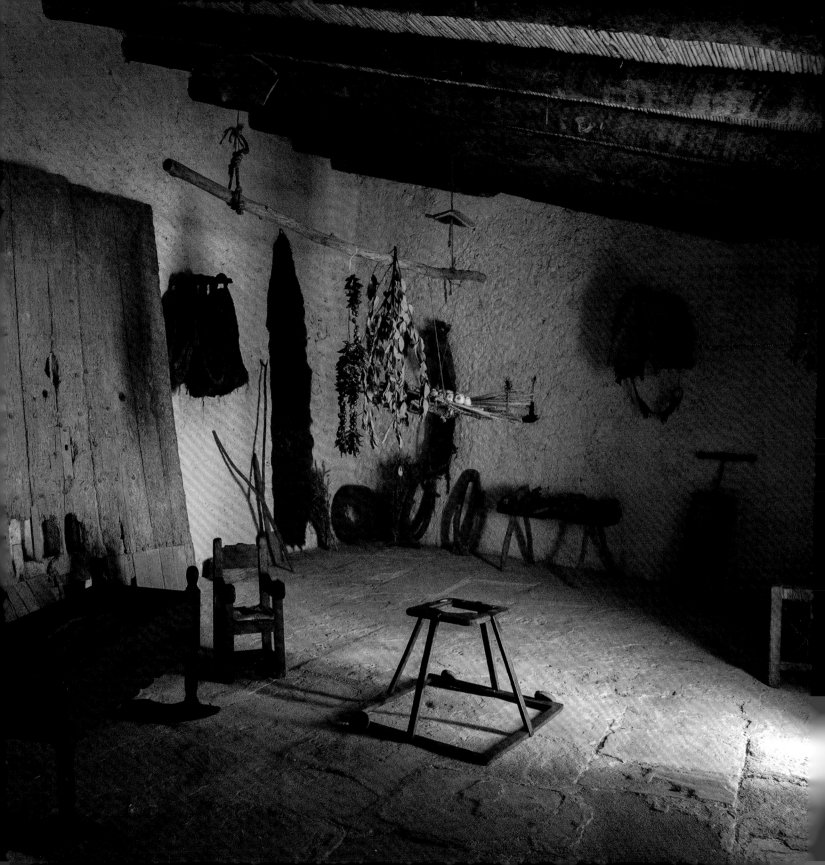

Serra in the Sierra

The Colegio de San Fernando had governed the missionary program in the Sierra Gorda since 1744. Nevertheless, the 1,000 Pame converts of Jalpan were only tenuously deemed Christian, whereas the majority remained gentiles or were construed pagan. Moreover, at the time of Serra's arrival, Jalpan consisted of a single adobe church, and a village comprised of jacal or pole and thatch huts and mud-covered structures. Despite the immediate challenges, Serra sought to see through the fulfillment of the missionary program among the Pame. To that end, Serra launched the construction of the ornate stone and stucco church that remains to this day, and worked to cultivate the economic and agricultural potential and religious indoctrination of the region. His efforts at Jalpan translated into similar efforts directed at the construction of permanent church buildings at the nearby towns of Concá, Landa, Tilaco, and Tancoyol. Much of this development occurred during Serra's tenure as president of the missions of the Sierra Gorda from 1751 through 1754. Moreover, while Serra's Sierra Gorda ministry spanned the period from 1750 through 1758, he learned the Otomi language, and converted the Pame by way of visual cues or methods, and personal deeds and actions on behalf of his community. Serra's success was bolstered by his transformation of the political economy of the region through the introduction of cattle, agricultural produce, and the promotion of trade and commerce. Serra's advocacy for the Pame peoples —like that subsequently undertaken on behalf of the indigenous peoples of *Alta California*—was perhaps his most successful tool in the arsenal of conversion, particularly as he was often pitted against Spanish and mestizo settlers in defense of Indian rights and against colonial encroachment on ancestral lands.

The prosperity of the Pame mission communities of the Sierra Gorda led to Serra's recall to the Colegio de San Fernando. Arriving on September 26, 1758, Serra and Palóu were assigned to serve as replacement ministers to the mission of San Saba, Texas, whose missionaries had been martyred and its mission campus destroyed during the course of an Apache attack. However, a host of factors forestalled Serra, and so he remained at San Fernando as the home missionary until 1767. There Serra served as choir director, master of novices, college counselor, confessor, and commissioner for the Holy Office. Serra's ministry on behalf of the Colegio de San Fernando spanned much of New Spain or Mexico, including missions in Mexico City, the Mezquital and Zimapan districts, the Rio Verde, central Oaxaca and Puebla, Tuxpam, Acayucan, Antequera, and into the Huasteca through to Valles, San Luis Potosi, and the Mesquital of Hidalgo, Mexico. While ministering in the Mesquital in 1767, Serra was once again recalled to the Colegio as a direct consequence of the suppression of the Society of Jesus in New Spain. Launched by Royal decree, the Jesuit expulsion swept Europe by way of Portugal in 1759, France in 1764, and Spain in 1767. Some 678 Jesuits from 16 missions and 32 mission stations from throughout the Viceroyalty of New Spain were forcibly removed and deported.

OPPOSITE
The upper floor of the Serra home in Petra, Mallorca, Spain. Note the vigas *or roof beams and* latillas *or wood thatching of the type that would come to dominate construction in the missions, presidios, and pueblos of Alta California.* PHOTO BY RUBÉN G. MENDOZA, 2015

Serra in the Californias

Upon his arrival in Mexico City, Serra was appointed Father President to the former Jesuit missions of Baja California. Although the expulsion order was first acted upon in Spain in April of that year, enforcement in New Spain did not commence until June 1767. Consequently, Serra departed for the Californias in July, but was waylaid by missionary activity in Tepic, Nayarit. Moreover, the relative isolation and logistical challenges of the Californias resulted in further delays, and action on the order was postponed until November 30, 1767. Administrative issues once again delayed enforcement in Baja California to February 3, 1768, and shortly thereafter, Serra departed the port of San Blas on March 14, 1768, arriving in Loreto on April 1, 1768. Upon arrival, Serra established himself at the former Jesuit cabecera or head mission and Spanish garrison or presidio at Loreto, and proceeded to assign Franciscan missionaries to the fifteen Baja missions left vacant by the departure of the Jesuits.

Within months of Serra's arrival at Loreto, Visitador generál José de Gálvez y Gallardo (January 2, 1720—June 17, 1787), the Marqués de Sonora, announced plans for the "spiritual and temporal conquest of Upper California." Serra volunteered for the mission, and conferred with Gálvez on the plan for a joint expedition to the north that would come to be known as the "Sacred Expedition" of 1769. The plan required that Serra join the Spanish Catalan commander and Governor of the Californias, Gaspar de Portolá i Rovira (January 1, 1716 – October 1786) in the spiritual conquest and colonization of Upper California. He was directed to serve as the founding Father President of the missions of that portion today identified with present-day California. On March 28, 1769, Serra set out from Loreto on a mule to rendezvous with the company of soldiers, civilians, and religious identified with the Portolá expedition. En route to meet the expedition, Serra founded the mission of San Fernando Rey de España de Velicatá on May 14 of that year. It was there, at Velicatá, that Serra found fulfillment in his lifelong calling to live and minister among the gentiles of the New World, and said of them, "they go about entirely naked like Adam in paradise before the fall." For Serra, his reward for years as a mendicant friar and missionary in New Spain was at hand. Serra blessed the Indians at Velicatá and then offered them a handful of figs. They in turn handed him roasted agave fronds and four fish, and the soldiers of the expedition reciprocated with other foodstuffs.

Despite the inflammation of his leg due to a leg lesion incurred on his journey to Mexico City from Veracruz in 1749, Serra insisted on continuing to the new mission founding at San Diego de Alcalá. When Portolá attempted to dissuade him from continuing with the expeditionary party, Serra instead insisted that he would nevertheless follow, and that even in the face of death. In an effort to assuage the concerns of the expedition commander, and minimize himself as a burden on his compatriots, Serra sought the medical assistance of Juan Antonio Coronel, an expedition muleteer. While the muleteer argued that his treatment of a tallow and herb poultice was only suitable for animals, Serra responded: "Well then, son, just imagine that I am an animal…." Serra thereby continued the arduous trek, and reached the site on July 1. Despite the tragedy that had befallen the

expeditionaries who anticipated his arrival, he immediately made preparations for the July 16, 1769, founding of San Diego de Alcalá.

It was there at San Diego, the first of those missions identified with Alta California, that Serra faced the first of many often heartbreaking and catastrophic challenges borne of the 900-mile trek across the deserts of Baja California. Serra's first mass was conducted in the land of the Kumeyaay peoples in the wake of the deaths of virtually half of the men who originally embarked on the expedition by land and sea. Whereas the land borne expedition was plagued by starvation, death, and desertions by the soldiers and Baja mission Indians accompanying the main party, the seaborne portion of the expedition was conducted on the Spanish packet boats *San Carlos* and *San Antonio*. The *San Antonio* made landfall at San Diego bay on April 11, whereas the *San Carlos* was lost at sea, only to return with its scurvy-stricken crew nearly three weeks later on April 29, 1769. Most of those identified with the supply ships were ultimately lost to scurvy. Serra therefore spent his first days in San Diego administering to the needs of the dead and dying. Within a month of the founding, a Kumeyaay uprising resulted in the destruction of the new settlement, and in the death of Serra's trusted protégé and assistant. Understandably, fear of other reprisals haunted this first of the foundings in Upper or Alta California, and this only hastened Serra's desire to achieve his principal objective, that of the founding of San Carlos de Monterey.

Such were the auspicious beginnings of Serra's 15 year quest to evangelize the indigenous communities of early California. While much has been said of the catastrophic toll on the indigenous inhabitants of California by the influx of Spanish colonials, the contributions of the Order of Friars Minor and their Indian converts has been minimized. The collaborative community efforts of Fernandino friars, Mission Indians, mestizo or Mexican Indian craftsmen and women, and their Afro-mestizo counterparts is mistakenly portrayed as a monolithic Iberian cultural invasion. In reality, the mission program envisioned by San Junípero Serra, OFM, and his actions on behalf of the indigenous inhabitants of New Spain and the Californias was borne of a compassion and desire to live and die among the peoples he so loved. Serra's legacy, while diminished by the actions of Spanish, Mexican and the American soldiers and colonists who followed, nevertheless holds claim to the very foundations of the political economy and settlement that today defines the modern state of California. As the seventh largest global economy, California owes much to Serra's role in the introduction and early development of the architectural, agricultural, technological, hydraulic, urban and cultural heritage of this, the Fourteenth Colony of the American experience.

ABOVE
Re-creation of Serra's spartan accommodations in the convento *at Mission San Carlos Borromeo, Carmel, California.* PHOTO BY RUBÉN G. MENDOZA, 2015

PART I: PRELUDE TO

THE CALIFORNIAS

SERRA IN THE SIERRA GORDA
1750–1758

Missions: Santiago de Jalpan, San Miguel Concá, San Francisco del Valle de Tilaco, Nuestra Señora de la Luz de Tancoyol, and Santa María del Agua de Landa

Founded: 1750–1761; Dedications: 1754–1768
Founder: Fr. Junípero Serra, OFM

Mexico's Sierra Gorda comprises the northeastern portion of the state of Queretaro, and constitutes one of the most biologically and climatologically diverse regions of Middle America. From the colonial city of Queretaro to Jalpan and the eighteenth-century missions of the Sierra, one traverses semi-desert regions and coniferous forests of the Sierra Madre Oriental through to elevations of 10,200 feet. Lush valleys alternate with desert vegetation and semi-tropical biomes replete with jaguars, bears, parrots, and monarch butterflies. By contrast, the missions of Alta California were situated in the Mediterranean-like landscapes of California approximating those of Serra's Majorcan homeland. In effect, Fray Junípero Serra, OFM, represents the common denominator linking the missions of Alta California with those of Querétaro and the Sierra Gorda. While the casual visitor might see little in the missions of the Sierra Gorda to suggest an architectural or cultural identification with the California missions, Serra's contributions in each region were pivotal. Serra's role in coordinating development of the five principal missions of the Sierra presents an important backdrop for understanding the motivations and beliefs of the founding father and Father President of the California missions.

After a year of training at the Colegio Apostólico de Propaganda Fide de San Fernando in Mexico City, Serra volunteered for a mission in the Sierra Gorda in 1750. In the catastrophic decade anticipating his arrival in the isolated and mountainous region that year, the Viceroyalty and the Spanish military actively sought to dismantle the fledgling missions of a province whose inhabitants long resisted Spanish encroachment. Indigenous resistance spurred a centuries-old conflict identified with the Chichimec Wars between the Otopame, Jonace and Pame, and Spanish settlers. The brutality of the subjugation escalated with the arrival of Spanish Colonel José de Escandón. The Colonel established a formidable track record suppressing indigenous rebellions dating back to the late 1720s. He also believed that spurring aggressive large scale colonization and pacification programs was the way of the future. For Viceroy Revillagigedo and the Marqués de Altamira, the use of treasury funds to subsidize the missionaries was an unwarranted expense. Escandón shared these views, and sought the dismantling of the mission system. As a result, his dissatisfaction with the missionary programs of the Sierra Gorda prompted an escalation of attacks on indigenous rebels, and efforts to coerce peaceable Pames into the missions through the destruction of their village settlements. Ultimately, Escandón was transferred away from the Sierra, but later returned to suppress an indigenous rebellion spurred by the famine of 1749. Shortly thereafter, Serra was dispatched to the Sierra to evangelize the Pames.

Although the Otopame peoples had undergone centuries of intermittent colonial contact and or missionization efforts, it was left to Serra to see through

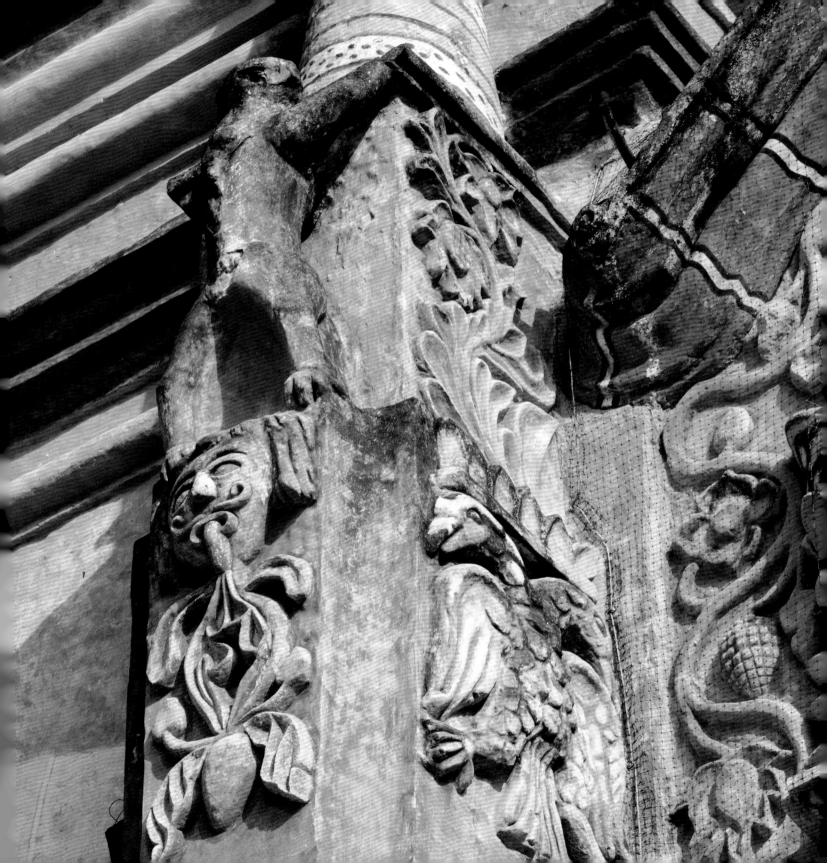

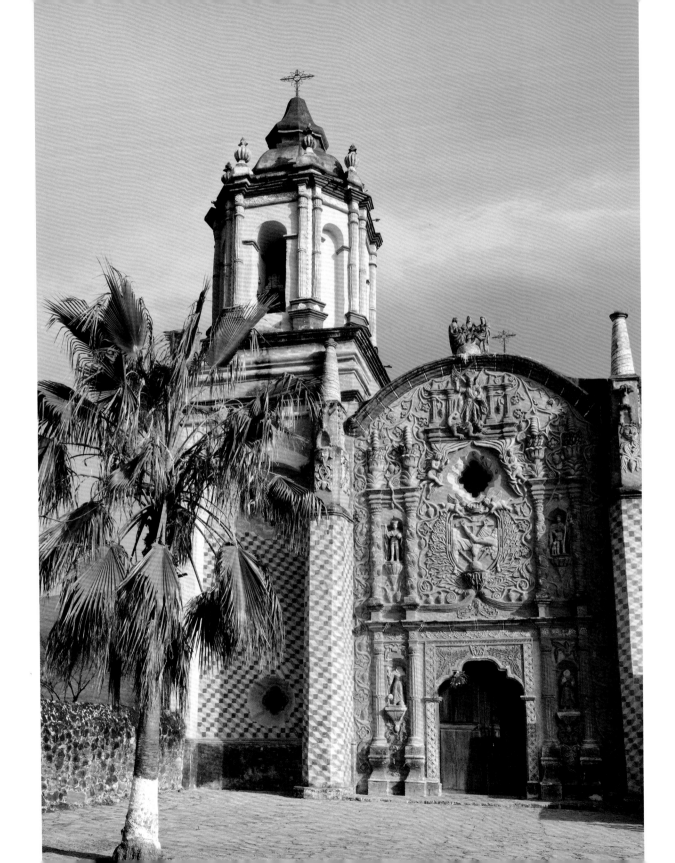

the missionary foundings in the Sierra Gorda. As such, the site of Serra's first missionary endeavor was tenuously anticipated by five friars from the Colegio de San Fernando in 1640. Prior to 1751, the missions of earlier Franciscans, Augustinians, and Dominicans seldom transitioned beyond temporary pole, mud, and thatched structures. Establishing himself at Nuestro Señor Santiago de Jalpan, Serra saw through the construction of its elaborate masonry Mexican or Mestizo Baroque church from 1751 through 1758. Although Jalpan experienced uneven success, Serra's initiatives resulted in the construction of a formidable church and agriculturally-based mission enterprise. Serra fully invested himself in the construction of a cabecera, or head mission, for the Sierra Gorda. Moreover, Fray Francisco Palóu, OFM, documented Serra's personal role in the construction of Jalpan in his capacity as Serra's biographer.

From Jalpan, Serra directed the construction of mission churches at San Miguel Concá, San Francisco del Valle de Tilaco, Nuestra Señora de la Luz de Tancoyol, and Santa María del Agua de Landa. In 1752, Serra departed for Mexico City to consult an architect, taking with him only 100 nails, a violin, a carpenter's tool, and the writings of the visionary María de la Agreda. Given the multitude of major church buildings under construction in Mexico at that time, Serra was clearly influenced and informed by his time in the city. Whereas the cruciform floor plans of the five churches exhibit a degree of uniformity, that of Jalpan was distinct for its monumental scale and complexity. Measuring 147 feet long by 30 feet wide, the church features a two-tiered bell tower with an octagonal first, and hexagonal second, stage and spire. Otherwise, the exuberantly embellished facades and ancillary structures of the Mexican or Mestizo Baroque churches of the Sierra all retain regionally distinctive elements. In addition, anachronistic themes and features derived from earlier sixteenth- and seventeenth-century churches found new life in the Sierra. Ancillary features included the placement of atrial crosses within walled forecourts or atriums, pozas or shrines, capillas abiertas or open chapels, and interior courtyards and gardens.

Jalpan's church plan follows the configuration of the Latin cross, replete with transept, domed octagonal vault, side altars, ornate tower with spire, and three-staged facade with four eighteenth century estipite or inverted obelisk-like columns surmounted by a Solomonic or helical shaft. Notably, this first of Serra's five missions set a stylistic precedent. Begun in 1751, Jalpan was completed in 1758, while Concá was completed in 1754. Jalpan's monumental Churrigueresque or elaborate Spanish Baroque facade incorporated six sculpted saints into its facade, including that of the image of the Virgen de Guadalupe, Mexico's Indian Madonna, as well as the Franciscan emblem of the Conformity, featuring the crossed arms of Saint Francis of Assisi and the martyred Christ.

Concá was inspired by that work undertaken on Serra's Jalpan church, and features an elaborate Mexican Baroque facade and domed vault. Unlike Jalpan, Friars José Antonio de Murguía and Joaquín Sorio, OFM, were the builders, and their church was among the first in the region completed and constructed entirely of quarried stone and lime stucco. Its facade was fashioned from an argamasa lime-sand and fiber mixture over wood and masonry forms. The façade is

OPPOSITE
San Miguel Concá was constructed by Pame Indians and completed in 1754. Its bell tower consists of a single octagonal drum or stage.

FOLLOWING PAGES
LEFT *Santiago de Jalpan was constructed by the Pame Indians under the direction of Fray Junípero Serra, OFM, 1751–1758. Mexican or Mestizo Baroque dominates the facade.*

MIDDLE *San Francisco del Valle de Tilaco was constructed by Pame Indians under the supervision of Fray Juan Crespí, OFM, 1754–1762. Crespí followed Serra to Alta California, and eventually to San Carlos Borromeo.*

RIGHT *Santa María del Agua de Landa was constructed by Pame Indians under the supervision of Miguel de la Campa, 1760–1768. The atrium is bounded on all sides by an exuberantly sculpted wall replete with a host of motifs akin to those of the main facade of the church.*

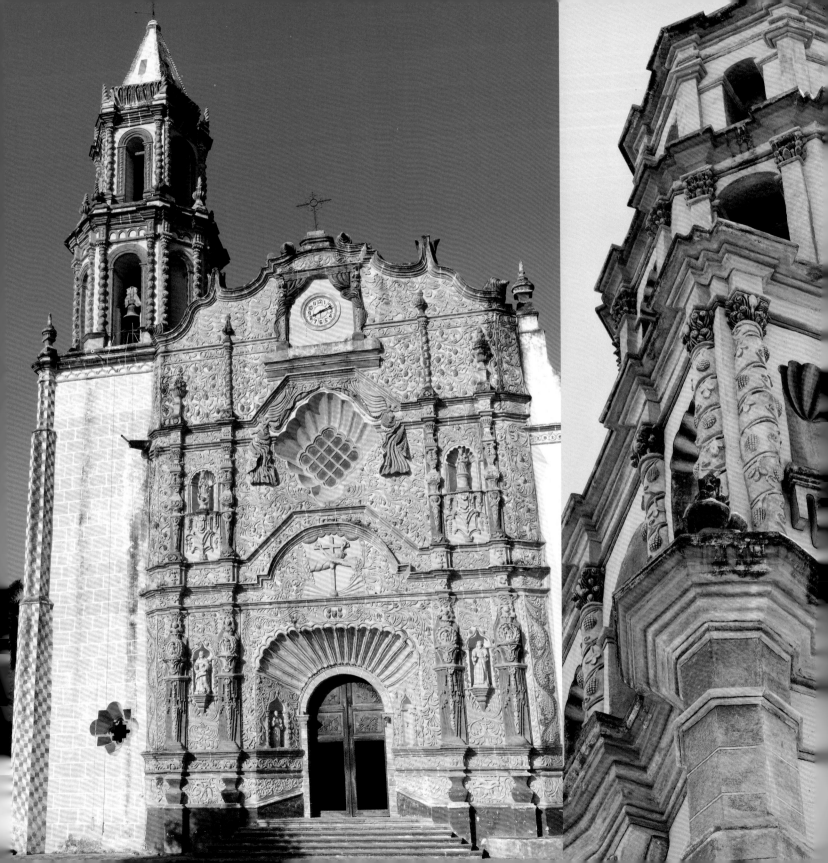

surmounted by a sculpted depiction of the Holy Trinity, or Father, Son, and Holy Spirit, and a single-stage octogonal bell tower. The facade integrates the Franciscan emblem of the Conformity over the main door, and five sculpted saints framed by estipite columns. Measuring 102 feet long by 22 feet wide, Concá was the smallest of Serra's churches. By contrast, Tilaco was the third church completed in 1762, and the tower some time thereafter. Dedicated to San Francisco de Asís, the church at Tilaco measured 111 feet long by 25 feet wide, and features a three-tiered bell tower with Solomonic columns and pilasters, the first stage squared, and the second and third octagonal in cross-section. The building of Tilaco is attributed to Fray Juan Crespí, OFM, who accompanied Serra to Alta California.

Although the final two churches, Tancoyol and Landa, were originally completed by 1762, the friars at those sites determined to revisit and build anew their churches. Therefore, Tancoyol's completion was delayed until 1764, and it is likely that Serra's May 7, 1766, visit prompted the blessing of the church. While the bell tower of Tancoyol is similar to that of Jalpan, the church measures 125 feet long by 28 feet wide, and is distinguished by the exuberance of its molded argamasa and masonry reliefs and iconography. Juan Ramos de Lora was the architect and builder of Tancoyol, with its distinctive crenelated atrial wall. The last of the Serra missions is Landa, which underwent construction from 1760 through 1768. Measuring 119 feet long by 28 feet wide, the two-stage bell tower consists of a square first, and hexagonal second, stage replete with spire and Solomonic and estipite columns. Miguel de la Campa is thought to have built the church at Landa. While its completion has been dated to 1766, a letter penned in that year by Padre José García, OFM, suggests otherwise, as does an inscribed bell dedicated to "San Antonio de Padua. Año de 1768."

Ultimately, all church facades of the Serra missions were rendered by way of molded and or modeled lime-sand and vegetable fiber stucco and mortar (argamasa) mixtures rendered over wooden or masonry forms. The plasticity of argamasa permitted the creation of exuberant bas-relief, and high relief, sculpted representations of anthropomorphic, zoomorphic, and botanical elements. Extant polychrome colorings of the facades consisted of red and yellow ochres, with ground slate for blue, charcoal or ash for black and dark brown, cattle blood-enhanced red ochre, and vegetable dies for green. These natural mineral and vegetal pigments were mixed with lime and nopal cactus resins or egg whites as binders. This formula for that craftsmanship represented in the modelling of an enduring church iconography was a mainstay for each of the churches of the Sierra Gorda.

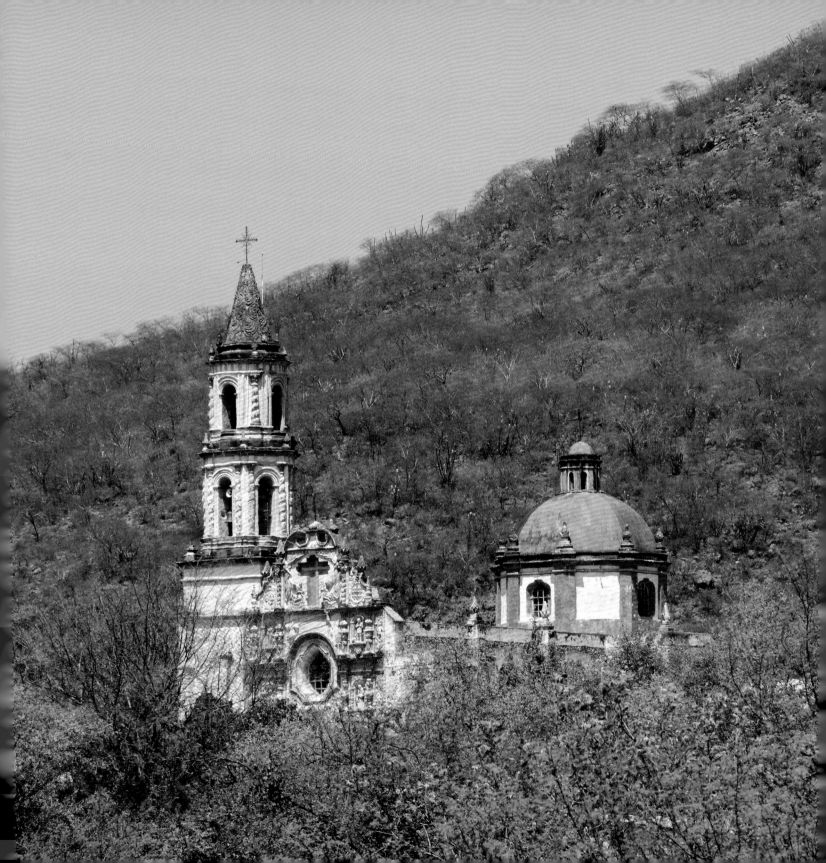

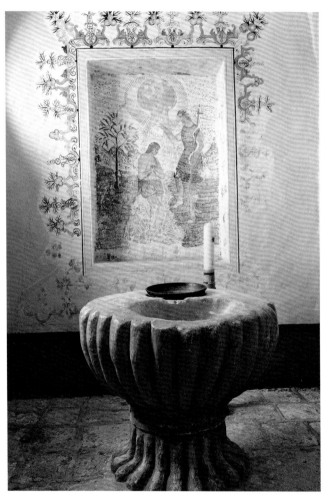

28 Serra in the Sierra Gorda, 1750–1758

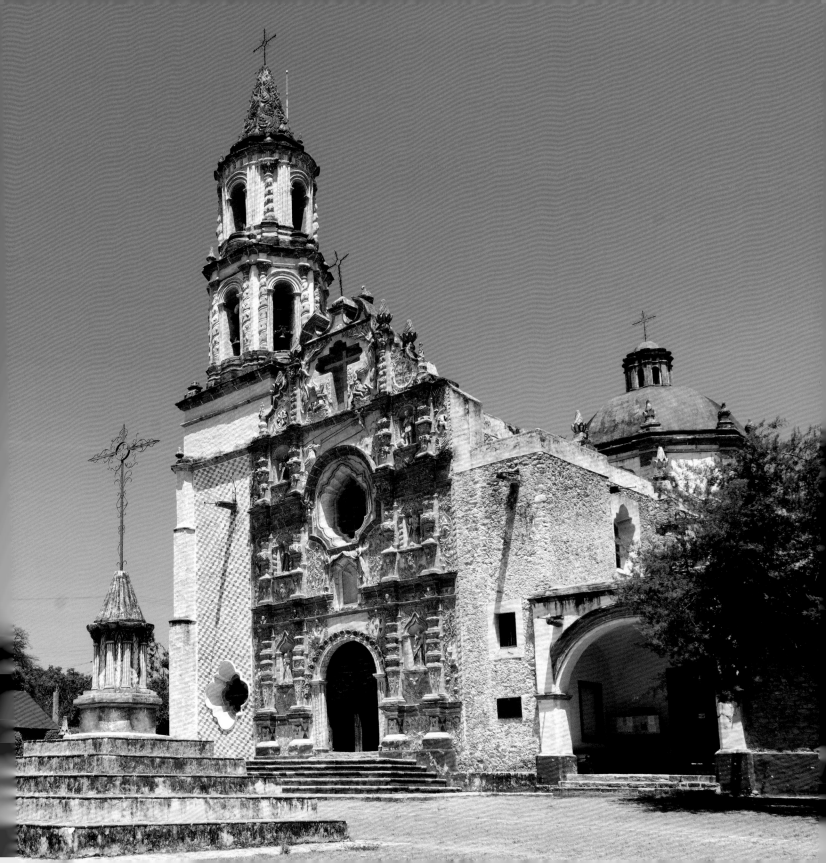

PART II: FIRST

FOUNDINGS

SAN DIEGO DE ALCALÁ

Founded: July 16, 1769; Dedication: November 12, 1813
Founder: Fr. Junípero Serra, OFM

PREVIOUS PAGES
The tile-covered gateway on the west side of the basilica church opens into the campo santo *or mission cemetery, which was largely devoted to the burial of the Excelen, Rumsien, Mexican, and other mission Indians of San Carlos Borromeo (see page 46).*

OPPOSITE
Unlike the campanarios *at other sites, access to the* campanas *or bells of San Diego was by way of an exterior, patio-oriented, masonry staircase.*

FOLLOWING PAGES
The façade or portada of the mission church incorporates neoclassical, mudéjar, and late Baroque architectural lines and elements. The curvilinear pedimented gable at the crest of the façade was one that set the stage for similar such features at other missions and presidio sites.

As the first of the Spanish Franciscan missions of Alta California, San Diego de Alcalá has long been construed the Mother of the California Missions. Founded on July 16, 1769, this first of the California missions was forged from the sacrifice, misfortune, and martyrdom of its earliest indigenous peoples, settlers, friars, and Catholic converts. Four expeditionary parties were dispatched from the Royal Presidio of Loreto, Baja California, on March 28, 1769. The undertaking is best known as the Sacred Expedition. Indomitable oceangoing headwinds and a host of trials plagued the expedition and prompted the loss of life. Despite such travails, San Diego was established in the wake of the arrival of an overland expeditionary force led by Captain Gaspar de Portolá and Fray Junípero Serra, OFM. Though both Portolá and Serra were charged with respectively furthering the colonial and missionary dimensions of the enterprise, they were the last to arrive at the appointed location. As such, they joined what remained of the advance parties already camped on the shore. There at the site of the Kumeyaay village of Cosoy, Serra established the first mission at the new garrison. Meanwhile, Portolá continued north in search of the fabled Puerto de Monterey.

Dedicated to Saint Didacus, a fifteenth-century Spanish Franciscan lay brother credited with miraculous healing powers, San Diego was the first mission christened by Serra. The site's tumultuous beginnings were exacerbated after the mission was moved inland to its present location in August 1774. It was in effect Fray Luís Jayme who wrote Serra on April 3, 1773, to request relocating the mission some six miles inland from the presidio in an effort to secure a dependable water supply and limit untoward influences of the soldiers on gentiles and neophytes alike. On November 4, 1775, the Kumeyaay launched an attack and sacked and burned the mission. Killed in the melee were master carpenter José Urselino, blacksmith Joseph Manuel Arroyo, and Jayme, who attempted to peaceably quell the uprising but was brutally martyred. Urselino is documented to have willed his worldly possessions and tools to the Kumeyaay mission neophytes.

Whereas two churches were built at the earlier presidio location, the current site evolved from simple pole and thatch structures to a more formidable complex of buildings consisting of stone foundations, adobes, adzed timber, fired roof (*tejas*) and floor tiles (*ladrillos*), and white-washed lime stucco walls. Rebuilding of the ruined mission began within a year of the conflagration that destroyed the first church. The first adobe church was erected in 1776–77. A second, larger church was begun in 1778 and dedicated on June 7, 1781. This adobe church consisted of ceilings of pine beams, sycamore and cottonwood rafters, a thatched tule and earth roofing membrane, and cedar grills and shutters. The third adobe structure was begun at the former Kumeyaay village of Nipaguay on September 29, 1808, and the church dedicated on the feast day of November 12, 1813. An elegant reredos crafted by Mexico City master carpenter José María Uriarte was installed in 1810. The refined curvature of the gable, small niche and window combination, and rectangular molding surrounding the arch at the center of the main façade

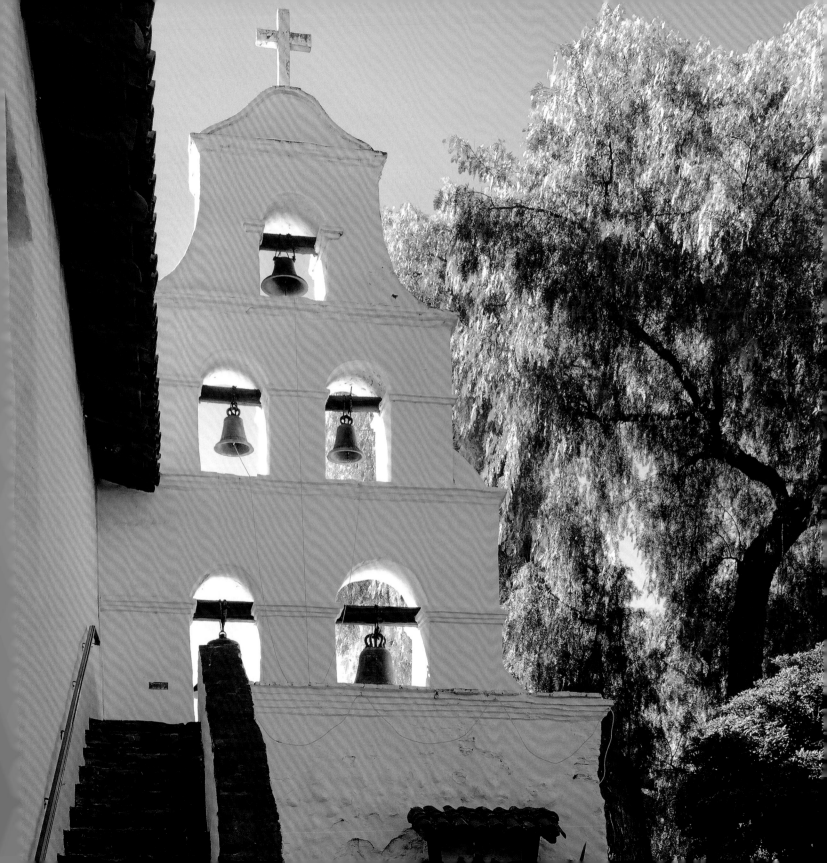

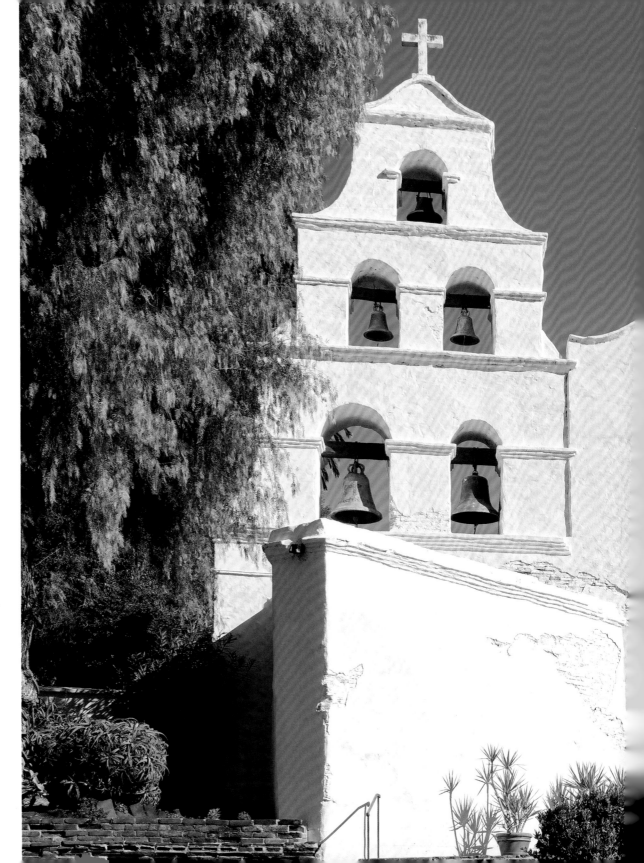

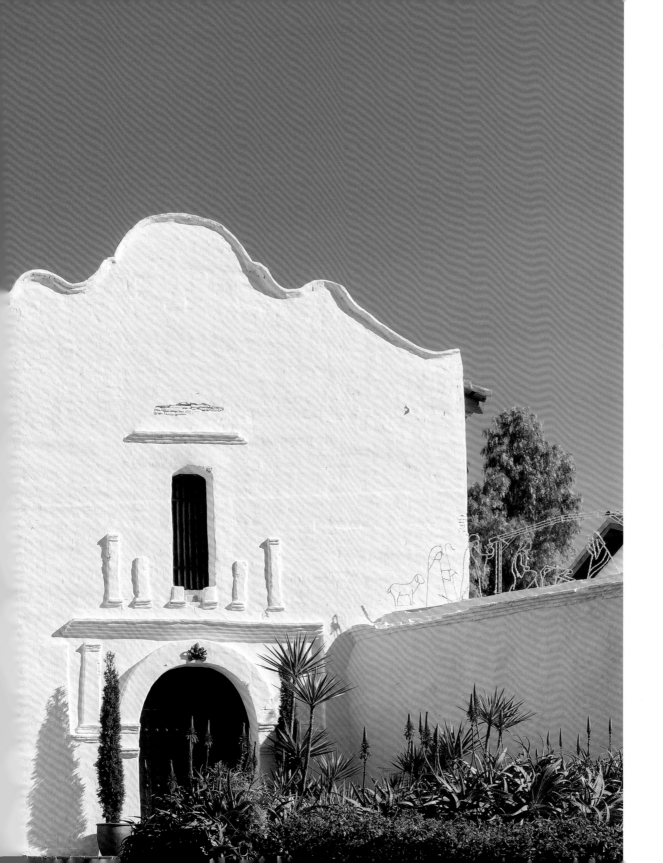

(*mudéjar alfíz*), all indicate an understanding of distinct architectural principles and practices attributed to master stone mason Miguel Blanco.

TOP RIGHT
The tiled portal in this instance represents a partial reconstruction of the convento *wing and arcade that once stood at this portion of the mission quadrangle.*

BOTTOM RIGHT
*Façade of Saint Bernardine Chapel (*La Capilla*).*

OPPOSITE
The sculpted Mexican fountain located at the center of the mission quadrangle stands as a reminder of the many waterworks that once fed the mission. A masonry dam on the San Diego River, a six-mile-long aqueduct or zanja, *and a waterwheel or* noria, *all fed the needs of the mission complex.*

FOLLOWING PAGES
This classically inspired mission arcade borders a patio that teams with mature plant life and garden statuary. While a particularly lush contrast to the otherwise workaday world and industrial patios and courtyards of the mission era, these gardens provide visitors with a serene and contemplative atmosphere within which to ponder the history of such sites.

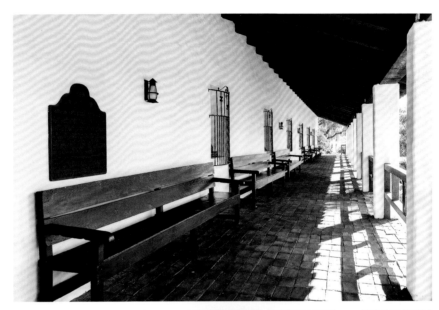

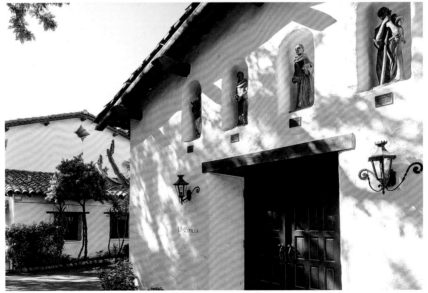

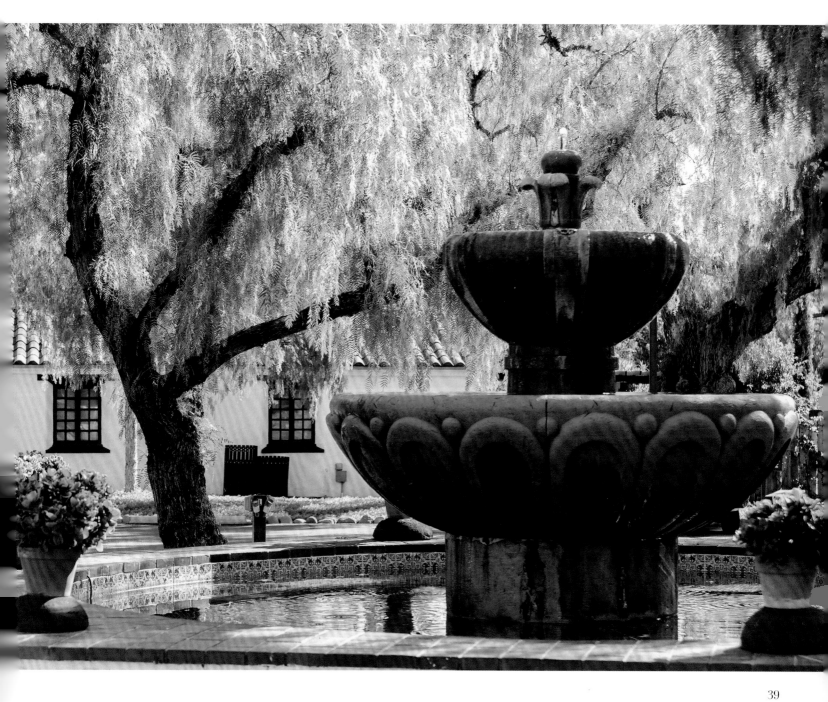

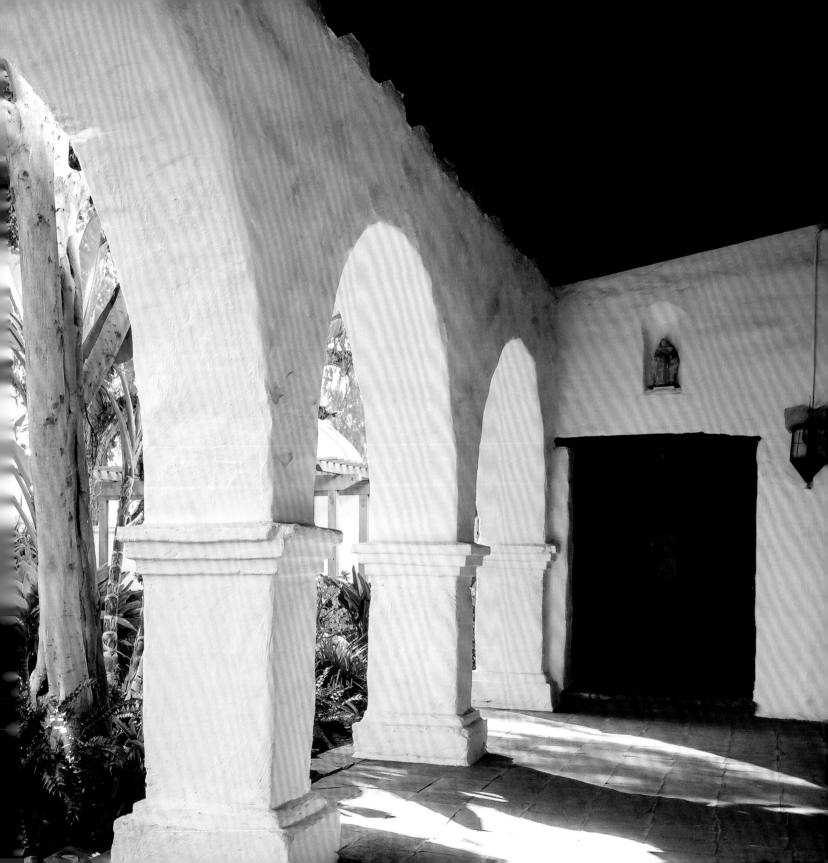

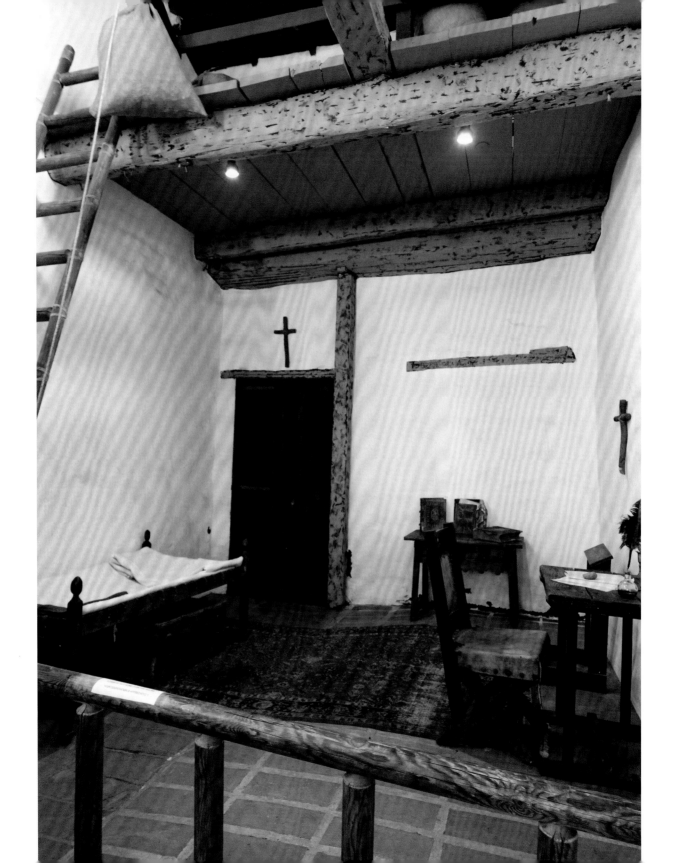

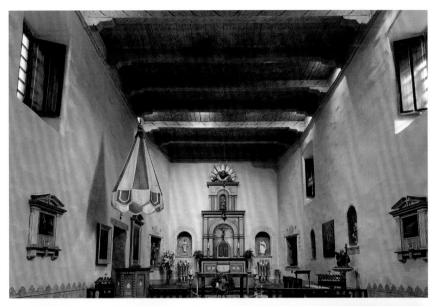

OPPOSITE
This reconstructed convento dormitory room incorporates a loft assembled with timber cross members or vigas *and* tablas *or boards.*

TOP LEFT
Originally constructed in 1813 as the third church at this site, the extant building was rebuilt in 1930–31, and rededicated a basilica by Pope Paul VI in 1976.

BOTTOM LEFT
Saint Bernardine Chapel (La Capilla) *features seventeenth-century choir stalls from a Spanish convent.*

FOLLOWING PAGES
LEFT *A modern depiction of San Francisco, or Saint Francis, stands vigil over the modern wishing well in the mission garden.*

FOLLOWING PAGES
RIGHT *The staircase to the back of the* campanario *or bell wall adjoins the patio garden.*

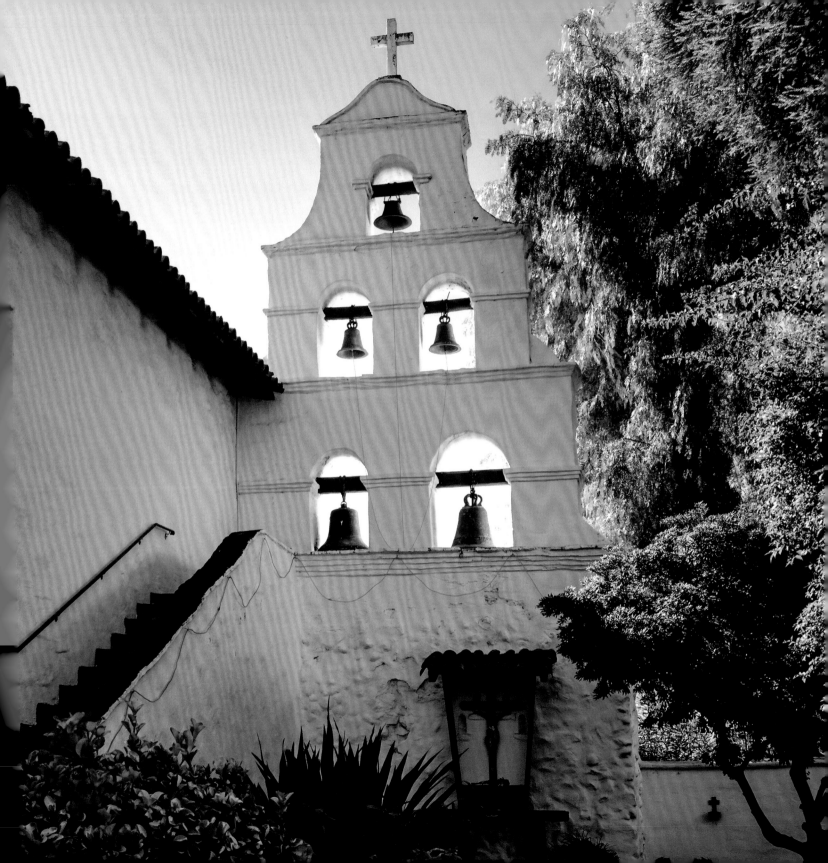

SAN CARLOS BORROMEO (CARMEL)

Founded: June 3, 1770; Dedication: December 25, 1797
Founder: Frs. Junípero Serra and Juan Crespi, OFM

OPPOSITE
Nine original bells once graced the bell tower of San Carlos Borromeo, and each was dedicated to a different Catholic saint. Each mission maintained bell ringers who passed on the craft of calling the people to worship from one generation to the next.

Deemed the Father of the California Missions, San Carlos Borromeo best represents the life and works of the newly sainted founding father of the California missions, San Junípero Serra, OFM. Canonized by Pope Francis on September 23, 2015, the venerable friar is buried on the Gospel (left) side of the sanctuary of the San Carlos Basilica. San Carlos Borromeo, the second of the Serra missions established in Alta California, was originally founded at Monterey on June 3, 1770, as a joint Spanish military and missionary enterprise. Situated on an escarpment overlooking the strategic Puerto de Monterey, the mission was erected just outside the southern perimeter defensive wall of the presidio stockade. With a chapel, missionaries' quarters, a store house (*almacen*), kitchen, and housing for neophytes and gentiles, the earliest site identified with mission San Carlos de Monterey was rudimentary at best. From the outset, Serra sought to distance the mission from that of the garrison. Serra's desire was to locate the mission in a populated and agriculturally viable location with a reliable water source. In 1771, Serra relocated the mission 1.5 leagues, or circa five miles, away at the village of Ekheya along the Río Carmelo, and within two cannon shots of the shore.

From 1771 until his death on August 28, 1784, Serra orchestrated the founding of the next seven missions from Carmel. As such, San Carlos Borromeo continued to play a pivotal role as the head mission (*cabecera*) of Alta California. Serra's homage to the original founding at Monterey was such that he identified the new location with San Carlos de Monterey, as opposed to Carmelo. Initial construction on the hillside overlooking the Carmel River resulted in a stockade-like pole and thatch compound replete with amenities and buildings akin to those erected at Monterey. In this effort, Serra coordinated a handful of soldiers, sailors, and Mexican Indians from Baja California in the construction of the first chapel and ancillary buildings. From 1771 through 1797, the friars and neophytes saw through the construction of seven successive churches ranging from pole, mud, and plank-roof affairs through to adobe and vaulted sandstone sanctuaries. The Basilica proper was commissioned by Fray Fermín de Francisco Lasuén de Arasqueta, OFM, in 1792, and designed and constructed by the master stone mason Manuel Esteban Ruiz and his team of journeymen. After a host of setbacks occasioned by ongoing projects at Monterey, construction on the extant Santa Lucia Sandstone church was resumed in 1795, and continued through to its dedication on December 25, 1797.

The basilica represents an eclectic array of architectural styles combined in a singularly unique fashion. In fact, the façade (*portada*) bears the unmistakable imprint of the Islamic Mudéjar tradition of the Moors or Muslims of Al-Andalus, Spain. The most distinctive elements include the mudéjar window denoting the Star of Bethlehem, the rectangular molding surrounding the parabolic arch (*alfíz*) and rectangular cornice over the main door, and the crenelated parapet or Gothic merlons atop the bell towers. After the earthquake of 1812, the friars dismantled the massive parabolic vault and installed a flat plank ceiling. In so doing, they in-

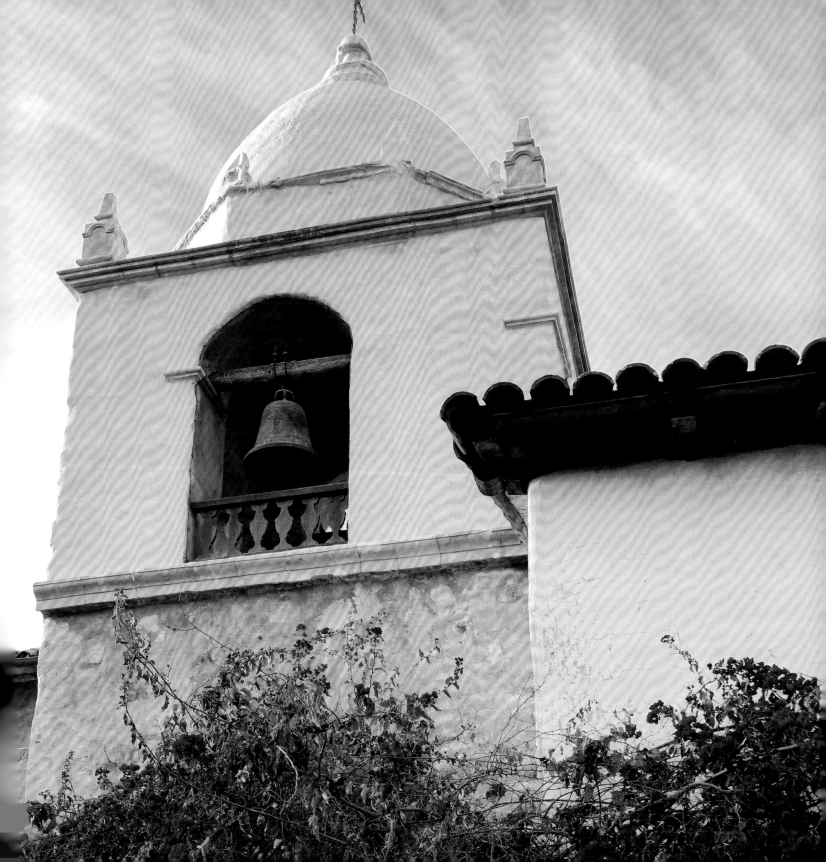

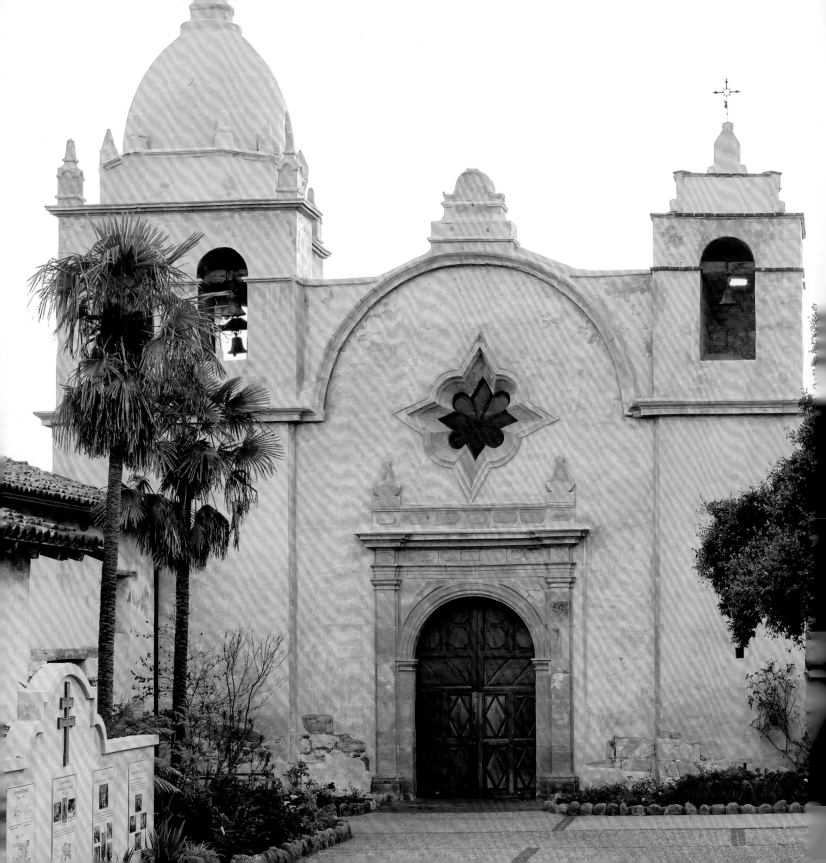

LEFT

The distinctive mix of neoclassical, gothic, and mudéjar or Islamic architectural expressions in the façade and interior vaults of the Basilica of San Carlos Borromeo set it apart from all others in the California missions. These features hearken to architectural expressions identified with the great churches of Cordoba, Granada, and Seville, Spain.

BELOW

The interior courtyard arcade once spanned the whole of the convento *quadrangle, and thereby framed the patio. Its depiction by various early visitors document its existence to as early as the 1790s.*

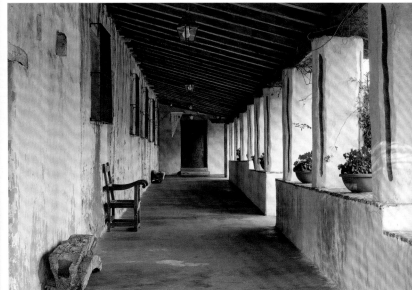

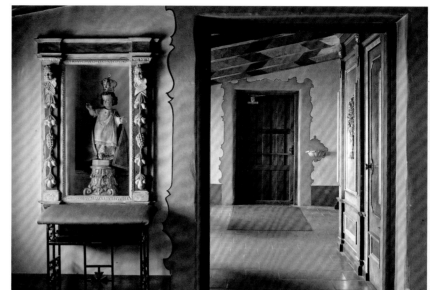

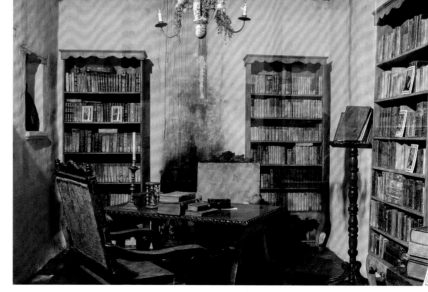

TOP RIGHT
Breezeway into the reconstructed convent wing that once housed the vestments room and the Downie Archives.

BOTTOM RIGHT
The Serra Library consists of Spanish colonial era books on theology, liturgy, music, and medicine, including the original Serra bible now housed in the museum. As was the case in many of the California missions, such books often originated from the Colegio de Propaganda Fide de San Fernando, Mexico.

FAR RIGHT
The parabolic vault of the church contains fourteen stone-and-mortar, and formerly wood, arches that further distinguish the basilica from all other California mission church buildings.

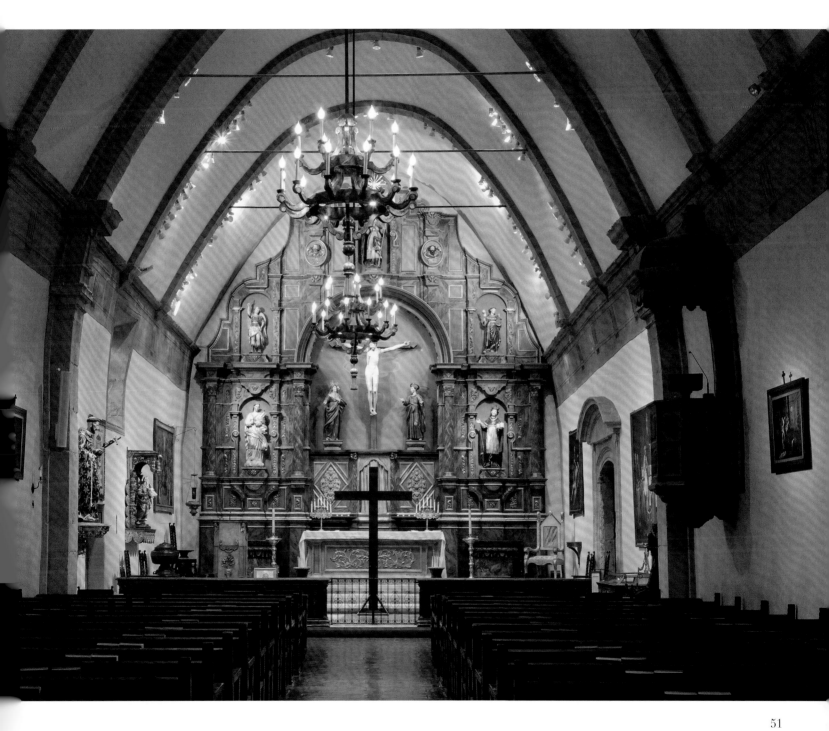

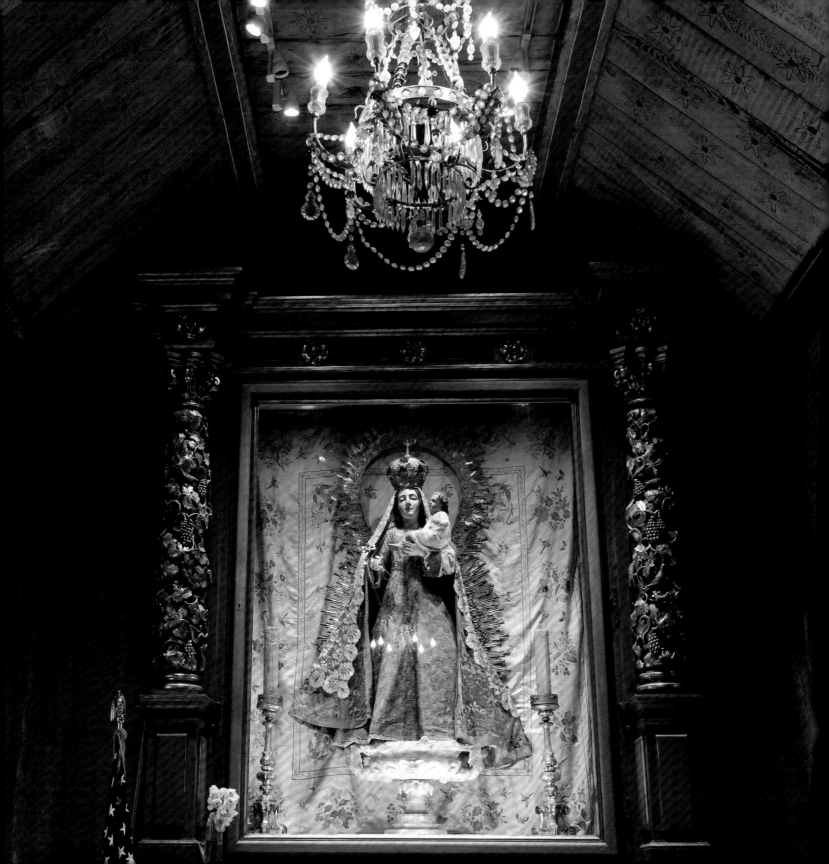

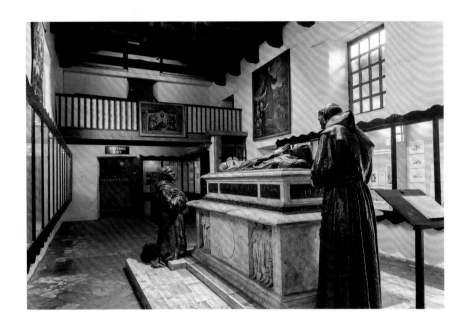

OPPOSITE
This side altar was installed by longtime-mission curator Sir Harry Downie, and was fabricated to incorporate both gilded Solomonic columns and a neoclassical entablature. The vitrine houses the original bulto or statue of Our Lady of Bethlehem, otherwise known as La Conquistadora.

LEFT
In the former sala or living room area adjacent the basilica, a monumental bronze and marble cenotaph created by area artist Jo Mora constitutes a tribute to Fray Junípero Serra, OFM. The Serra Cenotaph was originally commissioned to house the remains of the future saint within the sanctuary; but its particularly large size precluded its placement in the basilica.

creased the height of the upper register of the church and its façade. Masonry recovered from the retrofit was used to build the side chapel devoted to the Passion of the Christ, later repurposed as the Funerary Chapel, and today identified with Our Lady of Bethlehem. The bell towers flanking the arched gable and frontispiece evolved from the retrofit of two earlier free-standing bell walls (*campanario*). The basilica interior features a Gothic vault over the baptistery, and a parabolic vault with fourteen arches spanning the nave. Like the original reredos of San Francisco de Asís and San Diego de Alcalá, that of Carmel resonates with the signature style of master craftsman José María Uriarte. Although the extant altar screen at Carmel constitutes a reproduction by Diocesan Curator Sir Harry Downie, contemporary paintings make clear the association with the Mexico City craftsman.

53

RIGHT *Northwest of the mission church is a building that pays tribute to former Mission Curator Sir Harry Downie.*

BELOW *Father Junípero Serra, who is buried on the Gospel side of the main altar sanctuary, was canonized as a Catholic saint by Pope Francis on September 23, 2015. San Carlos Borromeo has since become a place of pilgrimage devoted to one of the very few Catholic saints interred in North America.*

FOLLOWING PAGES *The forecourt of the Basilica church has been transformed by the addition of a Mudéjar style fountain and lush gardens.*

PART 3: INLAND

MISSIONS

SAN ANTONIO DE PADUÁ

Founded: July 14, 1771; Dedication: 1813
Founder: Fr. Junípero Serra, OFM

Captain Gaspar de Portolá first scouted the location of the third Serra mission during the course of the Sacred Expedition of 1769, and named the region La Hoya de la Sierra de la Santa Lucia on September 17, 1769. The name was later truncated to Santa Lucia, and is better known as Los Robles, or The Oaks. Today, the Mission of the Sierras is nestled between the coastal range identified with the Santa Lucia Mountains and the Diablo Range. Shortly after relocating San Carlos Borromeo to the Carmel River, Fray Junípero Serra, OFM, traveled the course of the Río San Antonio to the region identified by Portolá. On July 14, 1771, Serra convened the formal dedication of the new mission by planting a newly fabricated cross and tolling mission bells suspended from an old oak. Within two years, the friars relocated the mission approximately one league or three miles distant.

Friars Miguel Pieras and Buenaventura Sitjar, OFM, coordinated the construction of the mission church devoted to the evangelization of the northern Salinan or Antoniaños of the village and area of Teshhaya, or Sextapay. In so doing, they built an adobe church and living quarters with flat roofs consisting of lime-plastered slabs of mortar. By 1774, the friars, soldiers, and neophyte converts constructed a masonry dam across the Río de San Antonio, excavated some 3.5 miles of canals for a masonry aqueduct, installed a mill-race and reservoirs, and erected an adobe granary. This undertaking produced the first such aqueduct in the Californias. Small mud-covered pole and thatch dormitory structures (*palisados*) were erected for a troop of soldiers (*escolta*) and their families. By 1776, the early church was enlarged and retrofitted with *teja* roof tiles. Moreover, this church was the first to deploy the iconic barrel tiles today identified with the California missions. Soldier and stone mason Eugenio Rosalio likely aided the innovations in question, as he was onsite during the 1776 retrofit. Construction on a second, larger adobe church and sacristy began in 1779, and was completed and dedicated in 1780 during the tenure of the neophyte Indian stone masons Pedro Antonio, Mathías Mendoza, and Simeón Figuerola. Between 1774 and 1806, the mission added scores of adobe dwellings for the neophytes, granaries, storage rooms, kitchens, housing for the soldiers and their families, a warehouse structure to house lumber, a tannery, a cemetery, and both horse and water-powered gristmills. The fired brick arcade (*portales*) running the length of the convento adjacent the church was added by 1817, by which time a barrel-vaulted brick and tile wine cellar and processing vats were completed.

The present Mission church, begun in 1810 and blessed in 1813, constitutes the third and final sanctuary at San Antonio. Friars Pedro Cabot and Juan Bautista Sancho, OFM supervised its construction. The broad 40-foot span of the nave demonstrates the ability of the builders to float exceptionally large timber from the mountains to the mission. Deemed the Great Church, one of its most distinctive features is the conjoined three-arched fired brick narthex (*portico*) and *espadaña* bell wall replete with two diminutive brick bell towers. The installation of the narthex and *espadaña* effectively framed the makings of a barrel-vaulted

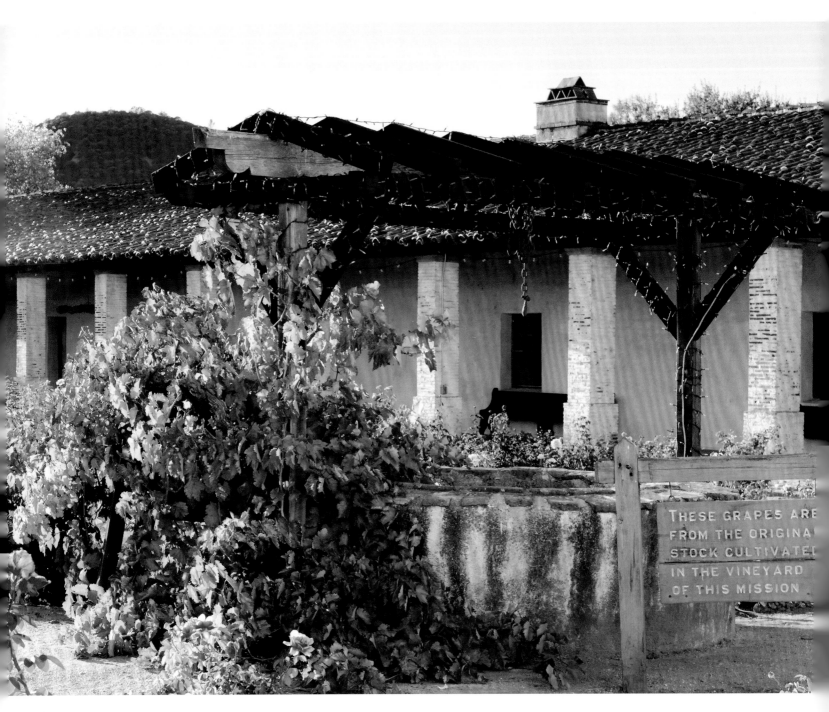

THESE GRAPES ARE
FROM THE ORIGINA
STOCK CULTIVATED
IN THE VINEYARD
OF THIS MISSION

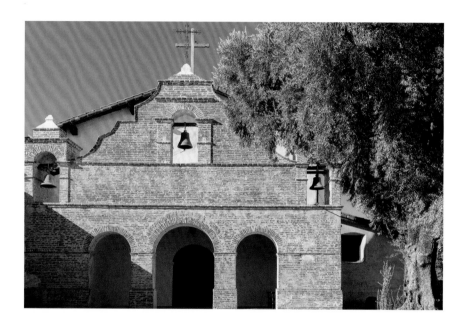

vestibule reception or receiving area (*bóveda*) for the unbaptized. The portico framed by the *espadaña* with three bells dates to circa 1821, at which time the church was retrofitted to accommodate a barrel-vaulted plank ceiling (*ochavado*) over the nave. The three-arched configuration of the church facade is identified with the propylaeum of Roman or Vitruvian architecture, and signifies the gateway to the Heavenly Kingdom. Ultimately, San Antonio prospered and construction continued through to the period of Secularization in 1831.

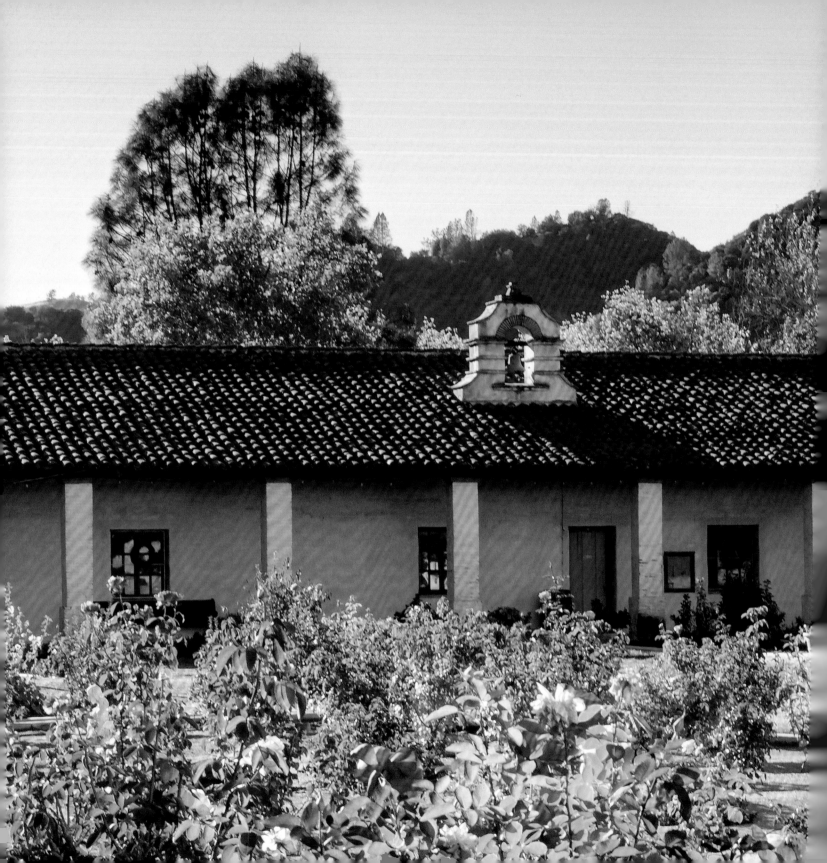

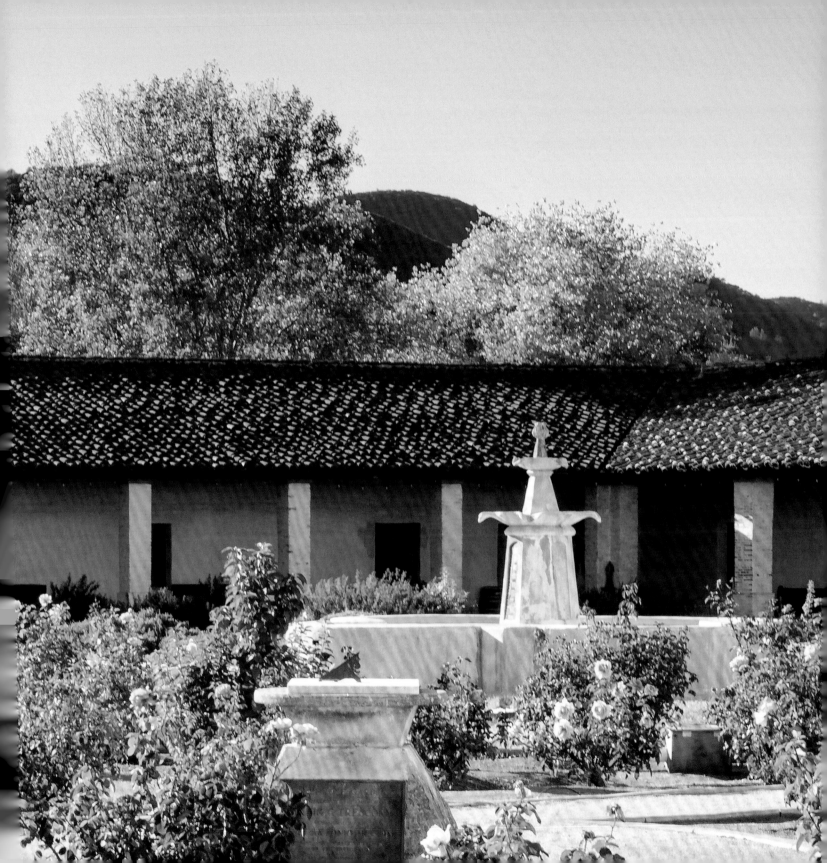

RIGHT *The ochovado ceiling or octagonal barrel vault of the main church is akin to those that once existed at other sites, such as that at San Juan Bautista. Though now restored, the star-studded blue vault delimiting the nave from the sanctuary and altar was an early feature documented by a host of nineteenth-century visitors.*

ABOVE *The holy water font was generally situated near the main or secondary church entryway, and permitted the faithful to make the sign of the cross or bless themselves with holy water.*

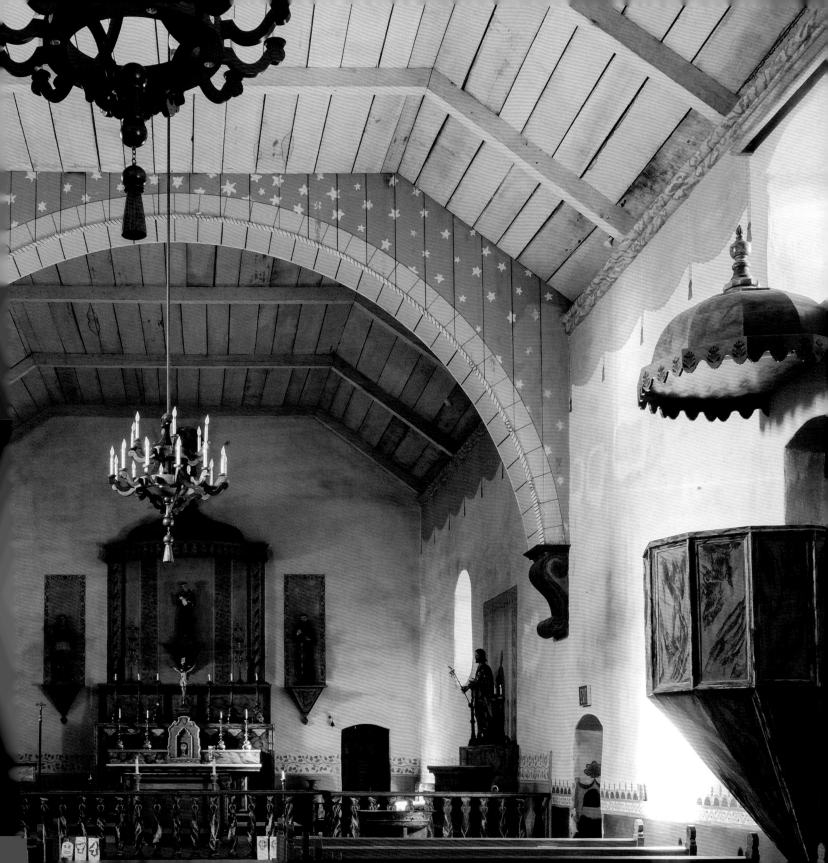

SAN GABRIEL ARCÁNGEL

Founded: September 8, 1771; Dedication: February 21, 1805
Founder: Fr. Junípero Serra, OFM

After the Spanish conquest of the Mexica Aztec in 1525, Capitán General Don Hernán Cortés ordered the planting of grapes for wine production in *Nueva España*. By 1595, New World vinification was so successful that it rivaled European wine production, thereby prompting King Carlos I of Spain to forbid new vineyards. Consequently, only the sacramental wine of the European *Vitis vinifera*, or its hybrid with native varietals, was produced in the New World, including Alta California. Wine cultivation at San Gabriel Arcángel after 1778 nevertheless proved the most successful such early enterprise on the west coast. Known for Vitus vinifera or "Red Palomino," San Gabriel boasts the *viña madre* or ancient vines that represent the beginnings of California wine and brandy industries in the late eighteenth century.

San Gabriel de los Temblores, as it was known, was founded as the fourth mission by Serra at the southernmost margins of the San Gabriel Valley at the Tongva or Kizh village of Shevaanga on September 8, 1771, officiated by friars Pedro Benito Cambón, and Ángel Fernández Somera y Balbuena. While Serra originally selected the Río de los Temblores (Santa Ana River), the friars soon relocated near the Río Hondo. The first mission experienced crop failures and recurrent conflicts with the indigenous community due to abusive soldiers. This so demoralized Somera y Balbuena that he grew ill and retired that year. In 1773, Pedro Fages reported the provisional quality of all buildings at La Misión Vieja, including a church, missionaries' dwelling, office, forge, and granary, all of *palisado* or pole and mud construction with tule thatch or *terrado* or earthen roofs. Fages also noted housing for five Mexican Indian neophyte families and six young men from Baja California adjacent to the compound. In May of 1775, as the result of flash floods, the mission was relocated to the current site at the village of 'Iisanchanga. In 1776, Fray Pedro Font, OFM, described the earliest buildings at the second site, which consisted of the friars' quarters, a granary, a 50-foot-by-17-foot shed for the church, a guardhouse, neophyte housing, sheep corrals, and a *zanja* irrigation canal. A 154-foot-long-by-15-foot wide granary was added in 1779, and by November 30, 1783, the quadrangle was enclosed with a new adobe church measuring 99 feet by 19 feet forming one side of the quadrangle. A second quadrangle was erected in the 1780s, and incorporated an infirmary, dormitory, tannery, guardhouse, hennery, and storerooms. By 1789, the earthen and thatched roofs (*terrado*) of the quadrangle were replaced with *teja* roof tiles, and store rooms for stockpiled adobes and tiles were constructed.

On March 11, 1795 construction began on the stone, mortar, and brick church originally featuring a masonry barrel vault or *boveda*, and capped buttresses inspired by the Moorish designs of the Mezquita-Catedral, or Mosque-Cathedral of Córdoba, Spain. Commissioned by Fray Antonio Cruzado, OFM, of the diocese of Cordoba, the Mexican Indian master mason Miguel Blanco of Baja California supervised construction. Craftsmen included journeyman mason Toribio Ruiz, master carpenter Salvador Carabantes of Tepic, Nayarit, and neo-

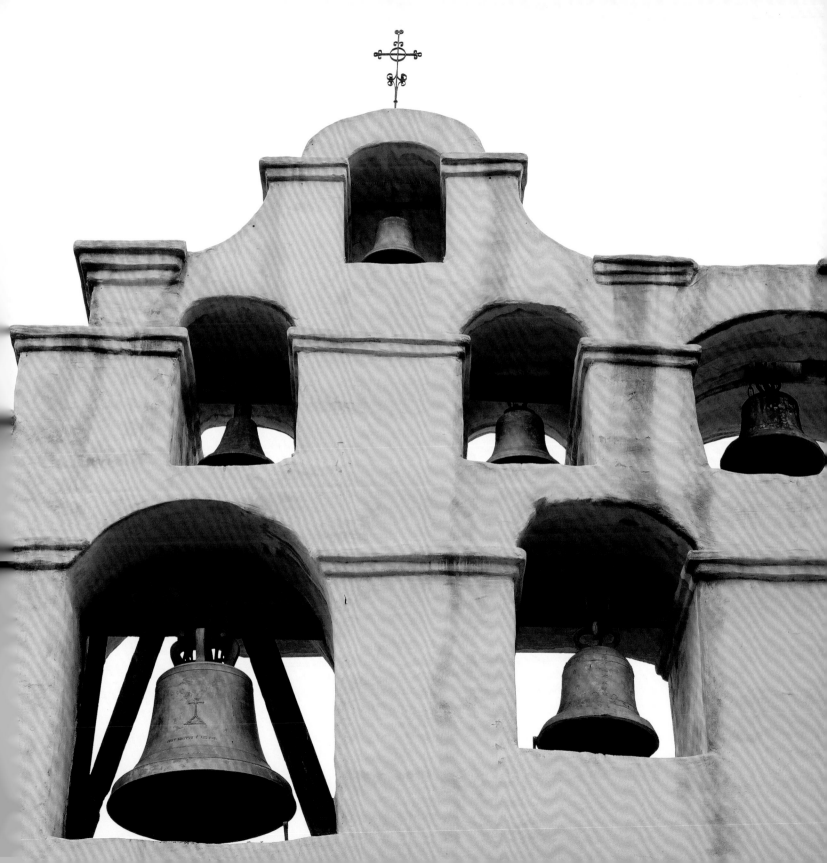

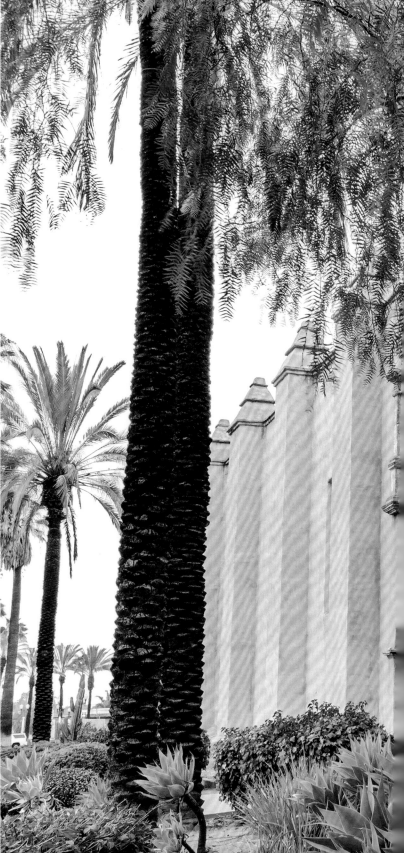

Although palm and pepper trees skirt the perimeter of the church of today, in its time San Gabriel boasted one of the most diverse agricultural enterprises in the whole of the missions system. Its bountiful products included wine, brandy, grapes, oranges, wheat, barley, beans, peas, lentils, maize, and chickpeas or garbanzos.

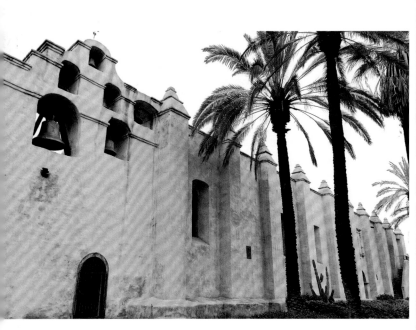

RIGHT AND FAR RIGHT
*Mission church chancel and
altarpiece detail.*

FOLLOWING PAGES, LEFT
*Detail of the Evangelist
Matthaeus, or Matthew,
from the baptistery vault.*

FOLLOWING PAGES, RIGHT
*The vault over the baptistery
bears images of the four
evangelists, and images of
fish and plants. Although el-
ements of the art depicted in
the painting of the vault
might well fit into a Mission-
era scheme, these particular
renderings are likely early
twentieth-century additions.*

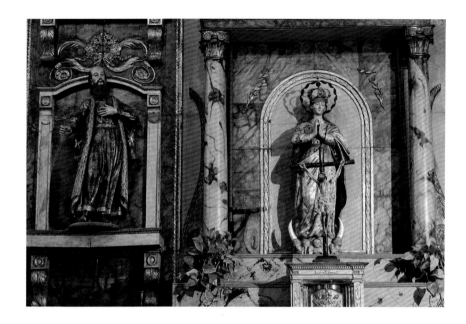

phyte mason Remigio. A masonry barrel vault was completed on February 20, 1799, but within two years the vault cracked, and later whitewashed and sealed by February 21, 1803. In 1804, a tiled corridor replete with brick and masonry columns and tiled roofs was added, as well as the friars' quarters, weavery, carpentry workshop, pantry, storerooms, and granary. The church was dedicated on February 21, 1805, but earthquakes further compromised the vault, and it was replaced with a flat beamed ceiling and brick and masonry roof in 1808. Between 1807 and 1811, an adobe convento building replete with arcade corridor, an adobe tannery with four sizeable brick-lined vats, two granaries, and seventy-seven 17-foot-by-14-foot-sized tiled adobe dwellings were constructed for neophyte housing. In 1810, an elaborate altar screen from the Mexico City workshop of master carpenter José María Uriarte was installed. On December 8, 1812, the Wrightwood earthquake rocked the mission and collapsed the original campanario bell tower. The severely damaged church forced the friars to conduct services in granary buildings, and the masonry church was not restored until 1827–28. At that time, the campanario was rebuilt at its present location fronting El Camino Real or The Royal Road. Thus, the mission stood at the confluence of one of the most elaborate waterworks and milling operations serving one of the most lucrative wine and brandy-making operations in North America.

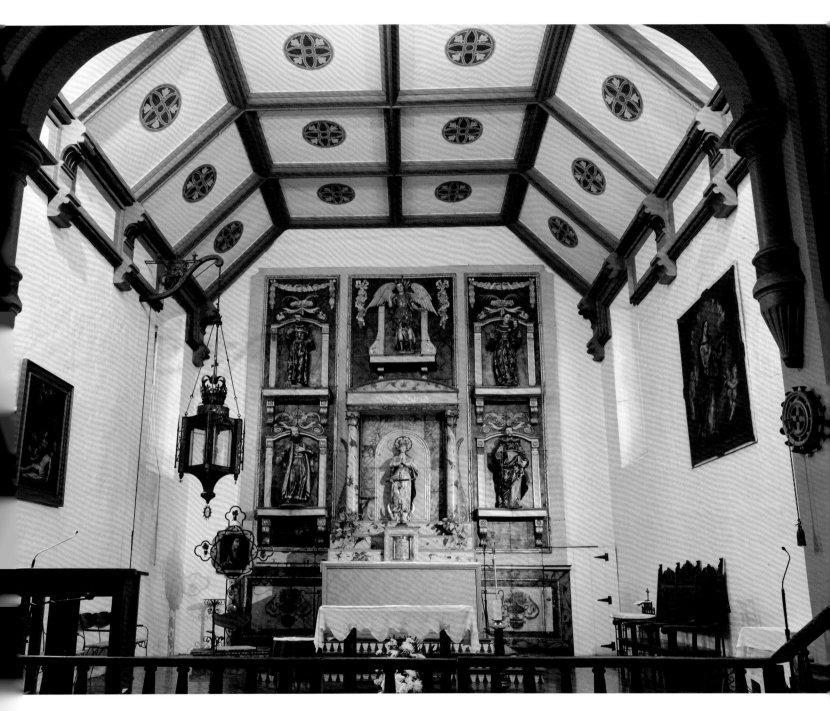

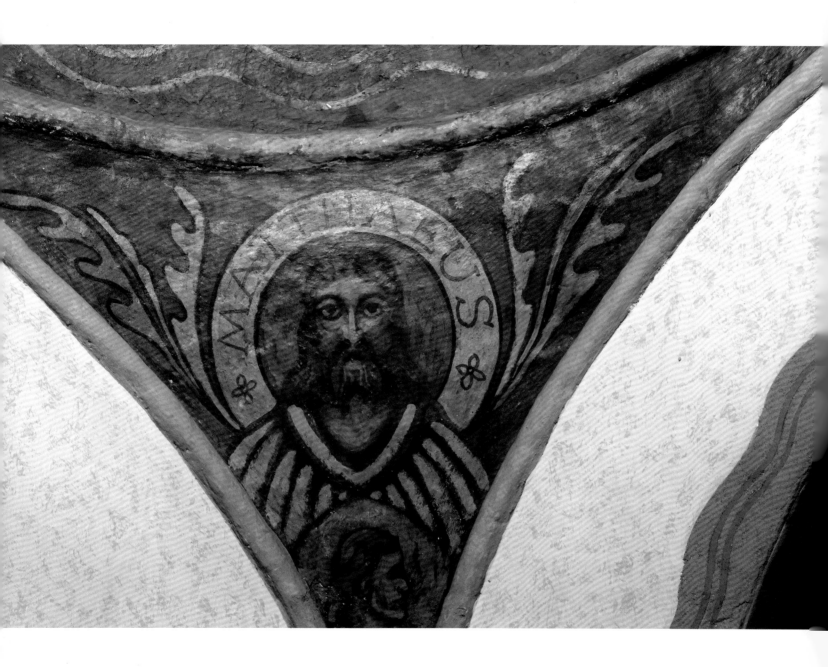

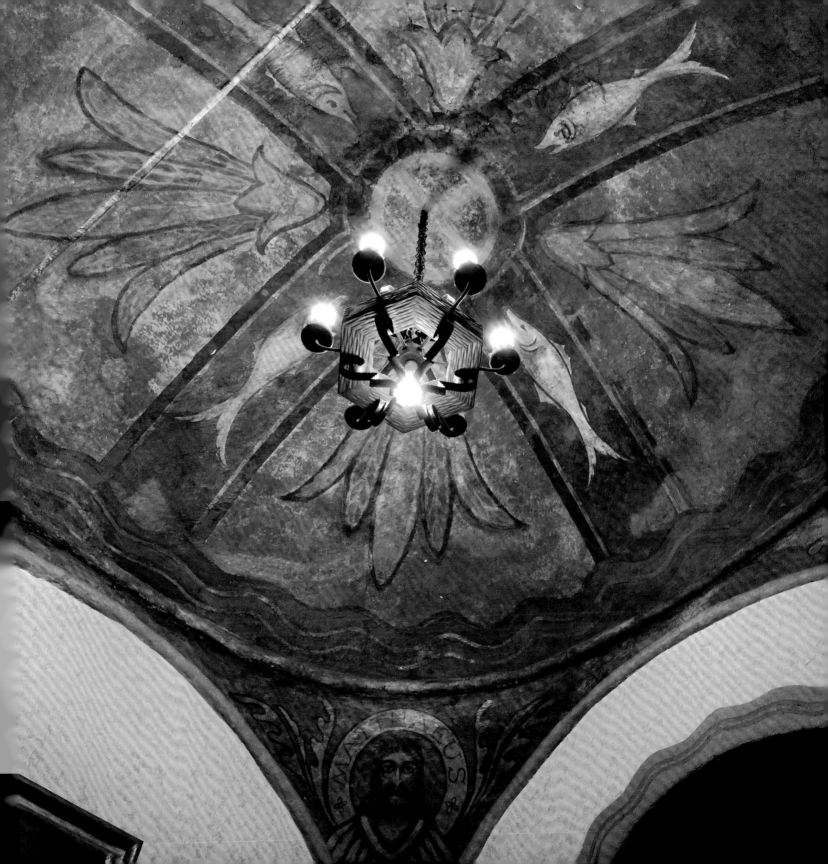

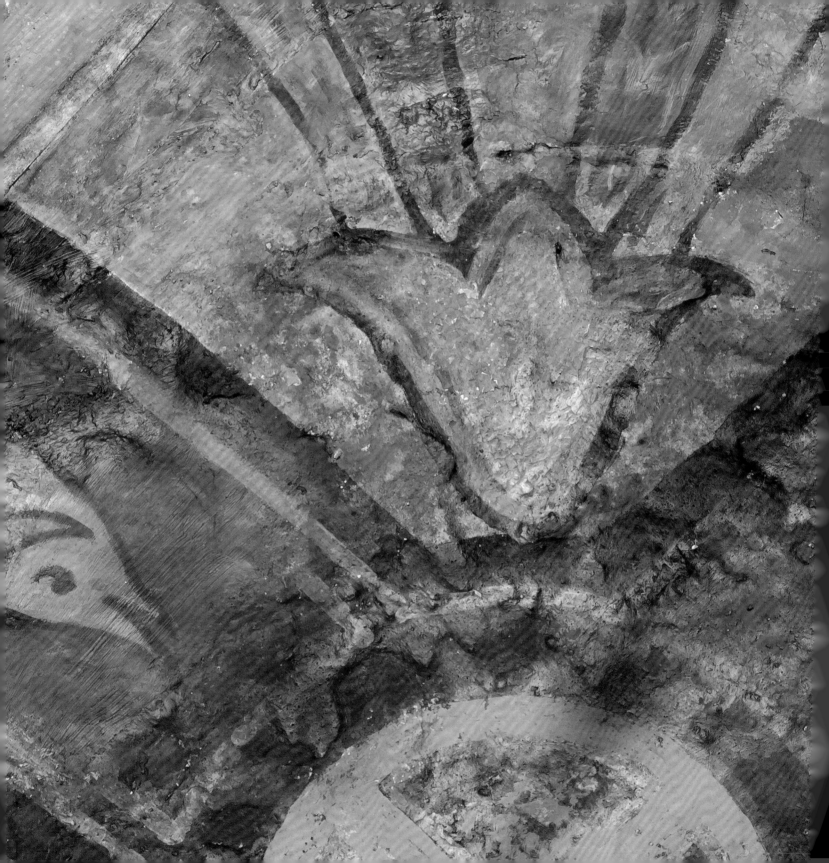

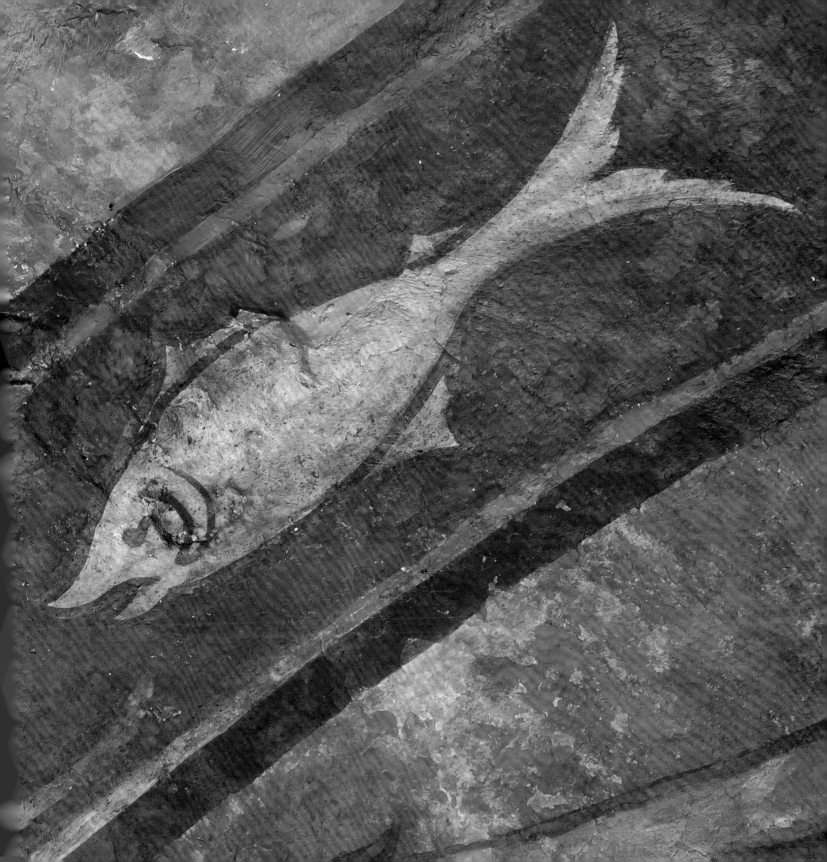

PREVIOUS PAGES
Detail of the murals of the baptistery vault.

RIGHT
The San Gabriel Mission Museum occupies the former padre's quarters or con-vento adjoining the church. In this room the trappings of the bishop, including a four-post bed replete with the hand-carved images of the Virgin of the Immaculate Conception continues to draw tens of thousands of visitors to the mission each year.

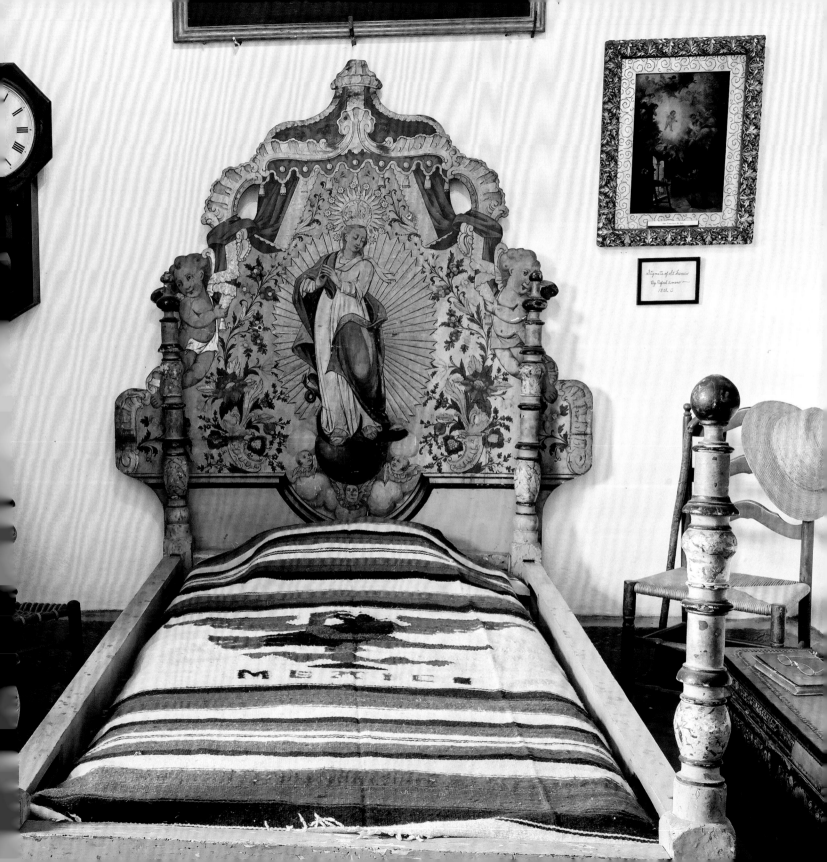

SAN LUIS OBISPO DE TOLOSA

Founded: September 1, 1772; Dedication: Circa 1790–93
Founder: Fr. Junípero Serra, OFM

OPPOSITE
*Constructed 1788–90, the
Mission church was retrofit-
ted with the addition of a
unique campanario-vestibule
addition in 1793. Featuring
five bells cast in Lima, Peru,
the façade was rebuilt as a
result of earthquake damage
in 1830. In 1880, the
vestibule and* campanario
*were dismantled, and a New
England steeple was added.*

FOLLOWING PAGES, LEFT
*The nave of the mission
church of 1790 was restored
to its original plan in the
1930s. In order to effect the
restoration, it was first nec-
essary to dismantle the
tongue and groove siding
that was affixed to the ceil-
ings and walls in the 1880s.*

FOLLOWING PAGES, RIGHT
The toral, *or archway vault
separating the sanctuary or
altar area from the nave,
symbolizes the Roman arch
of triumph.*

PAGES 84–85
*The bell loft is situated im-
mediately behind the main
façade, and is defined by the
bell wall fronting the
mission church.*

In 1771, the four extant California missions were imperiled by drought, failed crops, and diminishing supply stores that impelled the Father President to act. Recalling Commander Gaspar de Portolá's encounter with a Grizzly bear in the *llano* (plain) or Cañada de los Osos (Canyon of the Bears), and Fray Juan Crespí, OFM's 1769 accounts of the region identified with San Luis Obispo, Fray Junípero Serra, OFM, dispatched a hunting party. Lead by Monterey Presidio commander and Governor Don Pedro Fages, the expressed purpose of hunting grizzly bears was to provision their meat to the fledgling missions in dire need. After three months, over four and one half tons of dried and salted bear jerky were ported back to the famine-stricken missions on twenty-five mules, accompanied by a dozen carretas or ox-carts laden with edible seeds traded with the Salinan Indians. The salted meat and seeds sustained the missions through this defining moment in the history of Nueva California.

Upon their return to Monterey, the soldiers recounted the abundance of resources, temperate climate, and the industrious Chumash peoples. Thus, the fifth Alta California mission was established at San Luis Obispo de Tixlini. Founded by Serra atop an escarpment overlooking San Luis Creek at the Chumash village of Tilhini on September 1, 1772, mass was convened and a cross was dedicated to San Luis Obispo de Tolosa. The following day Serra and Fages departed for San Diego de Alcalá to intercept Spanish supply ships from San Blas whose passage to Monterey was stymied by headwinds. Fray José Cavaller, OFM, and five soldiers were left to establish the new founding near the Cerro del Obispo in the Valley of the Bears. The Chumash inhabitants of the region were grateful to the Spanish for eradicating the grizzly, and the villagers of Tilhini soon became the Obispeño neophyte community of the mission.

Within a year, Fages returned to find a church, missionaries' quarters, and offices fashioned of pole, mud, and thatch (*palisados*) or adobes within a stockade. A barracks was constructed for the eight cavalry soldiers, corporal, and servant, constituting the mission guard. At that time, Chumash tule dwellings occupied the site, and housing for Mexican Indian neophytes from Baja California were under construction. A zanja or irrigation canal channeled water to crops, and an unroofed adobe church measuring 55 feet by 22 feet were cited in Serra's report of 1774. The church was readied for the installation of a flat adobe roof (*azotea*), doors, and four windows. Its completion required the stockpiling of five-hundred cypress beams for the roof. Master carpenter Manuel Rodríguez oversaw construction, and during this period, two sizeable granaries (*troj*), a kitchen (*pozolera*), carpentry shop (*obraje*), and livestock enclosures (*corrales*) were added.

In 1776, indigenous rivals to the south attacked the neophytes with arrows tipped with flaming wicks and set fire to thatched roofs. While the church and granary survived, Corporal and master carpenter Ignacio Vallejo was recruited to rebuild the complex in 1777. After the construction of an aqueduct, Vallejo remained through 1780. During the midnight mass on Christmas day, 1781, cele-

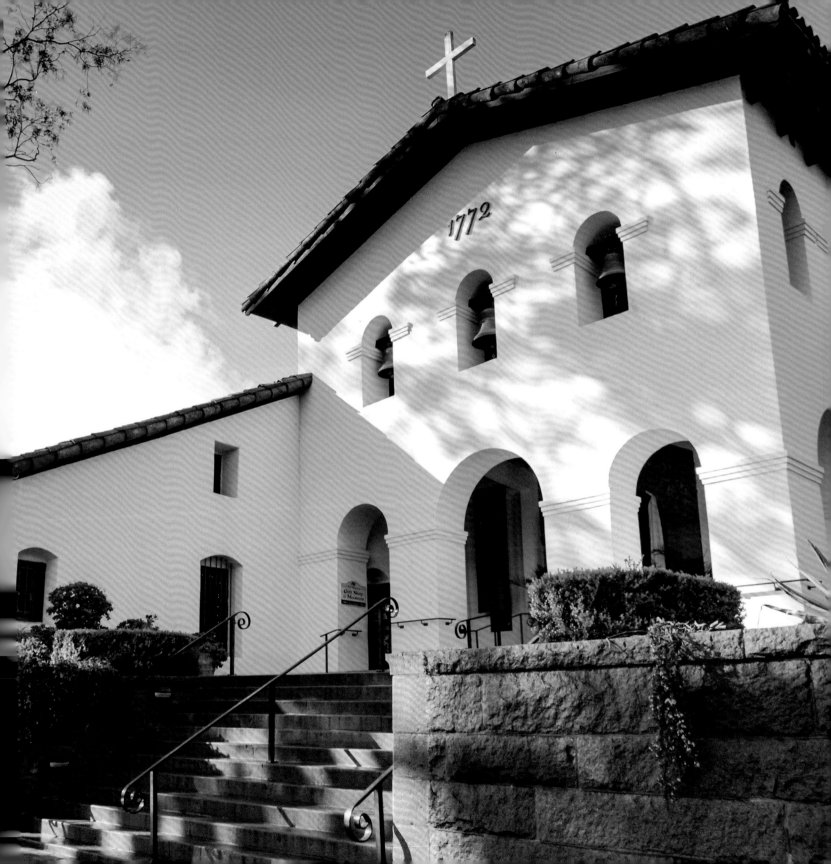

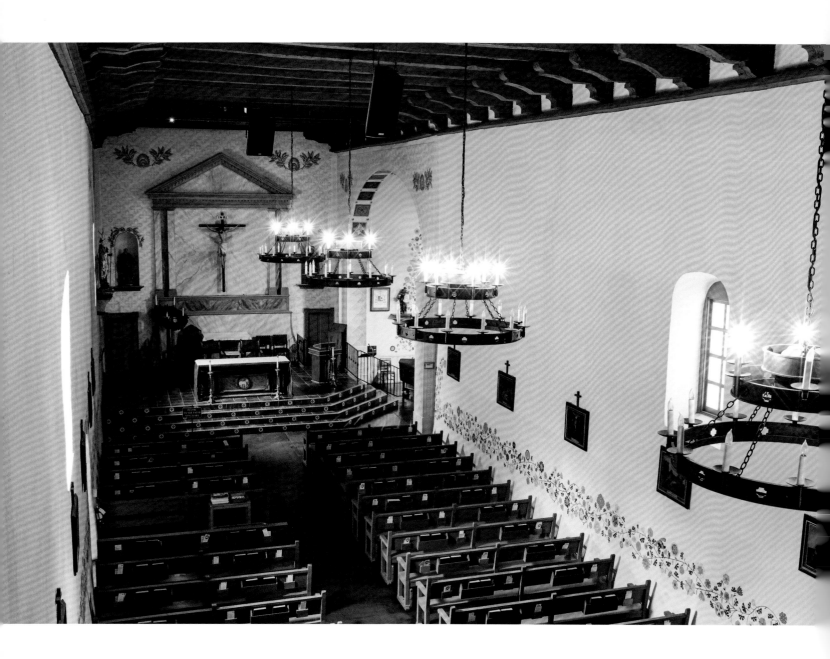

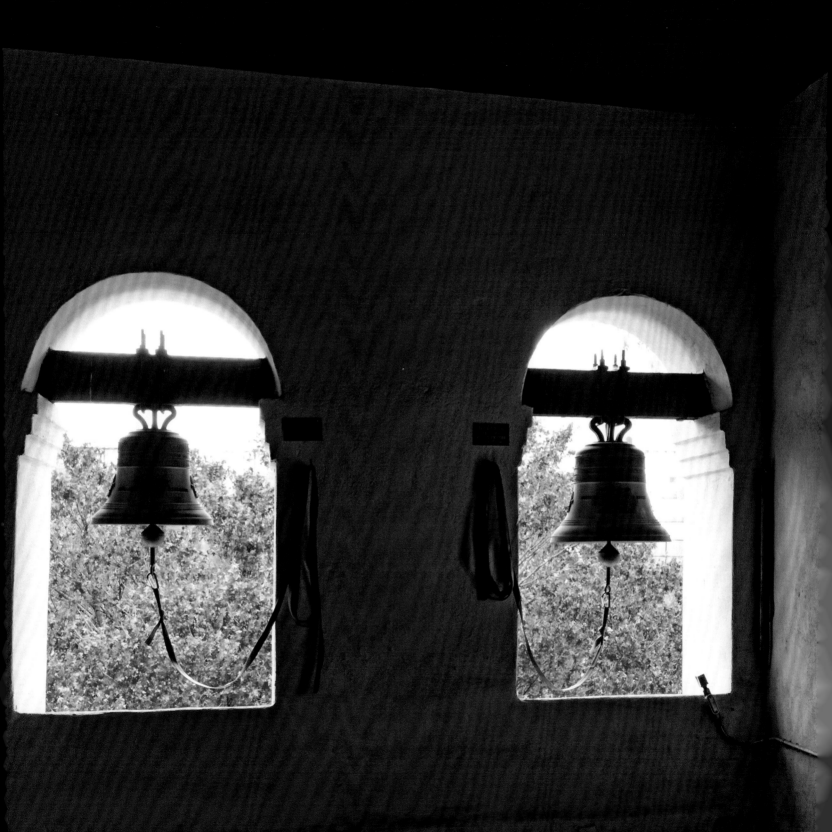

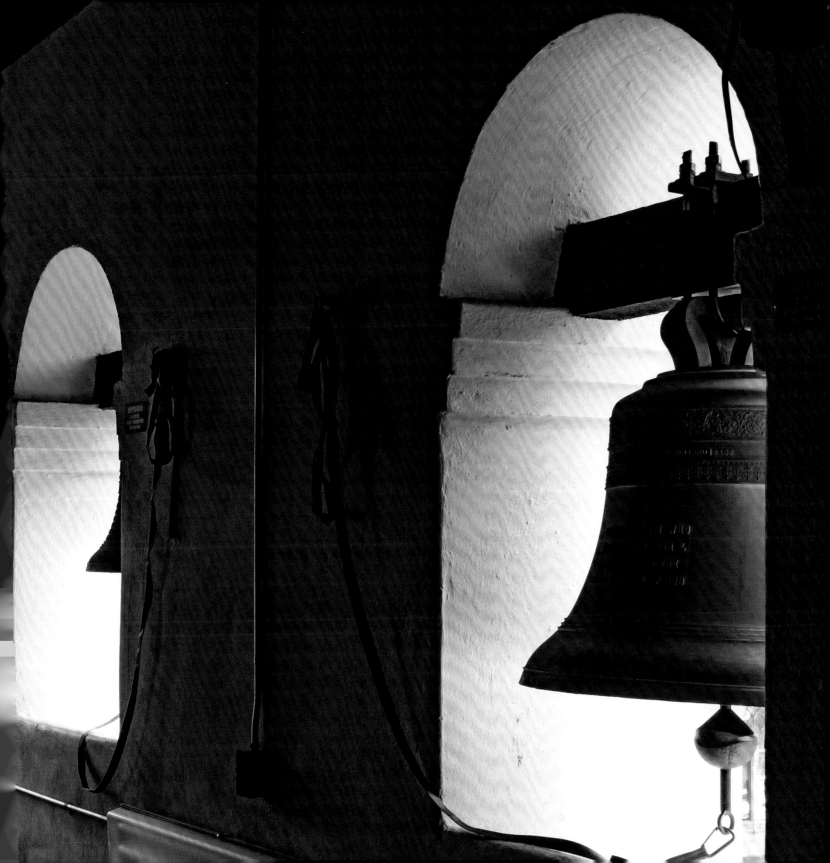

bratory musket-fire once again ignited a thatched roof. A third fire on November 1782 prompted the construction of a tile kiln in 1788 for the manufacture of *teja* roof tiles. Construction of the present church was initiated by Fray José Cavaller, OFM, in 1788, and finished after his death in 1790. Three years later, the conjoined vestibule and integrated bell wall completed the facade, thereby forming the narthex or portico. Evidence of the original church remains in the braided or chevron-like painted patterns of the ceiling beams (*vigas*) and stenciled blue stars on the planks (*tablas*) over the nave. Master carpenter and millwright Cayetano López constructed a water-powered gristmill, assisted by the soldier-blacksmith José María Larios in 1795. A hospital or infirmary was constructed in 1804, and the colonnade fronting the friars' quarters of 1794 was retrofitted with eleven cylindrical or Ionic masonry columns in 1816. Ultimately, the quadrangle was enclosed with the addition of an adobe room block in 1818. The earthquakes of 1830 and 1868 inflicted irreparable damage to the complex, forcing the dismantling of the vestibule and a "modernization" in 1880. The popularity of the Mission revival style of the 1930s incited the removal of Victorian or New England styled additions of the late nineteenth century.

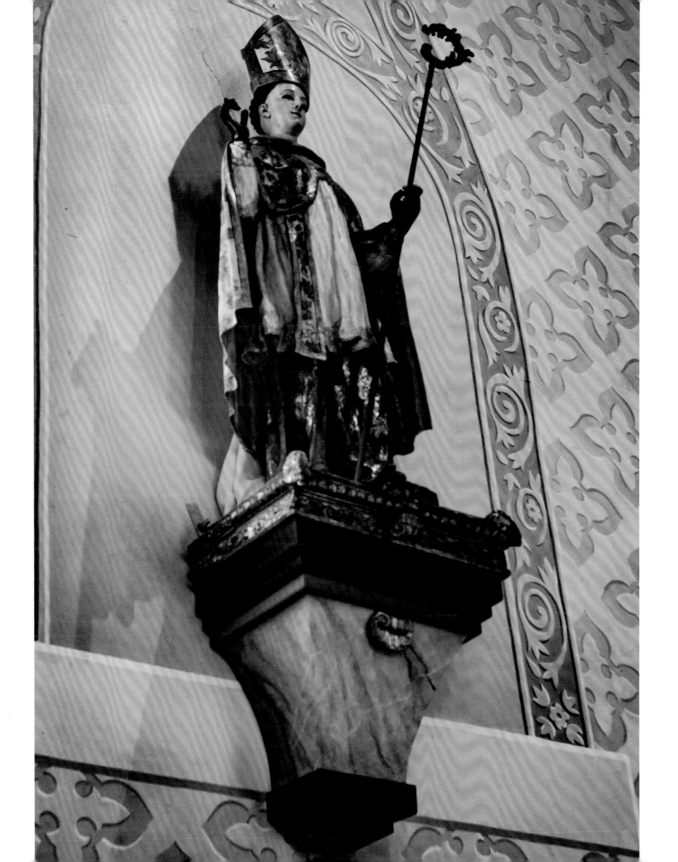

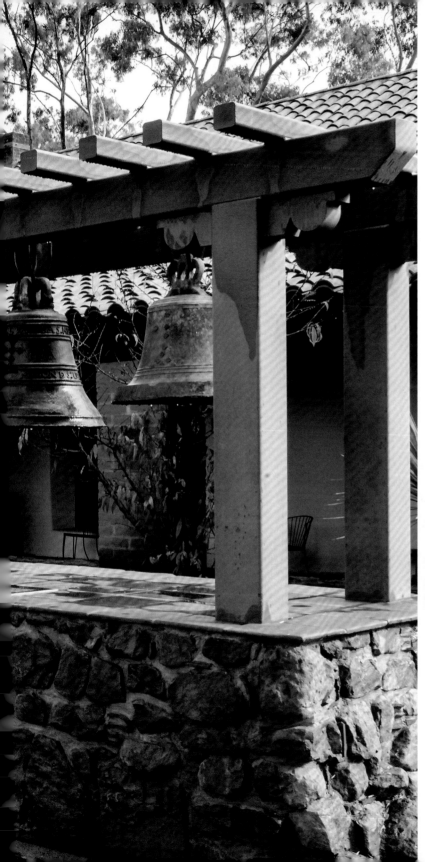

LEFT
In an effort to preserve the original mission bells cast in Lima, Peru, these were relocated to the courtyard, while new bells were cast for use in the bell wall formed by the church façade.

BELOW
The former quadrangle courtyard or patio is today dominated by a lush garden featuring Mission-era plantings.

89

PART 4:
MISSIONS OF THE

SERAPHIC FATHER

SAN FRANCISCO DE ASÍS
(MISSION DOLORES)

Founded: October 9, 1776; Dedication: August 2, 1791
Founder: Fr. Francisco Palóu, OFM

With the establishment of San Francisco de Asís, Fray Junípero Serra, was granted the namesake mission he sought for the founder of the Franciscan Order of Friars Minor. Merely a handful of years before, Fr. Serra was left to ask the question "Sir, is there to be no Mission for our Father St. Francis?" To which Inspector-General Don José de Galvez retorted, "If St. Francis wants a Mission, let him cause his port to be discovered and a Mission for him shall be placed there." Thus, the sixth mission founding in Alta California proved pivotal to Serra's evangelical aspirations, and the settlement of the San Francisco Bay. While Drake's bay was originally named La Bahía de San Francisco by the Portuguese-born Spanish explorer Sebastiano Cermeño in 1595, the first authenticated European sighting of the bay did not occur until the land expedition of Don Gaspar de Portolá chanced upon the often fog-shrouded inlet in 1769. Laguna de los Dolores was the focus of the initial church site, and on 29 June of 1776, Fray Francisco Palóu convened the first mass beneath a brush shelter (*enramada*).

This site eventually gave way to another nearby location, and ultimately the mission was founded at the Ohlone Indian village of Chutchui on October 9, 1776. A succession of temporary pole and thatch structures (*palisados*) and ancillary buildings followed. The lion's share of the work to build the fourth church, was undertaken in 1788, at which time some 26,000 of 36,000 adobes required to complete the building were set in place. Dedicated on August 2, 1791, the extant fourth and final adobe brick, redwood, and stucco church combines distinctive late baroque elements into the lime plastered *portada* (main façade), including paired Doric columns and arched bell windows. Though the walls were completed in 1791, another three years passed before the original flat wood plank, brick, and stucco roof was replaced with a gabled roof replete with fired tiles (*tejas*).

Upon entering the interior of the church, one cannot but be drawn to the panoply of color, painted walls and side altars, and the ornate rococo altar screen of 1796. Whereas the gilded altar screen was created in the atelier or studio of Mexico City master carpenter José María Uriarte, the elaborate interior wall and ceiling paintings of the church nave were rendered by both Spanish and Ohlone Indian artisans and craftsmen. Their respective artistic attributions and chevron-like designs continue to prompt wonderment by both scholars and the lay public, however the painted ceiling beams (*vigas*) and planks (*tablas*) conjure the artistry of Ohlone basketry design and workmanship. Discretely hidden behind Uriarte's rococo altar screen lies an elaborate red ocher line rendering of the earliest church *reredos* (altar screen) attributed to the Ohlone artisans of San Francisco. As the last of the original buildings, the church stands as a stalwart memorial to the many Ohlone, Miwok, Mexican Indian, and Hispanic builders and artisans of the fledgling settlement of San Francisco.

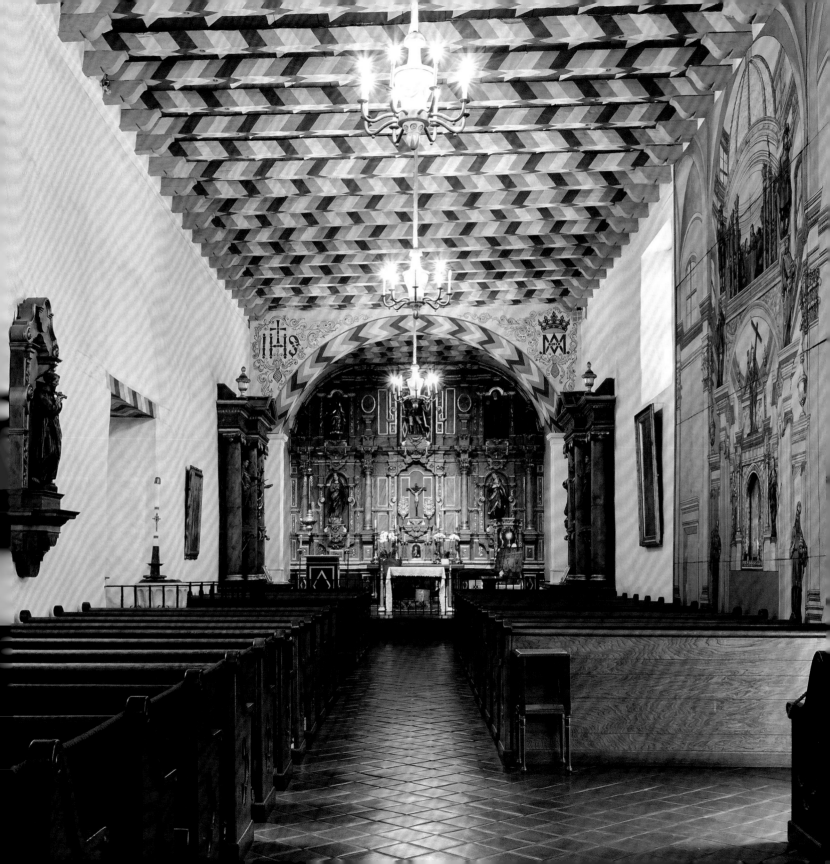

RIGHT

The late Baroque façade or portada of the mission church is among the finest crafted in the Californias. Its paired Doric columns, bell windows, wooden balcony, and stark white façade lend themselves to the inherent charm of today's Mission Dolores.

BELOW

The mission cemetery contains markers that represent a veritable who's who of early San Francisco peoples from all cross sections of society.

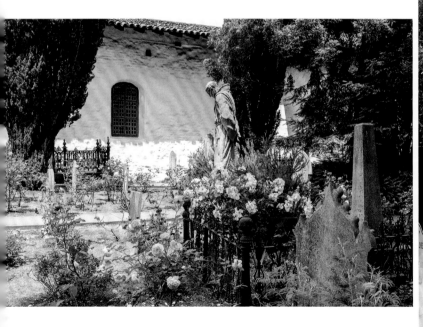

94 San Francisco de Asís (Mission Dolores)

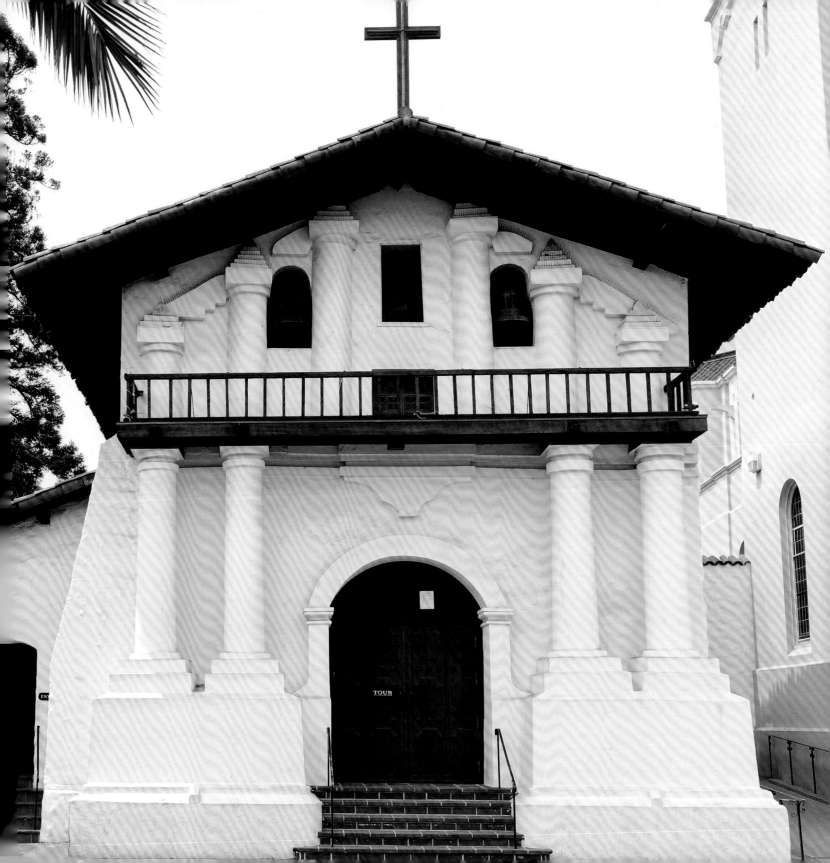

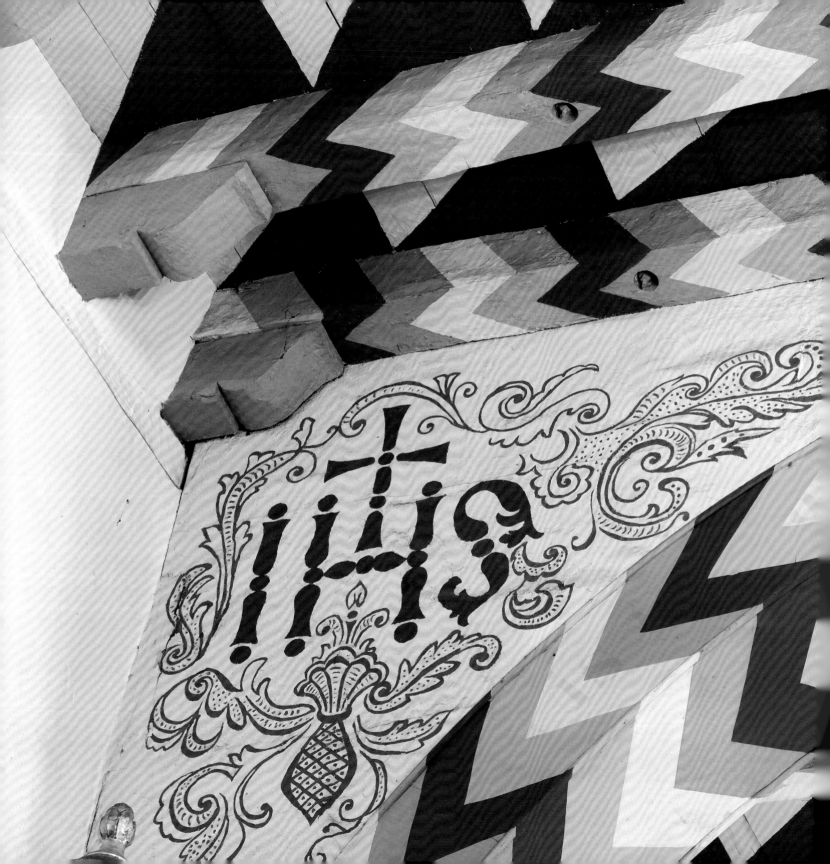

LEFT *The conjoined IHS and crucifix inscribed in red ochre over the* toral *or sanctuary vault signifies the Greek name for Jesus, or* Iesous Christos.

BELOW *The stone baptismal font remains a central feature of the rites of conversion and consecration.*

FOLLOWING PAGES *The upper register of José María Uriarte's Rococo altar screen or* reredos *of 1796 features three carved wood* bultos *or saints, including San Joaquín, San Miguel Arcángel, and Santa Clara de Asís.*

97

SAN JUAN CAPISTRANO

Founded: November 1, 1776; Dedication: September 8, 1806
Founder: Fr. Junípero Serra, OFM

After 1791, both religious and military initiatives increased demand for skilled artisans and other craftsmen in Alta California. Salaries and other incentives, including allotments of chocolate, were approved so as to lure potential artisans. With the founding of the seventh mission of La Misión de San Juan Capistrano de Sajavit on November 1, 1776, the consequences of this dilemma reared its ugly head. Despite this fact, on November 13, 1796, Fray Vicente Fuster, OFM, requested permission from Governor Diego de Borica to build a new church with the aid of the master mason Isídro Aguilár of Culiacan, Sinaloa. As the *maestro alarife*, or architect, Aguilar designed what was once the largest and most ostentatious church in the province. On February 2, 1797, the cornerstone for the new church was installed, and work began on the "most important and pretentious" church in early California.

Initially founded by Fray Fermín de Francisco Lasuén de Arasqueta, OFM, by way of a celebratory mass, the tolling of bells, and the planting of the cross on October 30, 1775, this collaboration with the Acjachemen was short-lived. Within days of building provisional dwellings, a large scale Kumeyaay rebellion at San Diego de Alcalá forced the abandonment of the new post. One year later, Lasuén returned to the site with Fray Junípero Serra, OFM, and a military escort, found the cross standing, and recovered the bells buried in the earlier abandonment. Serra and Lasuén rededicated the site in 1776, and resumed construction. The first church was completed in 1777, however, the scarcity of water prompted the friars to relocate on October 4, 1778 to the confluence of two arroyos at El Trabuco. The site prospered, and the original palizada of poles, mud, and thatch was replaced with adobe structures with flat terrado or tiled adobe roofs. Continuous construction resulted in the build out of the whole complex, and by 1782 included several adobe granaries (*troj*), housing for the ministers (*convento*), workshops (*obrajes*), a dormitory for unmarried women (*monjerio*), and an adobe church measuring 42 feet long by 14 feet wide, with a sacristy measuring 22 feet by 20 feet. Completion of the church and long buildings of 1782 enclosed the courtyard. The church became known as the Serra Chapel because Serra convened the dedication mass. By 1783, tiled corridors and bricked arcades were installed within the quadrangle, and the roofs were replaced with tiled gable roofing.

The growth of the neophyte population, and the prosperity of the hide and tallow trade and other industries, prompted work on the most ambitious project undertaken in the California missions. Blue and yellow sandstone and lime was quarried and collected some six miles distant at San Juan Point, and brought to the building site in wooden ox carts (*carretas*). Aguilár directed construction of the Great Stone Church, which featured a cruciform floor plan with a vaulted nave and sanctuary replete with seven massive masonry domes, a 120-foot-tall campanario with four Peruvian bells, and a floor plan 170 feet in length by 30 feet in width, with an 80-foot-wide transept. Whereas Aguilár and his neophyte crews sculpted the elaborate neoclassical columns, vaults, arches, and door surrounds,

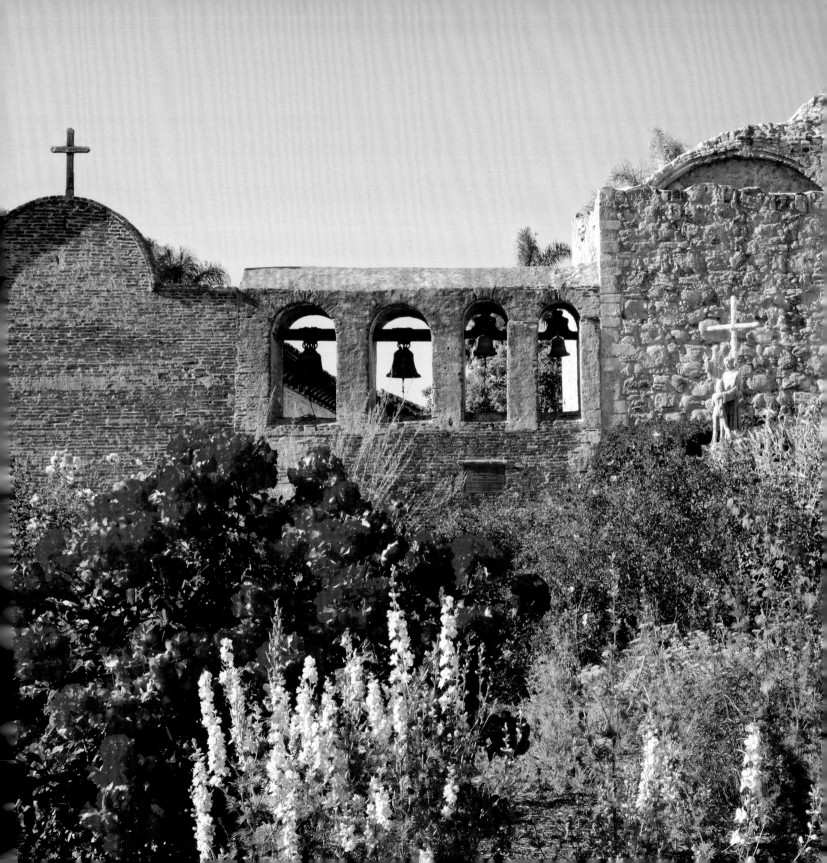

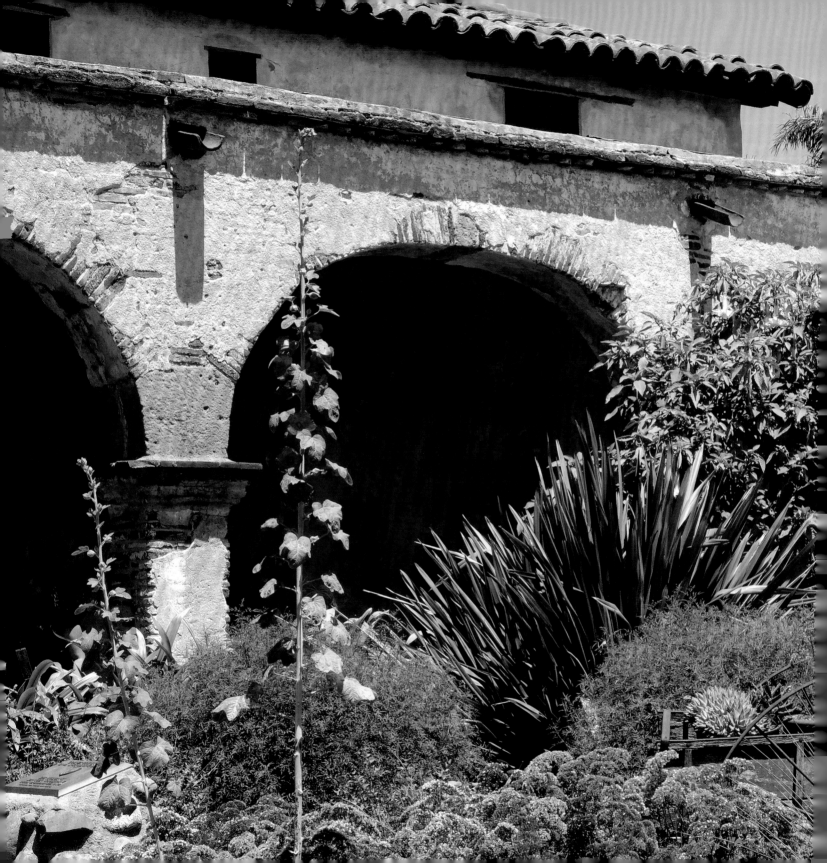

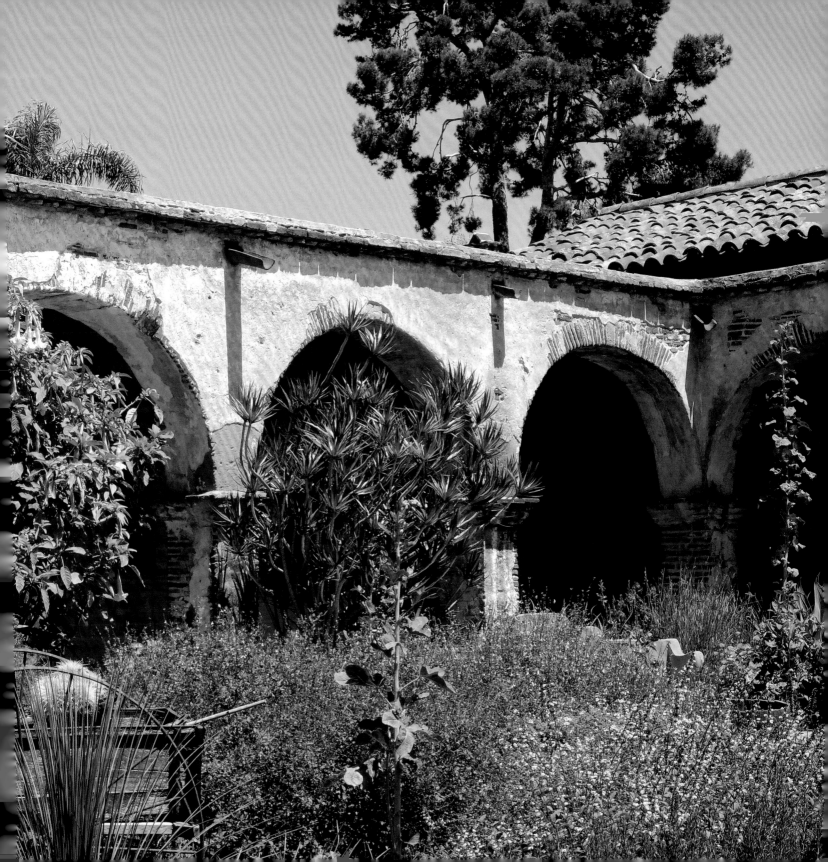

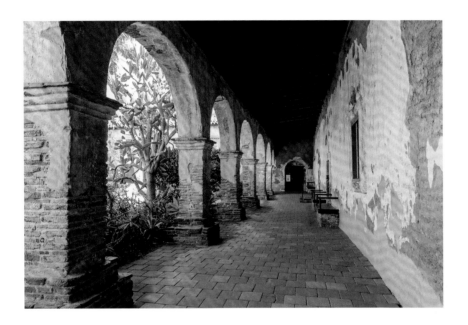

OPPOSITE
The inner patio fronting the quadrangle features the early twentieth-century Fountain of the Four Evangelists (fountain not visible). Although the majority of the missions of Alta California boasted such water works, many did not survive the many years of neglect and misappropriation.

LEFT
Although many of the buildings of the quadrangle began as provisional pole and thatch structures, or single course adobe buildings, these were replaced through the course of the late eighteenth century. The arcades and corridors were largely added in the period after 1782.

the neophyte painter, Teofilo, decorated the church interior in 1806. Construction on the vault ended with the tragic death of Aguilár on February 21, 1803. Consequently, construction proceeded without the supervision of a qualified architect, and after nine years, the church was dedicated on September 8, 1806. On the Feast of the Immaculate Conception, December 8, 1812, as two young boys tolled the bells of the twelve-story bell tower, the church was rocked by a massive earthquake, and the tower crashed into the church during morning mass. Despite efforts by Friars Francisco Suñer and José Barona, OFM, to direct the Acjachemen neophyte congregation to safety, forty Juaneños, predominantly women and children, were killed. With no resources to start anew, the church remained in ruins. From that point forward, the friars conducted mass in the Serra Chapel of 1782. Today, the Serra Chapel is the oldest church in continuous use in California, and features a gilded cherry wood altar screen from Barcelona, Spain, installed in 1824.

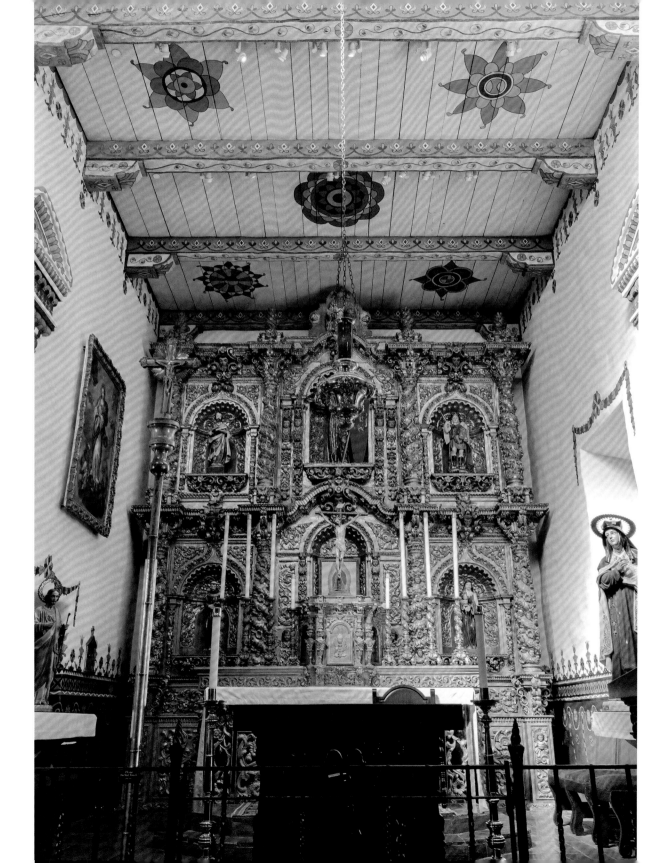

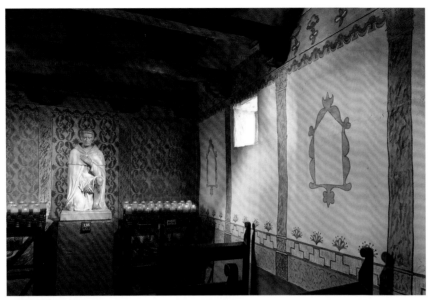

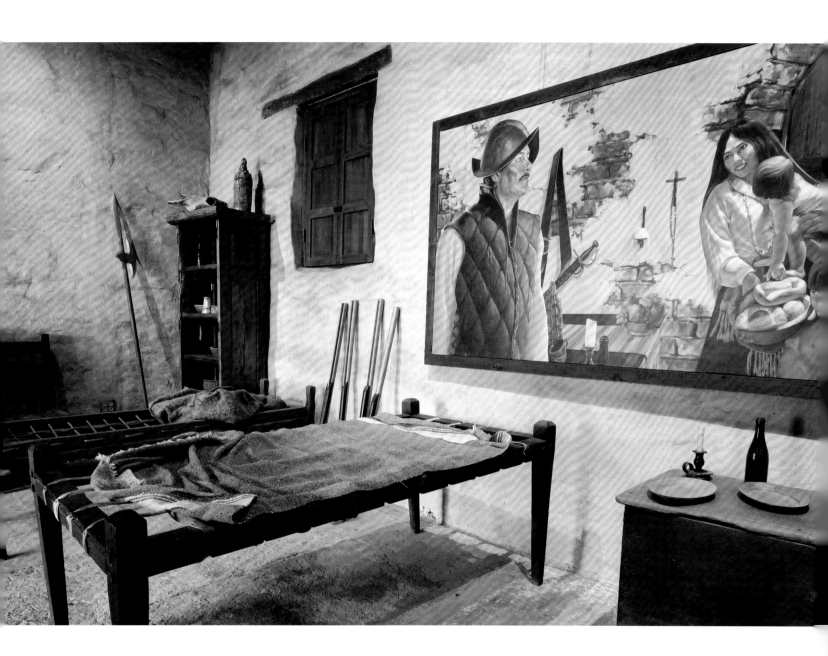

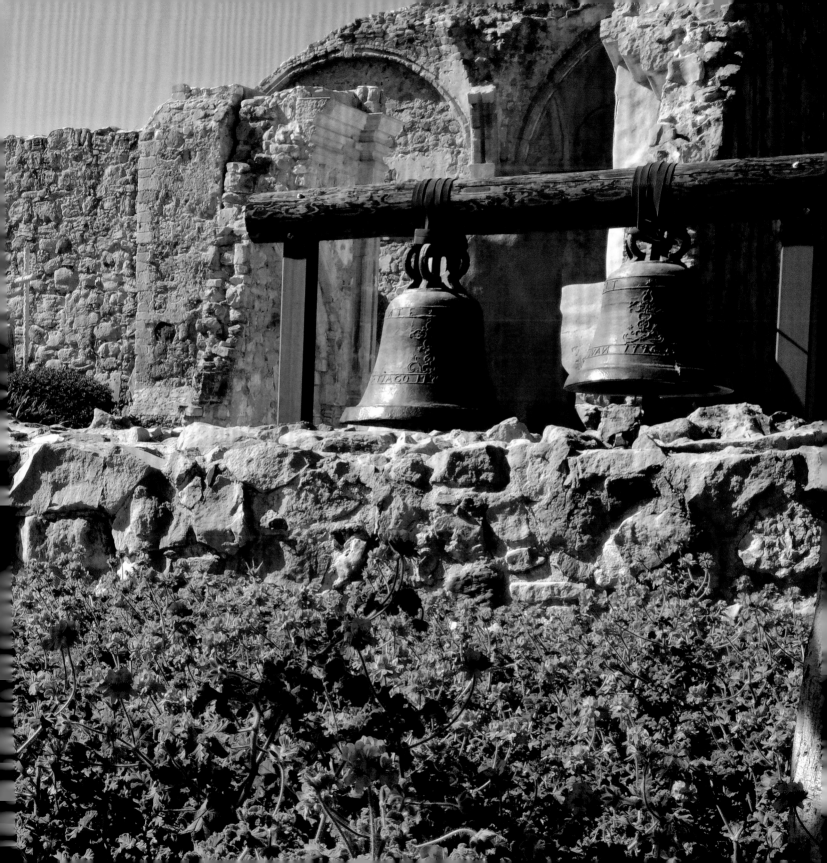

SANTA CLARA DE ASÍS

Founded: January 12, 1777; Dedication: August 11, 1825
Founder: Fr. Junípero Serra, OFM

OPPOSITE
While wrought iron chande-
liers have been integrated
into mission churches
throughout California in
recent years, the earliest
such lighting features
consisted of hand carved
wooden arañas (spiders)
comprised of crossed arms
atop which candles were
placed. The type represented
at Santa Clara is a modern
interpretation of the
Corona chandelier.

On November 19, 1781, Fray Junípero Serra, OFM, blessed the cornerstone of the third church erected at Santa Clara de Asís. In 1784, Serra returned four days after the death of the church's architect, Fray Joseph Antonio de Murguía, OFM, for the dedication. The eighth California mission, La Misión de Santa Clara de Thamién was founded at the Tares Indian village of Socoisuka on the Guadalupe River. Prior to his death that same year, Serra though enfeebled by a respiratory condition and hobbled by a cancerous leg tumor, officiated the dedication of the third church. Serra described her as "the most beautiful church yet erected" in Alta California. After sixteen long years, Serra's dream for the prosperity of the mission communities of the Californias would soon be realized.

Only seven years prior, Serra dispatched Fray Tomás de la Peña, OFM, to see through the dedication and the blessing of the cross on January 12, 1777. The founding of Santa Clara was predicated on earlier reports that noted the favorable conditions of the region, including ample water, wild game, and the more than forty Costanoan villages in the area. Originally identified by Spanish Lieutenant Colonel Juan Bautista de Anza in 1776, the promising locality was envisioned as a future sister mission to San Francisco de Asís. The first structures erected by de la Peña and Murguía consisted of earth-covered pole and thatch structures (*palisados*), including a church, sacristy, a five-room dwelling, kitchen, storehouse (*almacén*), corrals, henhouses, a dormitory, offices, and a dam, irrigation channel (*zanja*), and wooden bridge to span the Guadalupe. On January 23, 1779, the settlement was destroyed in a flood, thereby forcing the friars to relocate to higher ground. By the end of that year many of those structures lost were rebuilt at the current site, with the second church dedicated on November 11, 1779. A detachment of soldiers from the Presidio de San Francisco, sailors from San Blas, and neophytes from Baja California were recruited to rebuild the mission.

The first permanent adobe church designed by Murguía and blessed by Serra was officially dedicated on May 15, 1784. The interior of the 112-foot-long-by-25' wide thatched and gabled church consisted of paved adobe floors, hand-adzed redwood (*alerche*) roof beams (*vigas*) laid atop wooden corbels, stone foundations, cedar and redwood double doors, and whitewashed and painted walls and ceilings. The skillful craftsmanship has been attributed to the master carpenter Fernando Campuzano. In 1795, the church was enlarged, ancillary buildings were roofed with tile, and the padres planted hundreds of willows so as to form a tree-lined boulevard (*alameda*) from the mission to the nearby Pueblo de San José. Church enhancements included the 1802 installation of a neoclassical altar screen designed by Marcos López and crafted in Mexico City. The earthquake of 1812 compromised the mission, but that of 1818 rendered the church uninhabitable. Thus, an interim fourth adobe church was built and dedicated by December 31st of that year. This structure served the mission through 1825, at which time the fifth and final church was dedicated at a new site on August 11, 1825. The present church stands at the heart of the Santa Clara University campus, and

RIGHT
The extant church is a reconstruction of the fifth sanctuary built in 1825, destroyed by fire in 1926, and rebuilt on the foundations of the earlier church in 1929.

OPPOSITE
This reconstruction of the 1825 church belfry was fabricated from concrete and stucco in 1929. Storm damage destroyed the original belfry in 1839, and it was replaced by a wooden structure in 1841.

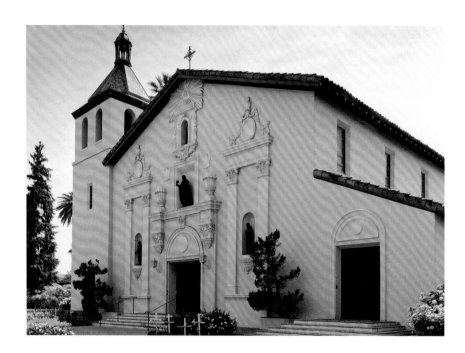

constitutes a modern interpretation of the 1825 church. Construction on an adobe quadrangle commenced in 1821, and was completed by 1823. Destroyed by fire in 1926, and reconstructed in 1929, the current church stands atop the foundations of the 1825 church, and features a replica of the belfry ruined in 1839, and replaced with a wooden structure in 1841. In addition to an expanded interior hall and elaborate murals dated to the 1929 reconstruction, the present facade consists of concrete and stucco features that simulate those painted by the artisan Augustín Davila in 1835. The neoclassically-inspired facade integrates paired Corinthian columns, ornate entablatures, a prominent cornice over the portal, niches with saints, Renaissance scrolls, and oval cartouches surmounted by the All-Seeing Eye of God.

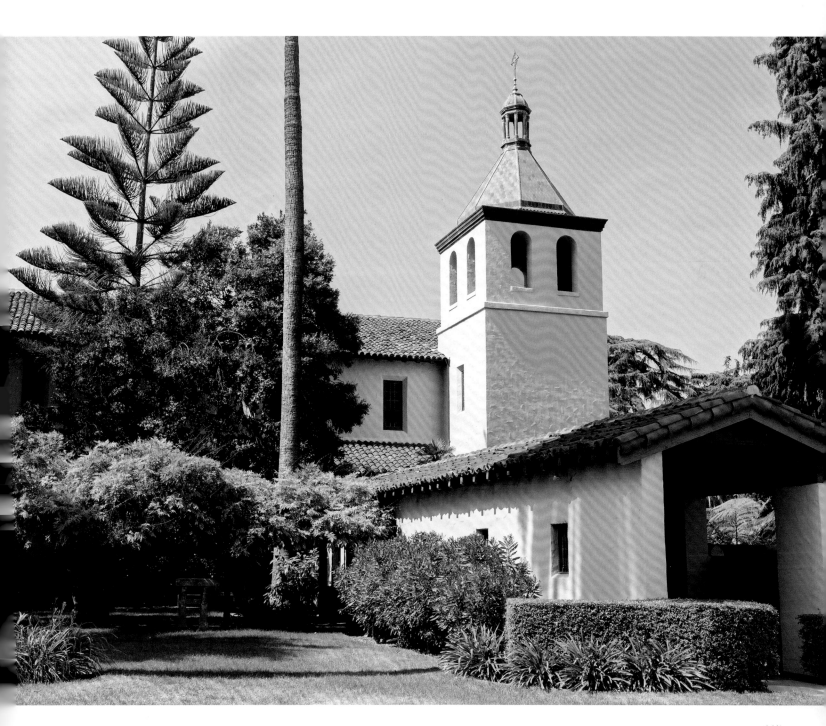

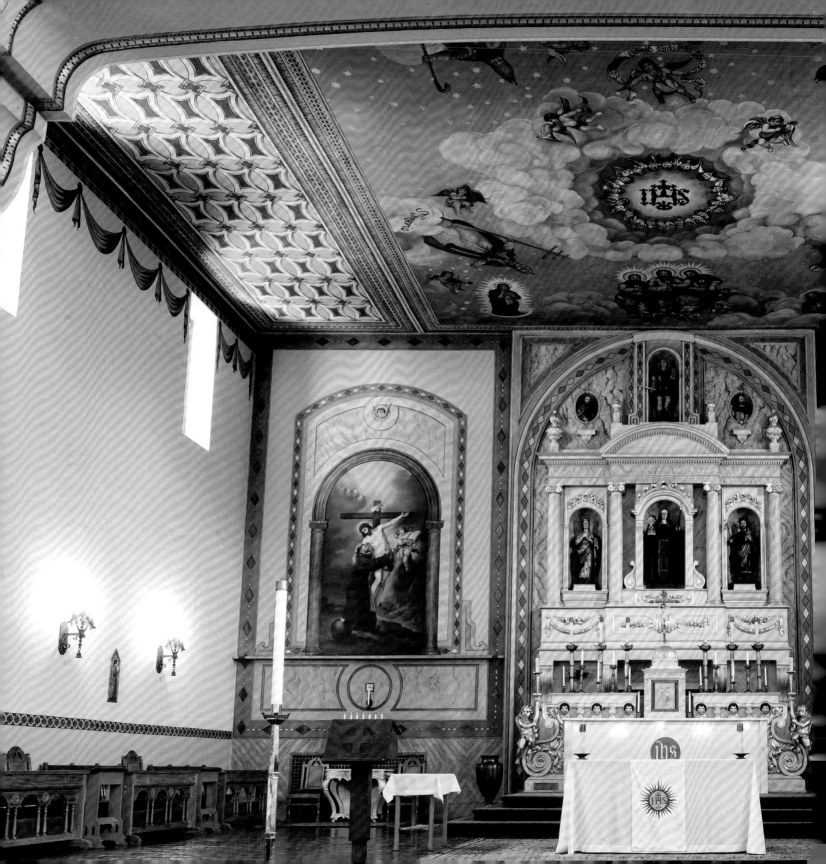

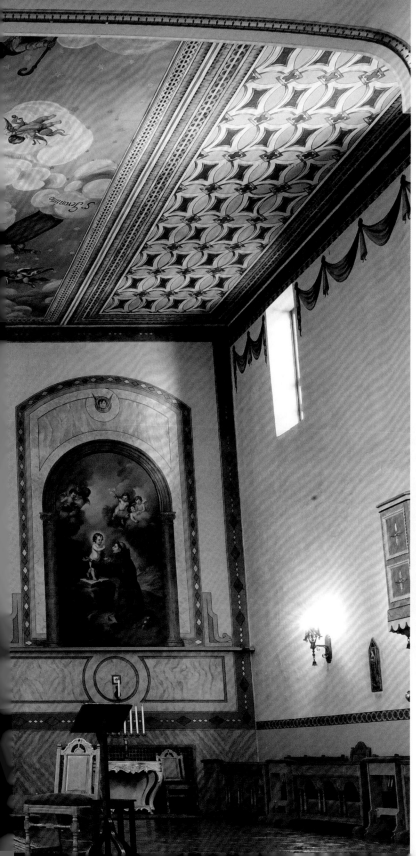

LEFT
The elaborate nave and sanctuary paintings of Agustín Dávila were lost in part when the church was retrofitted in 1884, and completely destroyed by fire in 1926. Today, the elaborately painted ceiling and sanctuary is a product of the 1929 restoration.

BELOW
Although imaginatively reconstructed in 1929, the original church of 1825 incorporated painted geometrically patterned ceilings, swags, a balustraded dado, and Corinthian pillars like those that divide the nave of mission San Miguel.

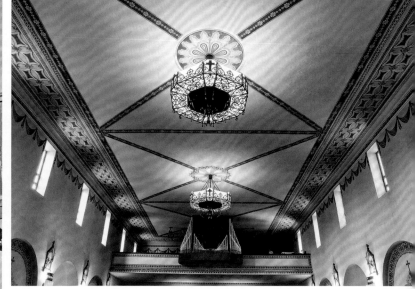

117

RIGHT, TOP
Moved to higher ground due to the floods of 1821, the mission quadrangle was relocated in 1822, and by 1825 the church and its belfry were completed. Two portions of a single free-standing adobe wall is all that remains of the convento of Santa Clara.

RIGHT, BOTTOM
Today, the mission stands at the heart of Santa Clara University, granted to the Jesuits in 1851. The first such college or university in California, the mission grounds are surrounded by lush gardens and arbors that belie the original agricultural and industrial use of the former mission campus.

FAR RIGHT
Today, a lush rose garden demarcates the site of the original campo santo *or mission cemetery of 1825.*

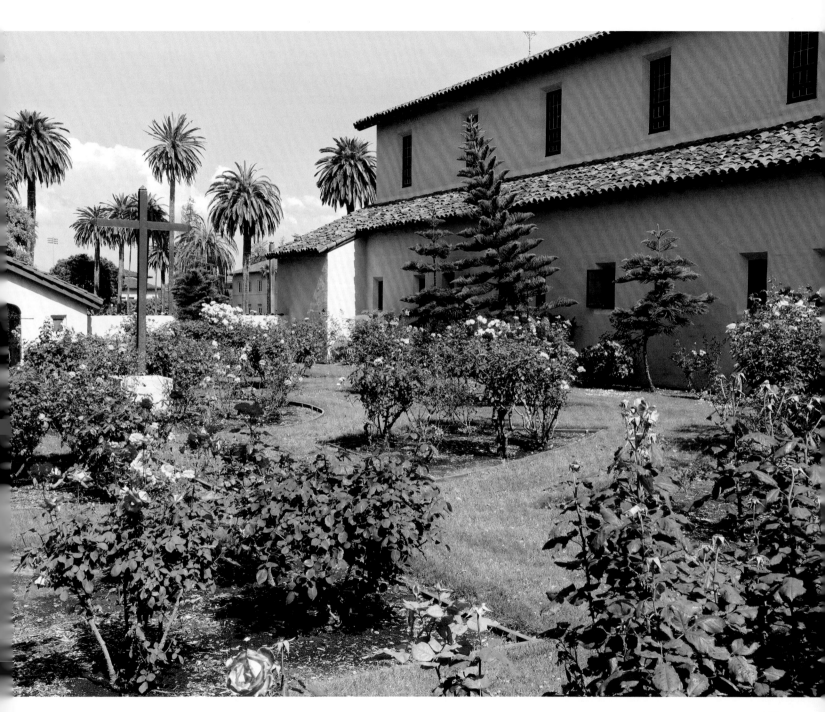

PART 5: SERRA'S

CHANNEL MISSIONS

SAN BUENAVENTURA

Founded: March 31, 1782; Dedication: September 9, 1809
Founder: Fr. Junípero Serra, OFM

PREVIOUS PAGES
*The marbleized finishes of
the modern color scheme of
the church at Mission Santa
Bárbara approximate some
of those finishing touches
that once graced the walls of
the church of 1820*

OPPOSITE
*Unlike the bells that grace
the church tower today, the
earliest bells on record at
San Buenaventura were
fashioned from wood. Two of
the wooden bells in question
may be seen in the museum
that fronts the courtyard.*

FOLLOWING PAGES
LEFT *The main
façade and the
talavera-tiled fountain
identified with the
mission church front East
Main Street and the
Figueroa Mall.*

RIGHT *The south elevation
of the church nave and
entryway fronts the lush
gardens of today's patio
courtyard, although during
the Mission era proper,
this area would have served
as a craft production
area and place for
communal congregation.*

As the first of three missions and a presidio planned for the Santa Barbara Channel in 1781, San Buenaventura was the ninth and final Alta California mission attributed to Father President Fray Junípero Serra, OFM. Established in one of the most densely populated regions of the province, San Buenaventura was part of a broader strategic religious and military initiative. The founding mission escort consisted of an *escolta* of eight soldiers, their families, an official delegation, muleteers, cattle, and pack animals bearing church furnishings and religious items, and agricultural implements. Governor Don Felipe de Neve followed the caravan from San Gabriel Arcángel with a second escort from the Presidio Real de San Carlos de Monterey. Although their destination was the Chumash village of Mitsqanaqa'n, Fray Francisco Palóu, OFM, recounted with trepidation the presence of 21 other Chumash towns for which he projected a population of 20,000 souls. Despite these formidable numbers, the friars and the escort found the Chumash friendly and industrious.

Founded on March 31, 1782, Serra originally intended to establish San Buenaventura as the third mission in Alta California, but instead prioritized San Antonio de Padua in 1771. The presidio founding took precedent over Serra's desire to establish a mission at Santa Barbara, hence the eleven-year delay. The Easter Sunday founding was followed by the installation of Fray Pedro Benito Cambón, OFM, as the mission administrator, and the subsequent construction of the first *palizada* consisting of a pole and thatch-covered chapel with adjoining room block. The first church was completed in 1784, and soon thereafter Cambón began construction of a seven-mile long masonry aqueduct from the Ventura River. A host of associated fired brick masonry water control features were also installed. The mission's agricultural prosperity and the dilapidation of provisional structures translated into the adobe reconstruction of the complex by 1789. Construction of a larger permanent church in 1787 halted when the structure was compromised, and demolished in 1790. A temporary church was erected, thereby bordering three sides of the new adobe quadrangle in 1792. In 1793, the first church was destroyed by fire, prompting the construction of the fourth church designed by architect José Antonio Ramírez, and built by Ventureño Chumash under the direction of Spanish carpenter Manuel Gutiérrez. The carpenter was then engaged in building the new adobe quadrangle completed in 1795. British Captain George Vancouver reported that the workmanship and materials (limestone, adobe clays, and flagstone) was such that the buildings were infinitely superior to their predecessors. Moreover, agricultural productivity was reflected in bountiful harvests of wheat, barley, maize, and fruit, including bananas, figs, and pears.

Initiated in 1793, equipped with a tile roof in 1798 and a brick sacristy in 1799, work on the present fired brick church spanned fifteen years, after which it was blessed and dedicated on September 9, 1809. By 1811, the church interior was decorated, the beamed or vaulted ceiling was painted, and the side altars were

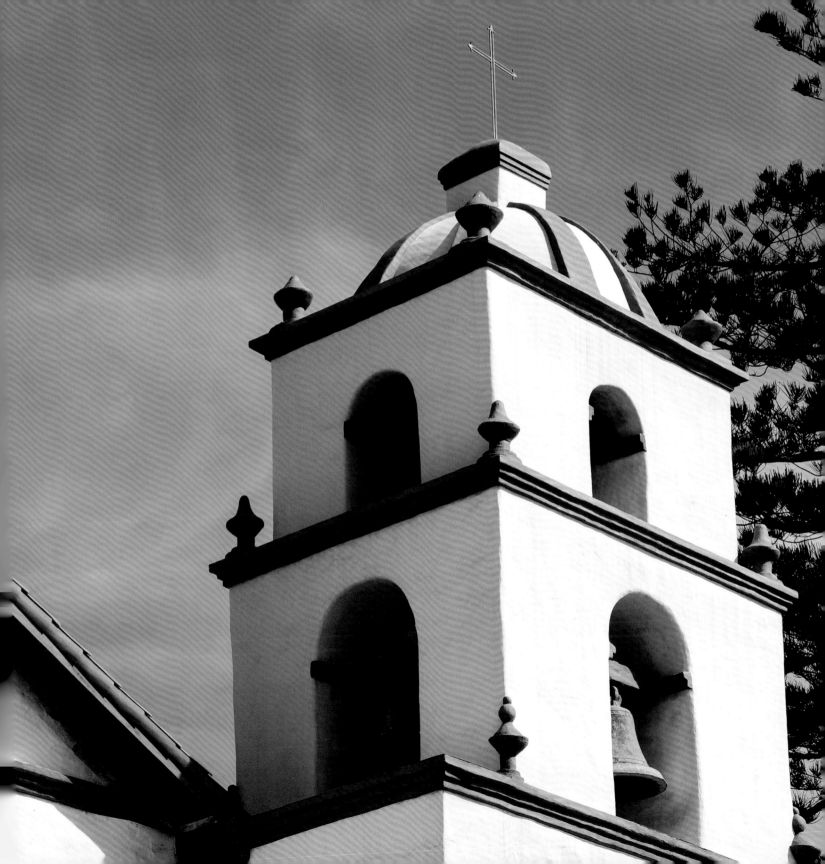

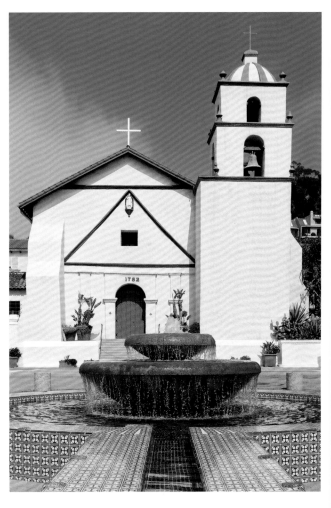

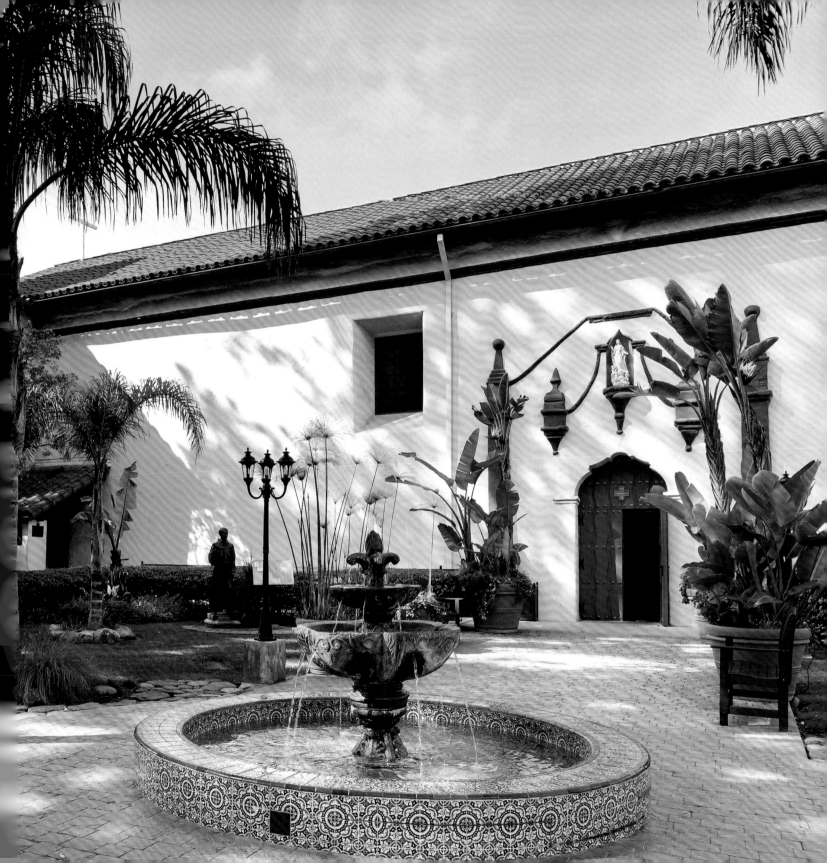

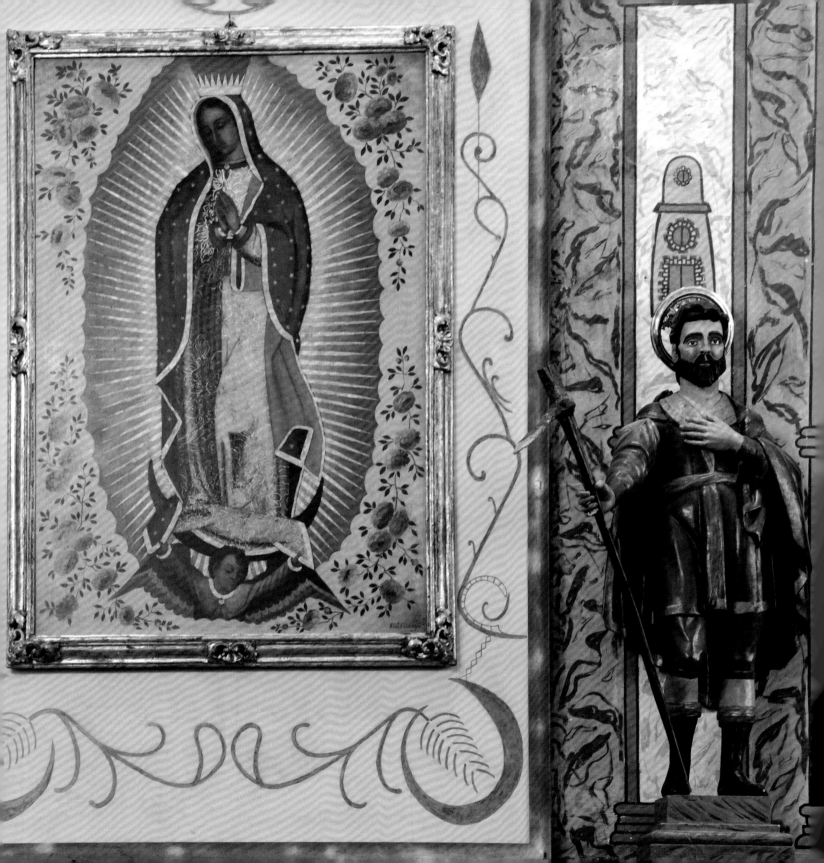

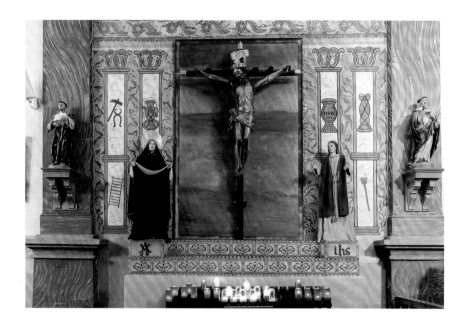

OPPOSITE
The south side altar of the church is devoted to Our Lady of Guadalupe, the Indian patroness of the Church in the Americas.

LEFT
The north side altar by contrast is devoted to the corpus and crucifixion of Jesus Christ, the son of Mary. In most such side altar displays, both the mother and the son are oriented to acknowledge the birth of the sun with Mary or Guadalupe, and sunset with the Christ.

FOLLOWING PAGES
LEFT *The balance of a monumental neoclassical main altar screen and proportional side altars present the viewer with mirrored proportions and liturgical contrasts in the guise of the Virgin Mother Mary and Jesus on the one hand, and the Immaculate Conception, Saint Bonaventure, and Saint Joseph on the other.*

RIGHT *The fountain on the mission courtyard.*

gilded. The neoclassically-inspired main altar reredos from the atelier or studio of Mexico City master craftsman José María Uriarte was installed in circa 1811–12. On the morning of the Feast of the Immaculate Conception, December 8, 1812, the Wrightwood earthquake (measuring 8.0 on the Richter scale) rocked the region and severely damaged other area missions. While San Buenaventura was initially spared, thirteen days later on, December 21, a second catastrophic earthquake struck the region, and severely damaged the church and leveled the bell tower. The wreckage forced the friars to build a new cupola-crowned bell tower, and retrofit the fractured brick church with massive brick buttresses. In addition, the masonry vault over the nave and sanctuary was replaced with timber ceiling beams (*vigas*), adzed planks (*tablas*), and the gabled roof seen today. Moreover, before restoration of the church began, the settlement was temporarily abandoned as a great tsunami swept the Santa Barbara Channel and threatened to eradicate the Mission by the Sea.

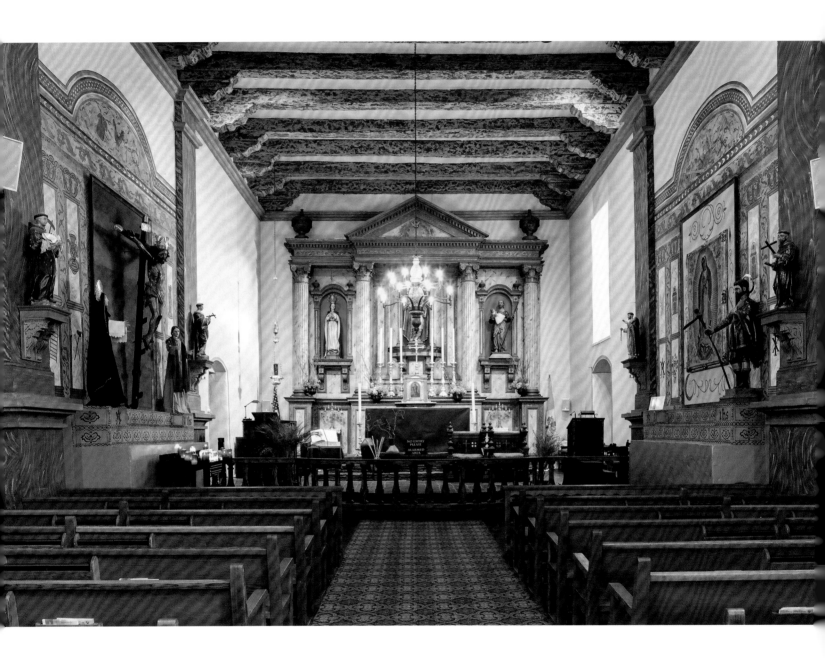

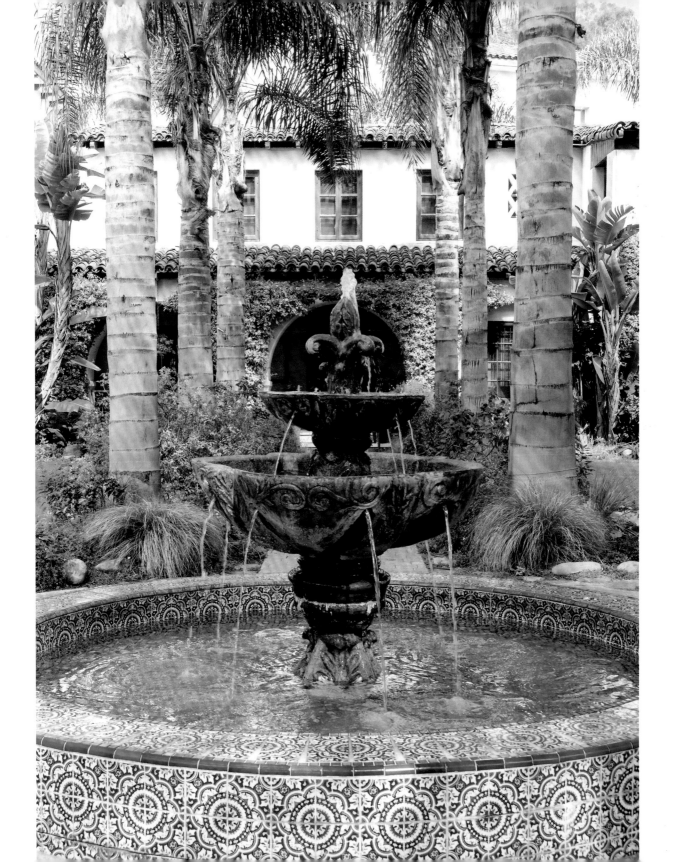

129

SANTA BÁRBARA

Founded: December 4, 1786; Dedication: September 10, 1820
Founder: Fermín de Francisco Lasuén de Arasqueta, OFM

Festivities that accompanied the September 10, 1820, consecration of the magnificent new fourth church were among Santa Barbara's most boisterous, and perhaps the most expensive and well attended on record for Alta California. The dedication of the new church commanded celebrants from throughout the province, including Governor Don Pablo Vicente de Solá and an official delegation from Monterey, officers and soldiers from the Real Presidio de Santa Barbara, auxiliary soldiers from Mazatlán, Mexico, and the friars of San Juan Capistrano, San Luis Obispo, and San Buenaventura. Also in attendance were Barbareño, Canaliño, and other Chumash neophytes, musicians, and dancers from Santa Inés, and the Tongva communities of San Fernando Rey de España. Over 1,132 Chumash neophytes from Santa Barbara celebrated with feasting, wine, brandy, and fireworks on the September 8 feast day of the Virgin Mary.

After Fray Junípero Serra, OFM, dedicated the Presidio de Santa Bárbara on April 21, 1782, he anticipated founding the tenth California mission during his sojourn. However, Serra was ordered by Governor Don Felipe Neve to await construction of the Presidio in 1784. As such, upon his death on August 28, 1784, Serra's successor Fray Fermín de Francisco Lasuén de Arasqueta, OFM, was left to dedicate the new mission. Deemed the veritable Queen of the Missions, Santa Barbara was in reality founded by Lasuén on December 16, 1786, in the hills overlooking the Chumash political capital of Syuxtun, and in the canyon identified with the village of Tanayan or Xana'yan. The area known as El Pedregoso, or the rocky place, was selected by Lasuén who convened mass and blessed the cross beneath a makeshift arbor (*enramada*) on December 15, but formally dedicated the site on December 16, 1786. Since that time, the Feast Day of Santa Barbara, December 4, has been hailed as the founding.

By the end of 1787, a provisional chapel (*capilla*), Padre's Quarters (*convento*), dormitories for unmarried neophyte women and girls (*monjerío*), and another with conjoined carpentry workshop (*obraje*) for unmarried men and boys, a granary (*troj*), and kitchen (*pozolera*), were completed. Unlike other California missions, each of four successive churches were constructed over the foundations of the earlier church. In 1789, the second church, a permanent tile-roofed adobe structure measuring 108 feet in length by 17 feet in width, was constructed. To this was added a larger adobe granary, *monjerío*, chicken coop, and jail. By 1793, the quadrangle was enclosed, and included an expanded *convento* room block, a guardhouse (*cuartel*), workshops, and stone corrals. Construction on the third adobe church was also initiated. The 124-foot-long-by-25-foot-wide structure included an adjoining sacristy measuring 26 feet long by 14 feet wide, and was dedicated on the Feast Day of San José, 19 March 1794. The new church was among the finest to date, and included whitewashed walls and tile roofs, six side altars, and a brick narthex or portico.

In 1806, Baja California Indian mason Miguel Blanco coordinated the construction of a two-mile long aqueduct (*zanja*) from Pedregoso Creek that was

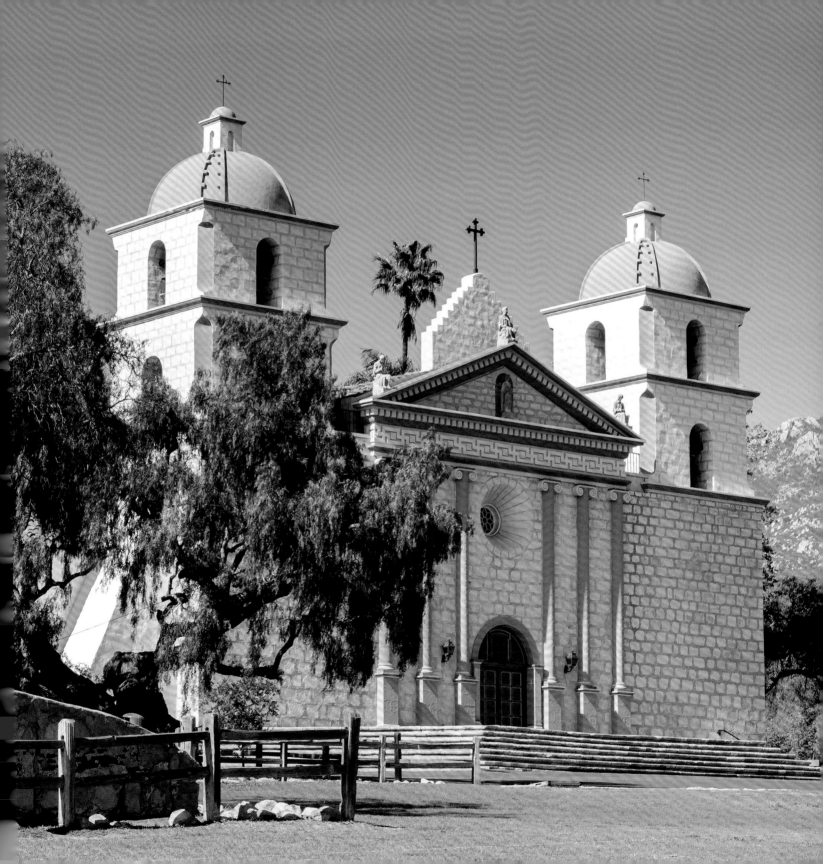

RIGHT
Today, lush gardens and elaborate fountains dominate the patio areas or courtyards of many a California mission, although in their time, such areas were dominated by industry, and fruit and vegetable gardens.

OPPOSITE
The current altar screen is a modern addition that only remotely resembles the painted lienzo *altar canvas that once spanned the whole of the apse or sanctuary back wall of the church of 1820. The lienzo canvas has survived, and bears the images of St. Joachim and St. Anne.*

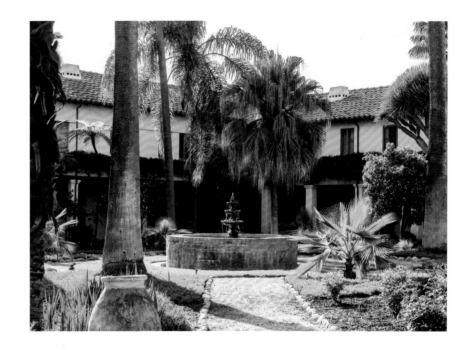

channeled to the mission. José Antonio Ramírez, master stone mason and carpenter, is credited with the sumptuous Moorish or Mudéjar fountain in the forecourt of the mission convento in 1808. The church was subsequently destroyed in the catastrophic quake and tsunami of December 21, 1812, and razed for construction of the fourth church in 1815. The fourth church consisted of dressed sandstone and mortar with 6-foot-thick stucco-coated walls, and stone buttresses with a two-storied belfry housing six bells forged in both Lima, Peru, and Mexico City. Between 1815 and 1820, Chumash stonemason and carpenter Paciano Guilajahichet crafted statuary for the church façade, as well as bear and puma effigies for the lavanderia. While the church was completed in 1820, a second belfry was not added until 1831, after which it collapsed and was rebuilt in 1833. The distinctively Roman temple-like façade was inspired by a 1787 Spanish edition of Marcus Vitruvius Pollio's *The Ten Books on Architecture* of 27 B.C., while the apocalyptic imagery of a painted reredos canvas (*lienzo*) once presided over the altar and other Vitruvian elements were affixed to the church ceiling of 1820.

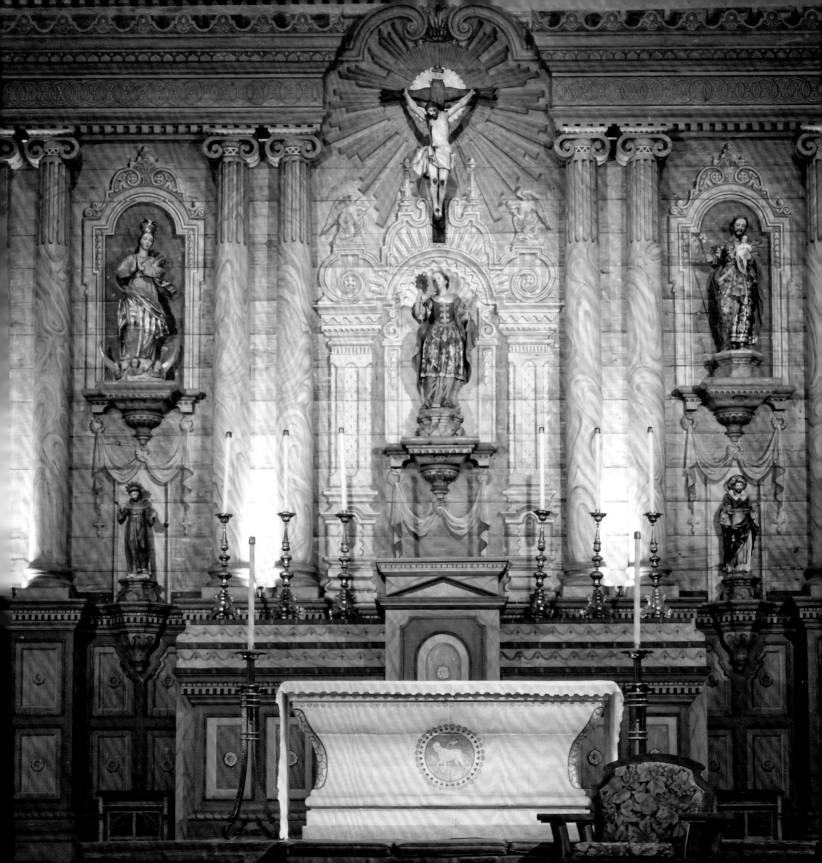

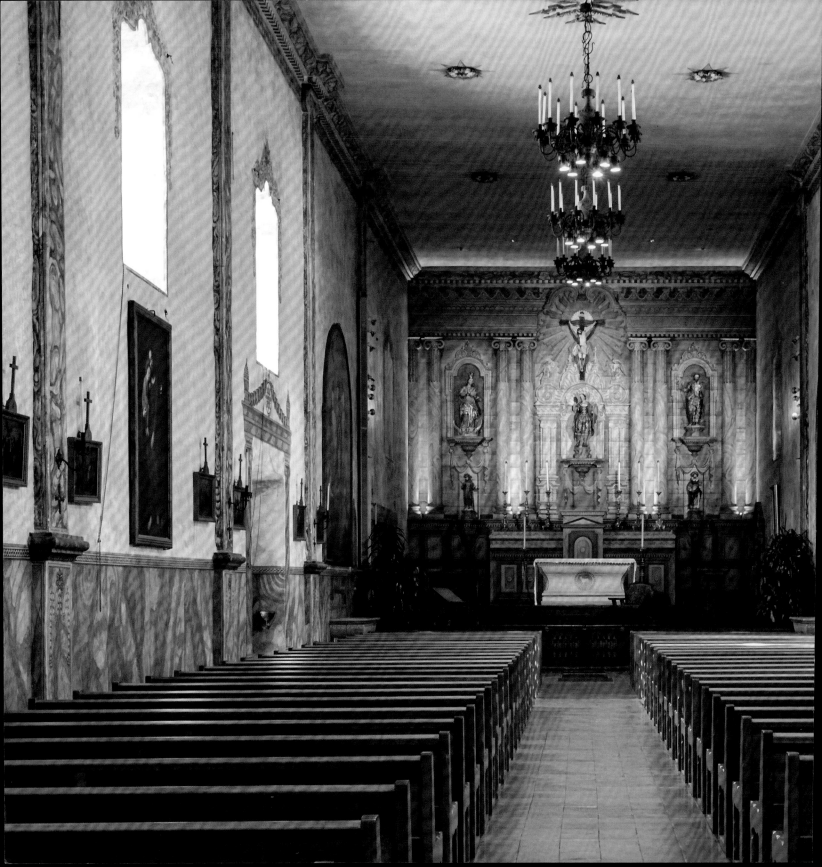

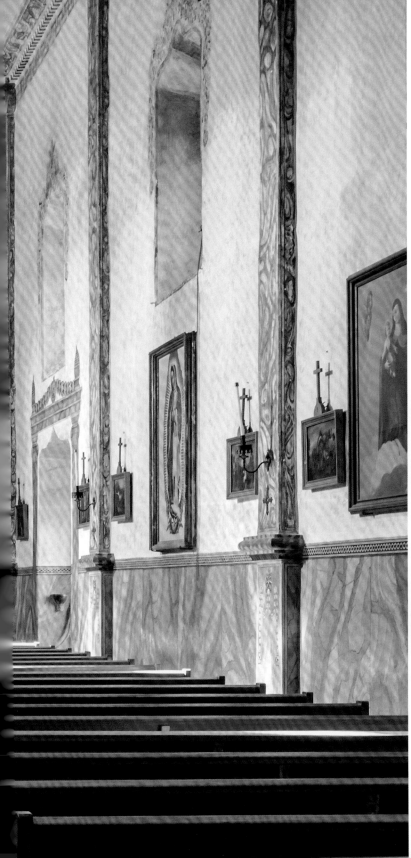

LEFT
The walls of the church nave were constructed over the foundation footings of two earlier churches, with the latest changes centered on the foreshortening of the sanctuary platform occasioned by the construction of the sacristy of 1927.

FOLLOWING PAGES
Although the statues of the saints are modern, the side altars were once part of a constellation of some six side altars that once graced the interior of an earlier iteration of the sanctuary.

PAGES 138–139
The present appearance of the main façade and architectural plan owes much of its existence to the construction of the church of 1820, the addition of the two-story convent wing, and a second bell tower added as late as 1833.

135

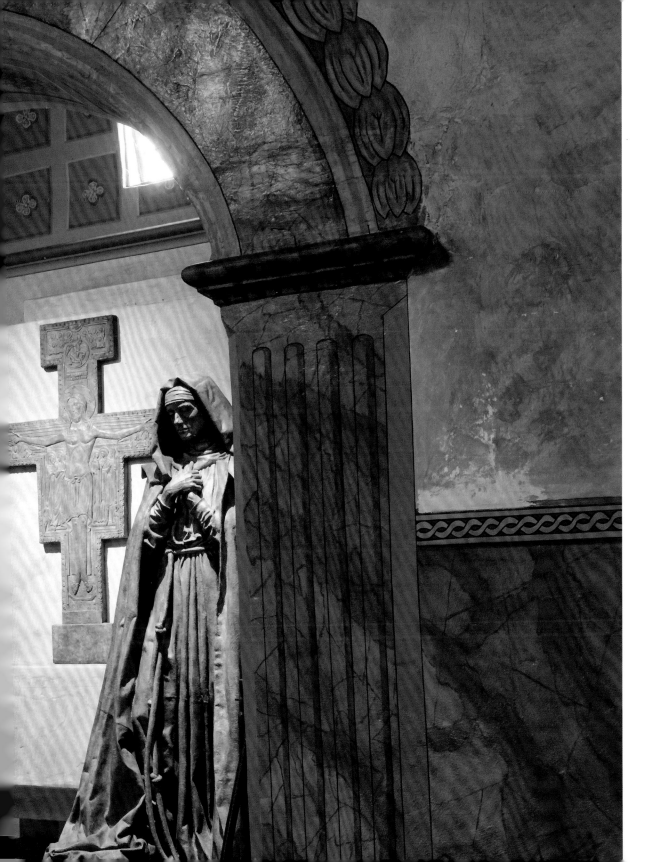

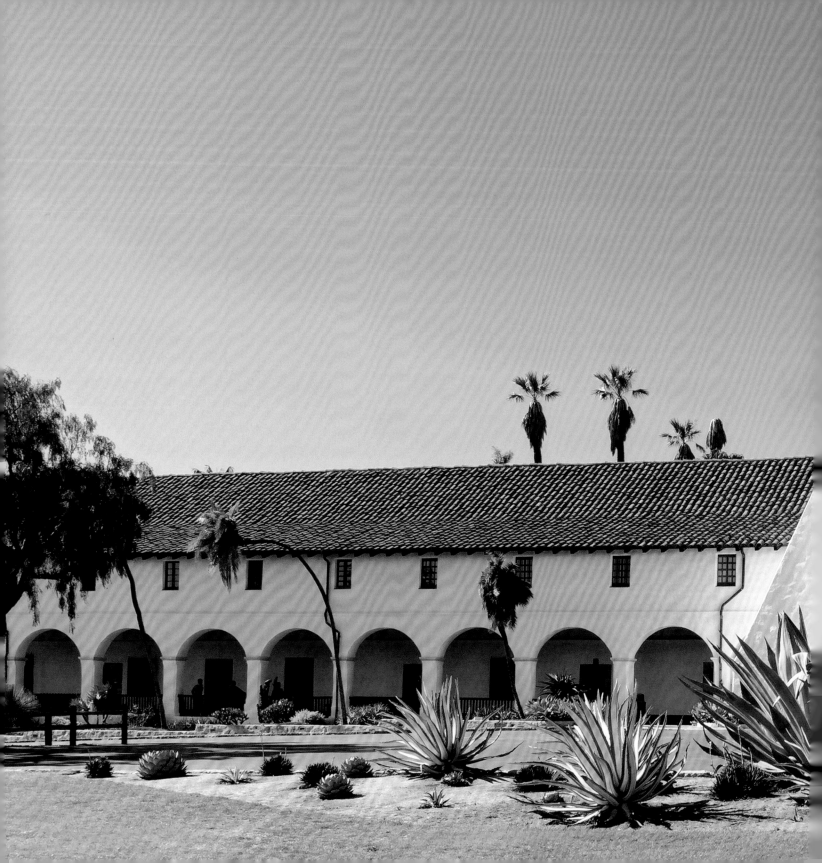

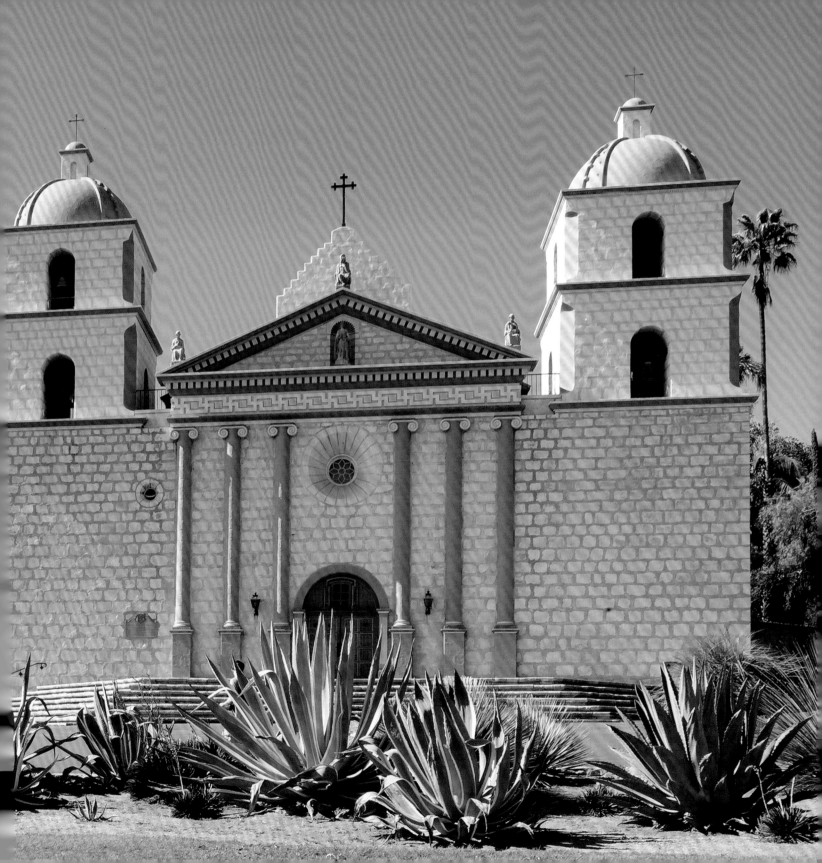

LA PURÍSIMA CONCEPCIÓN

Founded: December 8, 1787; Dedication: October 4, 1825
Founder: Fermín de Francisco Lasuén de Arasqueta, OFM

At 10:00 am on December 21, 1821, a sizeable tremor struck the mission community of La Purísima Concepción de María Santísima, thereby prompting the evacuation of 1,500 souls. Within minutes, a second earthquake jolted the earth, and wrought total destruction to the mission and the Chumash village of Algsacupí. The quake was such that the mission bells tolled continuously for nearly four minutes. Before residents could salvage what remained of the church and their homes, torrential downpours flooded the site, and three days later a torrent of mud and debris erupted from a massive fissure, burying the mission under a wall of mud. Fray Mariano Payeras, OFM, immediately petitioned the authorities to relocate the mission to its present area four miles northwest of the old stand. Twenty-four years of construction and prosperity were halted in the apocalyptic destruction that ensued, and amazingly, no lives were lost. With renewed vigor, Payeras mobilized the Chumash community in the rebirth of La Purísima in La Cañada de las Berros (Valley of the Watercress).

Despite its founding on 8 December 1787 as the eleventh of the missions of Alta California, construction of La Purísima Concepción de María Santísima was stymied by inclement weather, thereby postponing initial buildout until the spring of 1788. First buildings constructed at the village of Algsacupí by *soldados de cuera* (leather-jacket soldiers) and craftsmen dispatched from Santa Barbara consisted of a palisade (*palisado*) with thatched and earthen or adobe roofs, a provisional chapel, minister dwellings, corrals, and ancillary room blocks. By 1789, an adobe church, granary, and kitchen (*pozolera*) were built. The following year, another room block was added, along with a tile kiln. From 1790 onward, all buildings were roofed with fired tile and ancillary adobe buildings were added to the developing quadrangle in 1791. Between 1792 and 1800, the adobe church and granary were renovated, and an additional convento for the missionaries, dormitories for visitors, storage areas, a new *pozolera* (kitchen), barracks (*cuartel*), a residence for the site steward (*mayordomo*), a carpentry workshop and tack room were built. In 1798, excavations began for stone foundations for a new and larger church completed in 1802. Another barracks building was constructed in 1804, followed by a masonry dam and aqueduct. Under Payeras' skillful, tireless, and diplomatic leadership, the prosperity of the mission grew. The efforts of master carpenter Salvador Carabantes, and master carpenter and mason José Antonio Ramírez were duly noted by the padres, with the latter commissioned to craft stone basins (*pilas*), canals (*zanjas*), fountains (*fuentes*), and laundries (*lavanderias*). By 1810, an impressive quadrangle with two-storied adobe room blocks and a granary was formed, and that in addition to one-hundred dwellings to accommodate a portion of the site's 1,522 neophytes. All of this was to meet the ignominious end recounted in Payeras' journals.

Unlike the original site at Algsacupí, the new site chosen by Payeras in the Valley of the Watercress developed as a linear layout rather than a quadrangle. The new site was dedicated on April 23, 1813. Tiled provisional buildings, includ-

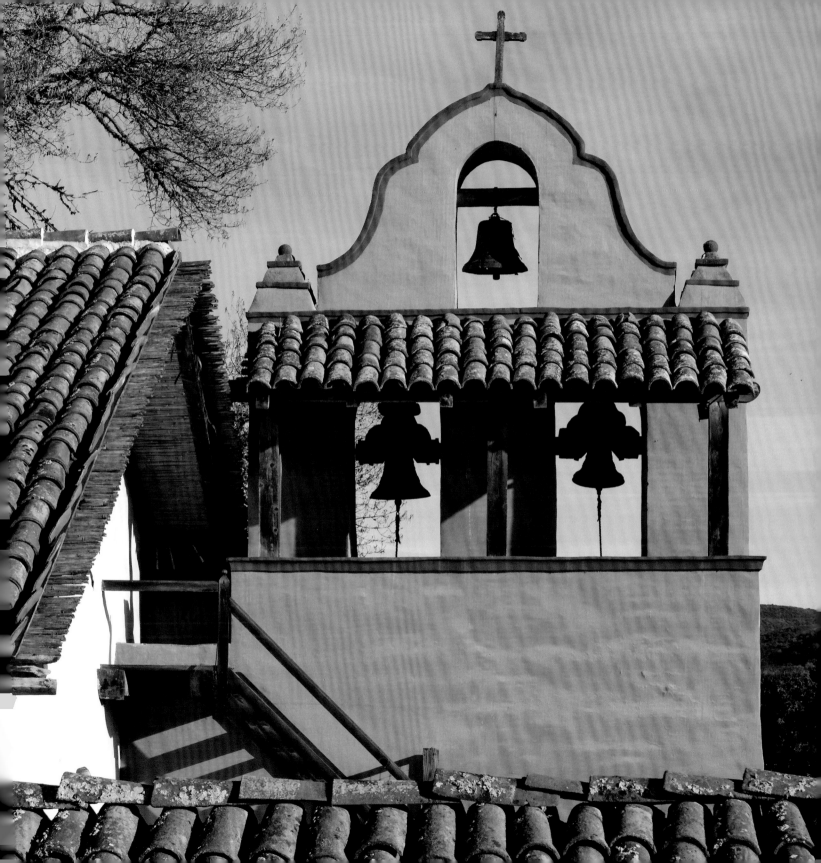

LEFT AND OPPOSITE
The painted sanctuary walls at La Purisima were often the mainstay of church décor and canonical displays.

FOLLOWING PAGES, LEFT
Mission industries spanned the gamut from the production of textiles of wool and cotton through to the tanning of cattle hides and the production of tallow candles.

FOLLOWING PAGES, RIGHT
The wood, and or wood and metal chandeliers of the Spanish colonial era were intended to evoke the classical lines of Roman architectural features.

ing a church consisting of a palisade with adobe infill and veneer construction (*horcón*), and other ancillary structures in 1813. Excavation of a three-mile long aqueduct to channel water from the Santa Ynez River to the mission also began. By 1815, Payeras oversaw the construction of a 277-foot-long-by-166-foot-wide two-story adobe range building that included housing for the missionaries, a private chapel, a weaving room, and a tiled courtyard corridor and monumental brick arcade *galería*. A second large adobe structure was erected the following year that contained a cuartel, housing for the *mayordomo*, a hospital or infirmary, and workshop areas. In 1817, foundations for a new church were excavated, and the building completed under the supervision of Ignacio Higuera in 1818. In that same year, a fire swept the neophyte housing complex on September 29, and another provisional church was built after the collapse of the temporary church of 1813. Otherwise, the following year was devoted to rebuilding neophyte housing lost to the fire. A walled *campo santo* or cemetery was completed and an adjoining *campanario* bell wall was erected in 1821. The church was ultimately dedicated on October 4, 1825. Tragically, the Mexican era ushered in a period of decline anticipated by the death of the long-serving Payeras in 1823, followed by a large-scale Chumash rebellion against Mexican rule staged from La Purísima in 1824. In the 1930s, the Civilian Conservation Corps reconstructed all buildings and furnishings at La Purísima. Today, the site constitutes one of the most complete pictures of life in the California missions.

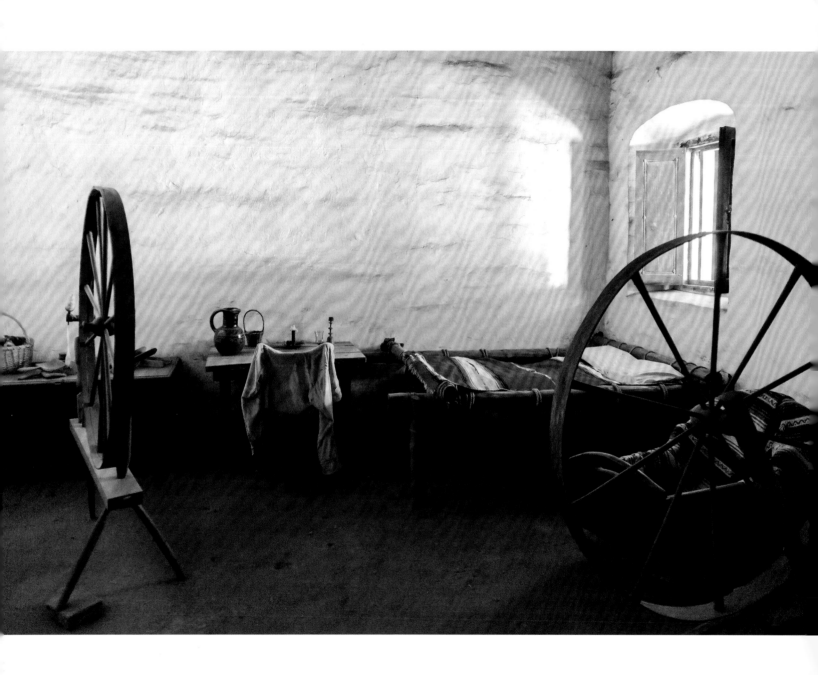

146 La Purísima Concepción

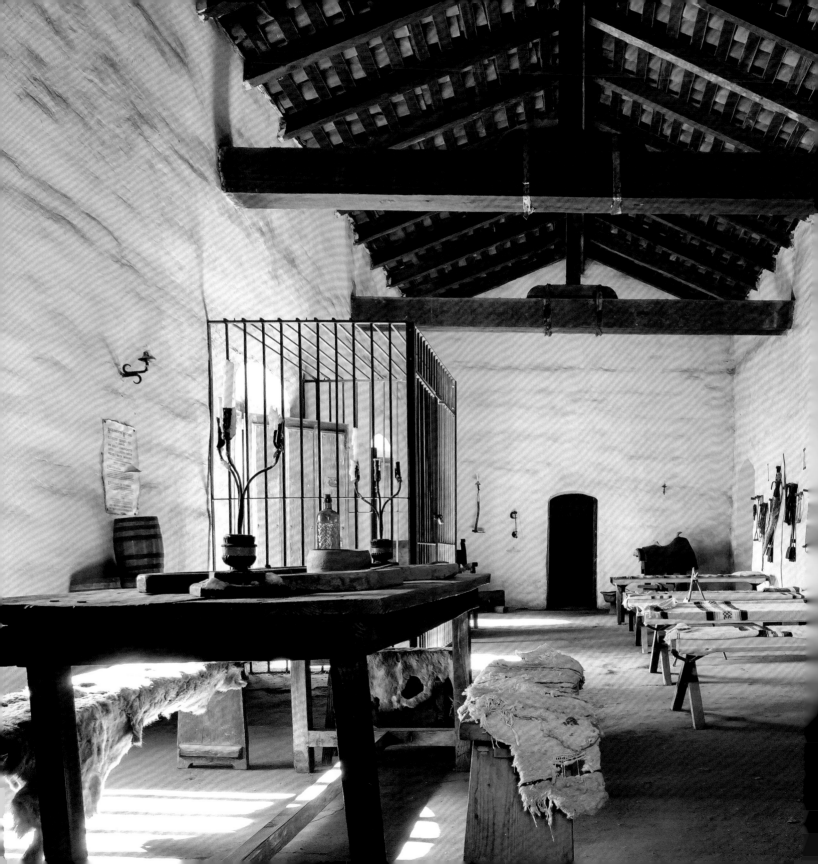

LEFT
The spartan conditions of the cuartel *or guard house are here exemplified by the open un-walled space and ceilings, massive adobe walls, and wood plank beds.*

BELOW
The cuartel *at La Purisima provided housing for the* escolta *or mission guard.*

149

RIGHT, TOP, FAR RIGHT,
AND FOLLOWING PAGES
*The linear plan of La
Purisima is unique among
the California missions, and
represents a shift away from
the quadrangle enclosure of
the mission complex
destroyed in the great
earthquake of 1812.*

RIGHT, BOTTOM
*Outbuildings at La Purisima
provide a sense of the agri-
cultural emphasis and
industries of the
mission enterprise.*

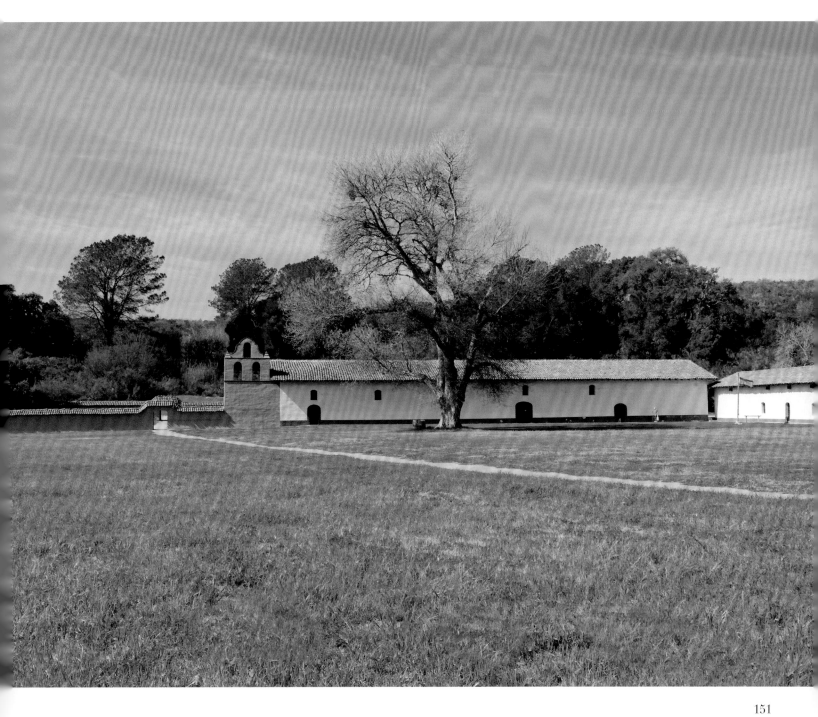

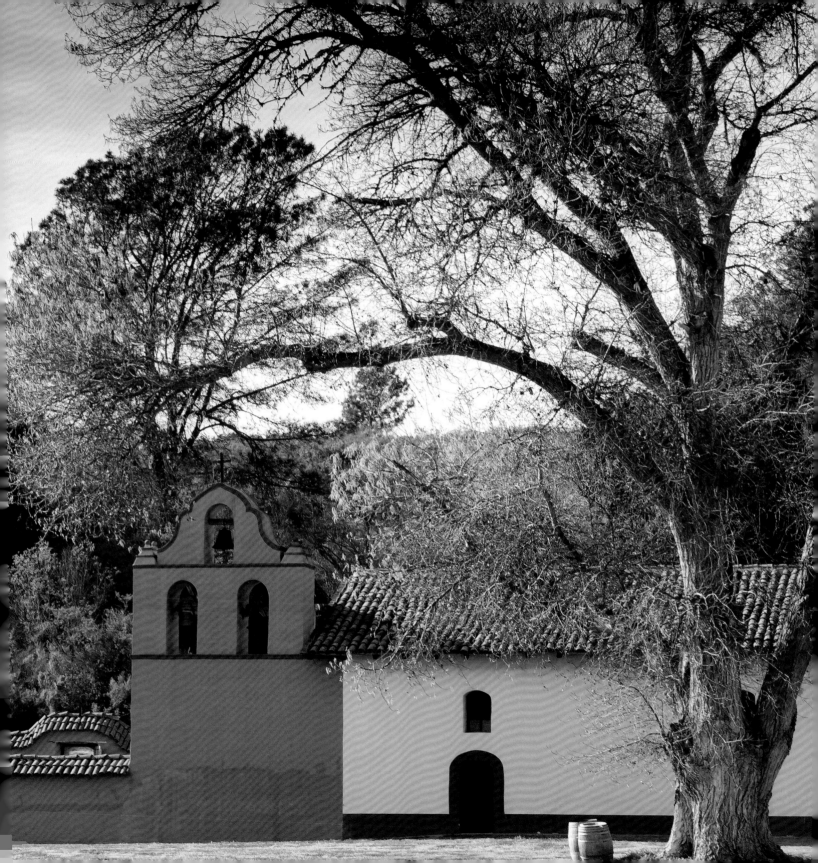

PART 6: HOLY CROSS OF

AND THE MISSION
SOLITUDE

SANTA CRUZ

Founded: August 28, 1791; Dedication: May 10, 1794
Founder: Fermín de Francisco Lasuén de Arasqueta, OFM

On the January 20, 1791, Fray Fermín de Francisco Lasuén de Arasqueta, OFM, was directed by Viceroy Don Vicente de Guemes to found La Misión de la Exaltación de la Santa Cruz. Although many of basic implements needed for the new mission were available, the Father President notified the viceroy of the lack of religious utensils and furnishings for the proposed new church. On July 22, 1791, Lasuén distributed a circular soliciting religious articles from missions as far afield as San Antonio to San Diego, including chalices, altar utensils, and vestments. In addition, the procurator in Mexico drew on the Pious Fund, and shipped the equivalent of $1,000 in church articles, including vestments, bronze bells, two altar stones, and altar crosses and linens from Mexico City. Lasuén hastily assembled the goods needed for the founding of the twelfth mission in Alta California.

Departing Santa Clara de Asís in August of 1791, Corporal Luis Peralta, five soldiers from the Presidio de San Francisco, and Lasuén set out for the village of Aulintac by the San Lorenzo River. On August 28, Lasuén dedicated the new mission, and raised and blessed a cross over the proposed church site. Under orders from Governor Antonio Roméu, Ensign Hermenegildo Sal, Peralta, and five soldiers from the Presidio de San Carlos de Monterey traveled to Santa Clara with those goods required for the new settlement. From Santa Clara, the detachment departed for the San Lorenzo River with Friars Isídro Alonzo Salazar and Baldomero López, OFM. Beginning on September 14, 1791, the friars and their neophyte companions felled timbers and prepared the grounds for construction. The earliest buildings, including the provisional chapel consisted of palisades with adobe veneers and thatched roofs. While the neophytes were compensated in blankets and maize, other local people, the Awaswas or Costeños, sought induction into the mission community and this prompted by their tribal leader or chief Sugert and his family of converts.

In 1792, the threat of flooding compelled the missionaries to relocate Santa Cruz to its present location on Mission Hill. The friars and artisans from the Department of San Blas mobilized around the construction of adobe buildings. The first structure was a large adobe house for the ministers whose flat roof was sealed with mortar and bitumen-sealed *ladrillo* or fired rectangular tiles. The second church consisted of a portion of the corridor in the new building enclosed in redwood planks. The provisional wooden church was replaced by a permanent third church whose cornerstone was set on February 27, 1793. As was the custom, into the concavity of the stone were deposited religious objects and coinage. Period descriptions of the great adobe church indicate that it measured 105 feet long by 27 feet wide, and 27 feet high, and boasted double-wall construction, masonry door surrounds, and a cut stone facade or *portada*. The presbytery, vestry, baptistery were accessible through stone archways, and wooden doors with corresponding locks. Moreover, the essential geometry of the church facade and bell tower with cupola mirror San Buenaventura, and the beamed ceiling was painted

OPPOSITE
The interior of the diminutive memorial chapel of 1931 only vaguely simulates some elements of the sanctuary of the original church of 1794.

in a basketry-like chevron pattern like that at San Francisco de Asís. This required skilled craftsmen, including carpenters Pablo Béjar, Ygnacio Chumacero, and Joaquín Mesa. The master carpenter Don Francisco Gómez was present for the dedication of the church on May 10, 1794, which included the ceremonial granting of the keys of the church to the sponsor, Don Hermenegildo Sal of the Presidio de San Francisco. Construction activity dominated the site's history such that the neophyte housing block survives to this day under the stewardship of the California State Parks. By 1795 the quadrangle was fully enclosed. Whereas the earthquake of 1840 brought down the church bell tower, the February 1857 earthquake brought down what remained. A frame structure replaced the church in 1858, and was in turn replaced by the Victorian church of 1889. Whereas Holy Cross Catholic Church sits atop the foundations of the original adobe church, a smaller one-third sized concrete replica was constructed on the east side of the modern plaza in 1931.

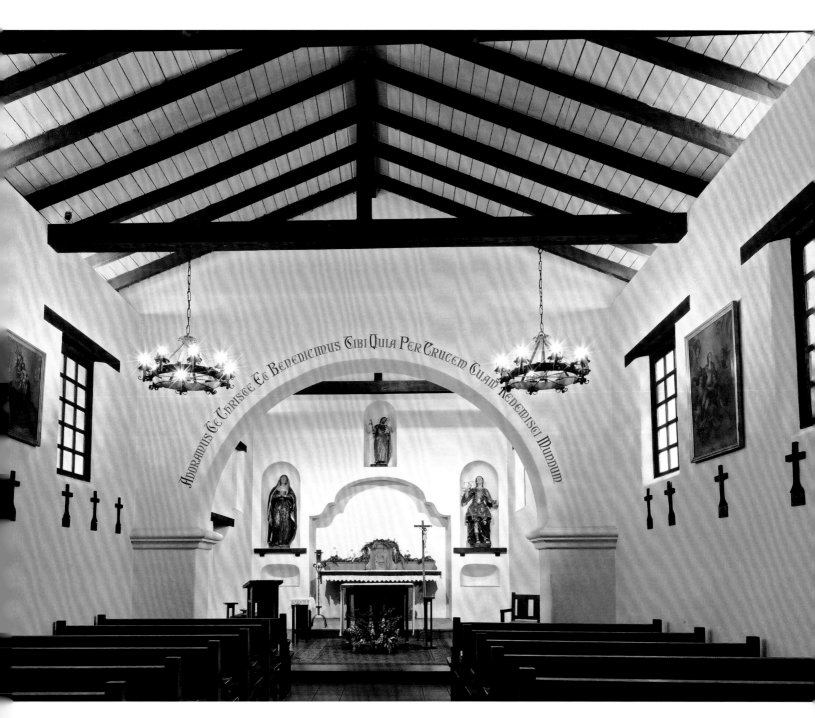

RIGHT
The Neophyte Housing Area of Mission Santa Cruz today houses a museum and period rooms replete with reproductions of period artifacts and furnishings. This portion of the site is today maintained by the California State Parks system.

BELOW
The one-third scale replica of the church includes a tranquil courtyard garden and a room block that is today used to house the mission museum and gift shop.

FOLLOWING PAGES
The Neophyte Housing area is stocked with period furnishings and features of the type used in the Mission era.

NUESTRA SEÑORA DE LA SOLEDAD

Founded: October 9, 1791; Dedication: 1797
Founder: Fermín de Francisco Lasuén de Arasqueta, OFM.

On August 24 of 1774, Fray Junípero Serra, OFM, recounted the day he chanced upon the name for the place later identified with the thirteenth mission. On his trek through the valley he encountered an Indian woman bearing gifts. Asking her name, she responded with what Serra interpreted to be "Soledad." At this point, he informed his companions that "'Here, gentlemen, you have Maria de la Soledad!" And, without more ado, the name stuck to the place. Seventeen years later Father President Fermín de Francisco Lasuén de Arasqueta, OFM, convened mass near the Esselen village of Chuttusgellis and founded La Misión de María Santísima, Nuestra Señora Dolorosísima de la Soledad, or simply, Nuestra Señora de la Soledad. Dedicated to our Lady of Solitude, Soledad has more than lived up to its reputation as the mission of solitude. During its tumultuous 44 year tenure, 30 friars served this distant outpost, with its last lonely friar, Vicente Francisco de Sarría, succumbing to starvation on May 24, 1835.

The site first described by Fray Juan Crespí, OFM, during the Sacred Expedition of 1769 eventually prompted Lasuén to petition the Viceroy for a new mission. The designated founding missionaries, Friars Diego García and Mariano Rubí, OFM, anxiously awaited approval from August 2, 1790, through July 15, 1791. On September 29, Lasuén dispatched a party of 11 Indian neophytes to the distant village of Chuttusgellis to construct a provisional shelter. The neophytes fabricated the first wattle-and-daub (*jacales*) or mud-plastered pole and thatch structures (*palisados*) that served Lasuén and the founding missionaries in their efforts to convene the formal dedication on October 9, 1791. Construction of the first adobe church began in 1792. By 1793 a more substantial adobe church was in use, and an adjacent *convento* dormitory was completed in 1794. Ultimately, the new thatched adobe church was consecrated before the end of 1797. With hundreds of California Indians flocking to the mission, including Chalon, Esselen, Yokut, Sierra Miwok, and Salinan, the friars enlarged the church by 34 feet in length. In addition, the friars increased the height of the roof by 9 feet so as to accommodate an oversized altar screen sent from Mexico City.

The rapid development of the quadrangle was undertaken during the tenure of José María Leocadio Martínez, a soldier, master carpenter, and painter first assigned to Soledad from the Presidio de Monterey in 1791. By 1808, Corporal Ignacio Vallejo, the soldier-carpenter and surveyor identified with the construction of waterworks at Santa Cruz and San José doubtless played a key role in the planning of a 15-mile-long masonry aqueduct (*zanja*). Neophyte mason Simón Cárit was the likely builder of the aqueduct that once bisected the grounds, thereby dividing the Neophyte Plaza from the mission quadrangle (*casco*). Archaeology crews from California State University, Monterey Bay, have since recovered and mapped a host of buried structures, including the dwellings of the Neophyte Plaza to the south, *convento* of 1794, soldiers' quarters (*cuartel*), sacristy (*sacristia*), church narthex (*pórtico*), and a portion of the aqueduct once fed by the Arroyo Seco. The floods of 1824 and 1828 severely damaged the original church that once stood at

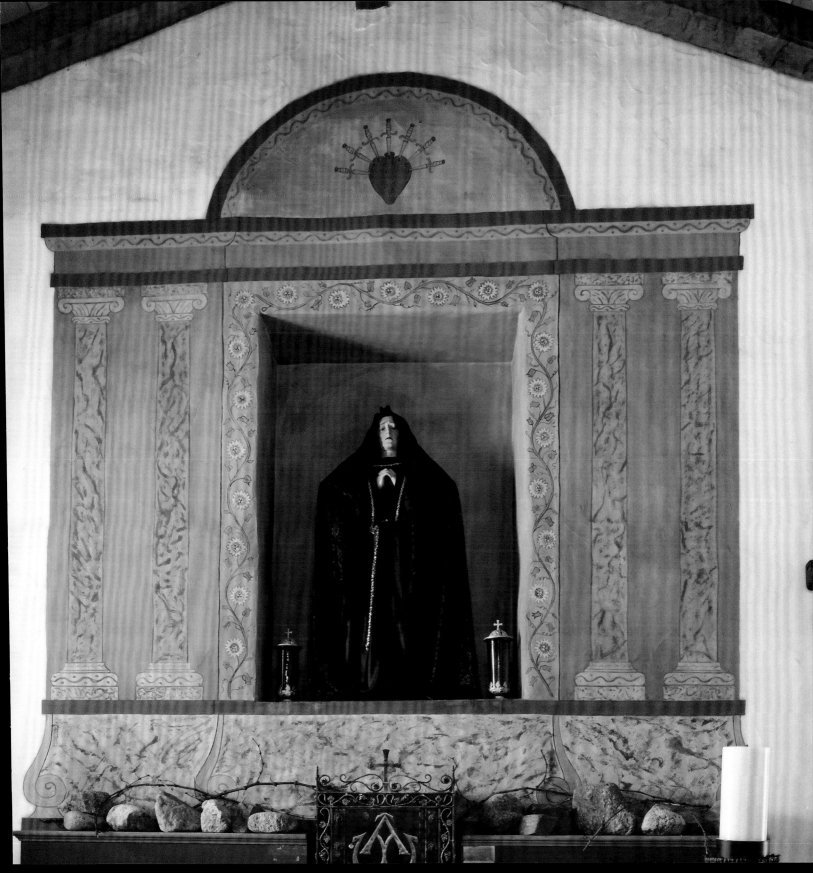

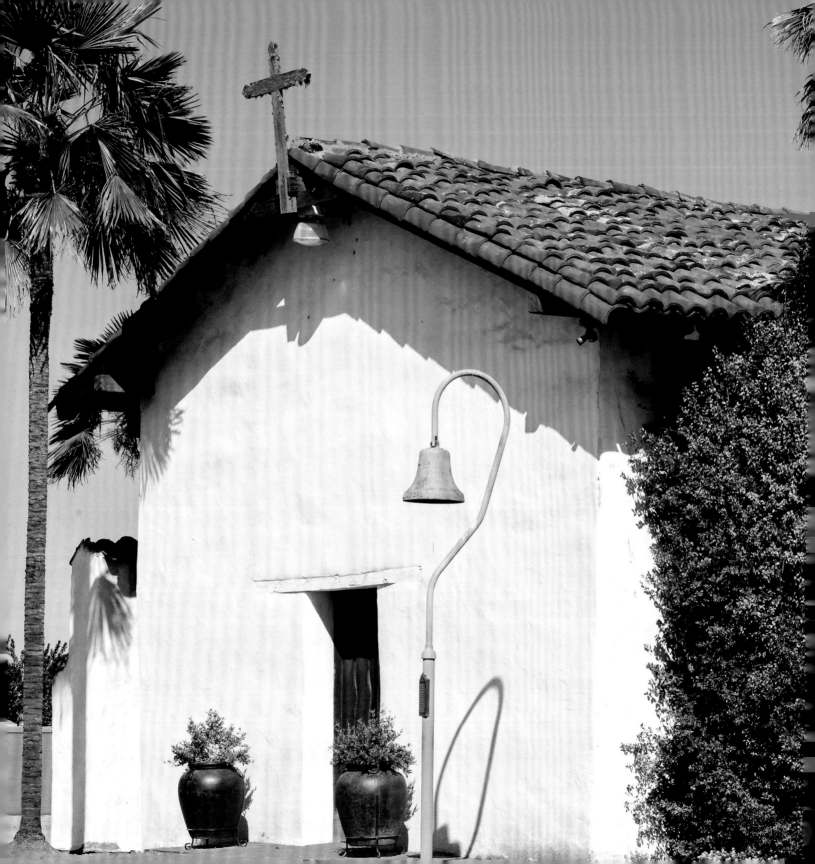

The chapel of 1832 was built in the wake of the destruction of the main church in 1828. The stark white exterior constitutes a dramatic contrast with the painted embellishments of the interior. Were it not for the restoration of 1954, little would remain of the eroding adobe buildings of the original mission quadrangle.

Today, Soledad lies in the midst of what today is deemed the "Salad Bowl of the World," but which in its own time, was hardly productive until the installation of a 15-mile network of aqueducts and feeder canals in the period before 1808.

167

RIGHT
The chapel of 1832 was erected after the main chruch at the east end of the convent wing was destroyed in the floods of the late 1820s. Its gabled roof plan and viga *or beamed cross members replicate the roofing framework of the original buildings.*

OPPOSITE
This recent depiction of our Lady of Solitude is but one of many such devotional artifacts donated to the church for the perpetuation of the faith.

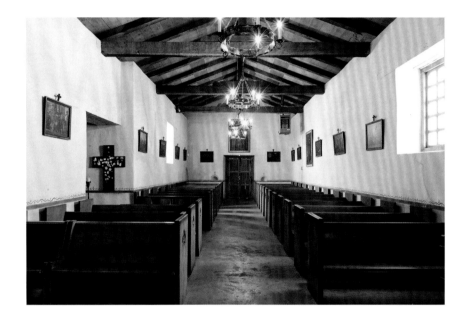

the east end of the existing *convento* and current museum. Consequently, the ruined church was abandoned in 1828, and the existing chapel located at the west end of the padres' quarters was converted from an existing room block in 1832. Deemed "the last mission church [constructed] in California," the subsequent 1834 secularization of mission landholdings presaged the rapid decline and abandonment of the mission with the death of Sarría. By 1840, the mission caretaker was forced to sell 6,000 roof tiles to purchase provisions for feeding the remaining neophytes.

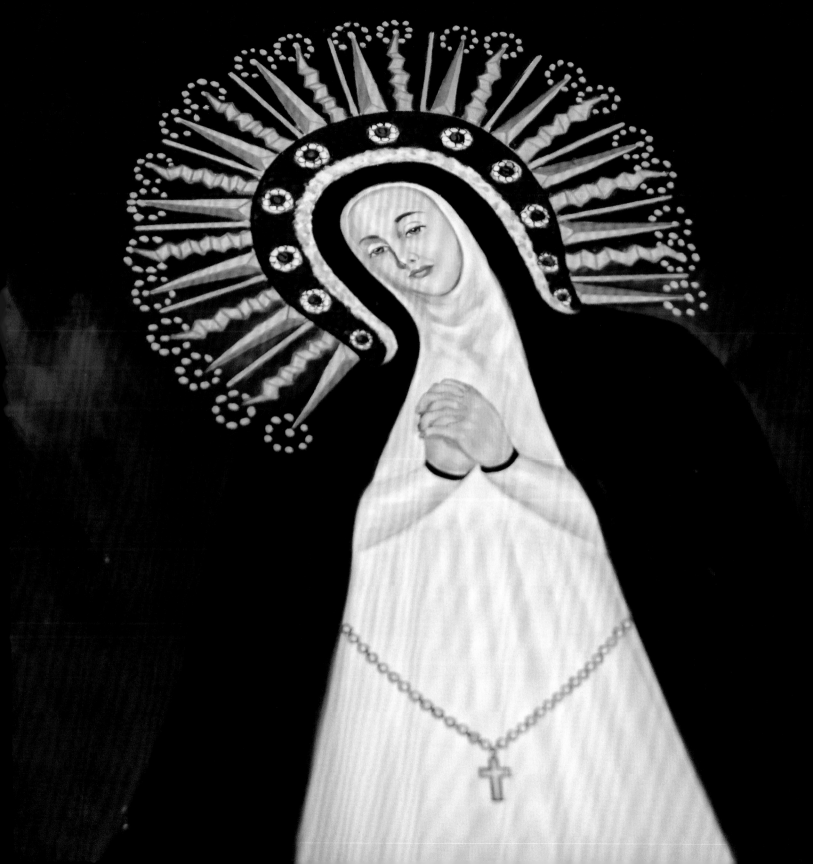

PART 7: LASUÉN'S

LEGACY

SAN JOSÉ

Founded: June 11, 1797; Dedication: April 22, 1809
Founder: Fermín de Francisco Lasuén de Arasqueta, OFM

Consecrated by the blood of a Grizzly felled by eleven musket rounds on June 10, 1797, Fermín de Francisco Lasuén de Arasqueta, OFM, ordered the fabrication of a great Cross and the construction of a wildflower-draped *enramada* or brush shelter for the altar. Lasuén was joined by founding Friars Isidro Barcenillas and Agustín Merino, OFM, a contingent of six Catalan soldiers, and neophytes from Loreto, Baja California, for the dedication of the fourteenth mission. On June 11, 1797, the Father President commenced the ceremony with the ringing of bells, incense, the lighting of candles, and the discharge of six musket volleys, which drew the Oroysom, Bolgon, Chuchiyon, and Chequemnayon peoples of the region. Lasuén concreated the site with holy water and convened prayers for the veneration and installation of the cross, and raised the Spanish royal flag atop a nearby tree.

Prior to the dedication of San José, temporary housing for the friars and a chapel were erected. As with other sites, temporary buildings consisted of pole, mud, and thatch (*jacales*). By the end of that year, corrals for livestock provisioned by Santa Clara de Asís, and a fenced orchard was reported. By 1798, a granary (*troj*) and irrigation canals (*zanjas*) were added, and the chapel was enlarged. The largest project was initiated under Fray José Antonio de Uría, OFM, in 1805, and centered on the excavation of the foundations for a new church completed and dedicated on April 22, 1809. Designed by Fray Felipe Arroyo de la Cuesta, OFM, of San Juan Bautista, the exterior of the church measured 135 feet in length by 30 feet wide, with a 24-foot-high ceiling and 4-foot-thick walls. The beamed ceilings were harvested and adzed from redwoods (*palos colorados*) located six or seven leagues, or circa 25 miles north. In addition to tiled floors and wooden doors with hardware, the windows incorporated iron grills. The north wall of the church was equipped with monumental buttresses to counteract seismic damage. Despite inclusion of a sizeable bell tower in Arroyo's original plan, the tower was truncated to withstand earthquakes. In addition to the construction of an adobe sacristy and baptistery, a monumental two-story, fifteen room, missionaries' quarters, measuring 275 feet in length by 47 feet in width, was completed by 1810. This was conjoined with a similarly large adobe building housing a granary, workshops, and storage areas. Completion of these structures enclosed the quadrangle, and in 1812 the church roof was raised and tiled. In 1819, a masonry dam spanned Mission Creek, and the irrigation system included a fountain channeling water from area hot springs. Dwellings for soldiers, their families, and the neophyte community were the mainstay of continued construction. Much of the indigenous population by 1825 numbered 2,000 Miwok, Patwin, Wappo, and Northern Valley Yokut. The church was largely completed by 1810, after which the Mexican independence movement hindered the delivery of supplies and halted funding for mission and presidio operations.

Secularization in 1834 resulted in the dismantling of the mission, forcing the neophytes and tens of thousands of livestock to disperse. On October 21, 1868,

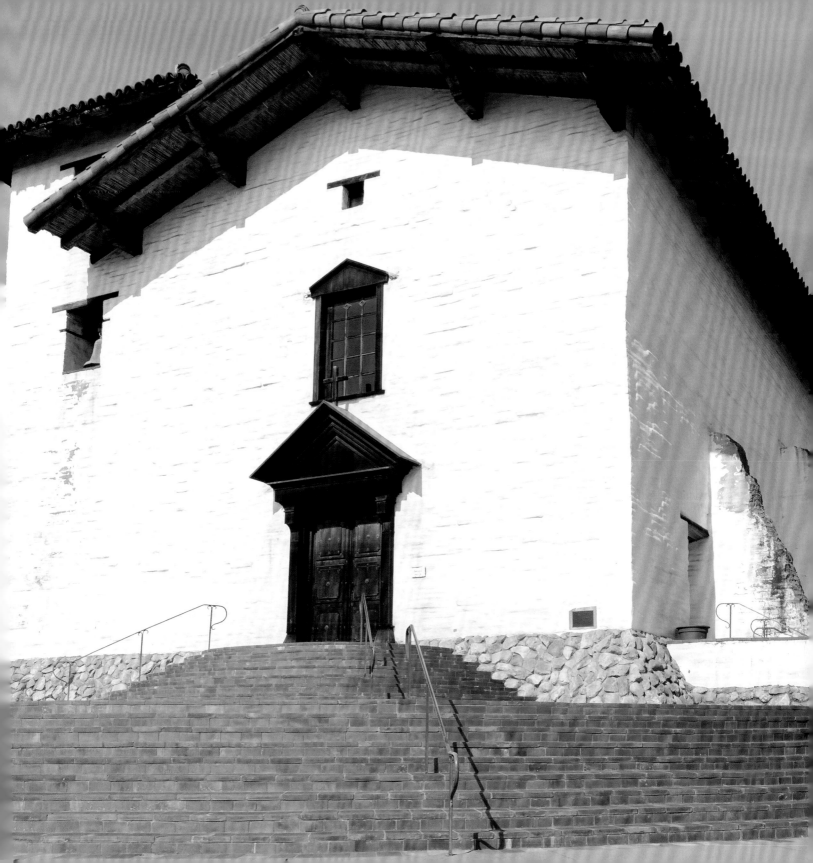

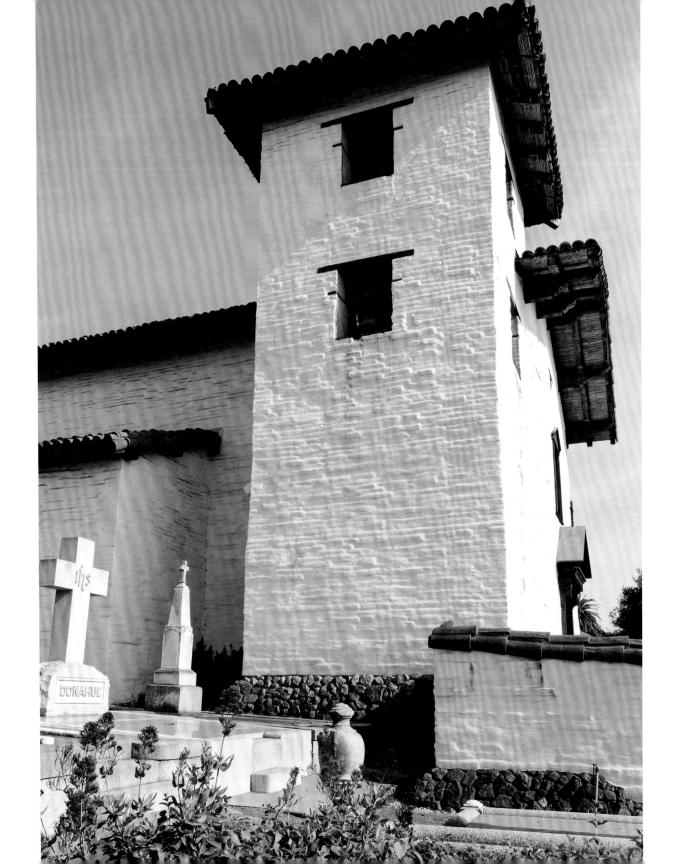

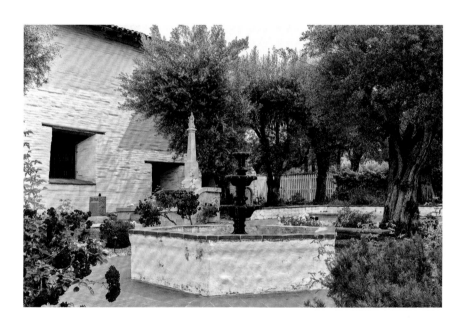

OPPOSITE
The tower, like the façade, has long been characterized as both massive and plain. Spain's wars with France and the intervention of the Mexican Independence movement curtailed further elaboration of the church and its buildings.

LEFT
Though a modern installation in this instance, the mission once boasted a host of water features, including a fountain fed by area hot springs.

FOLLOWING PAGES
The painted swags, marbelization, and Corinthian columns were replicated by Carmel master craftsman Sir Richard Menn on the basis of those designs originally rendered by painter Augustín Dávila in 1835.

the Hayward Fault erupted and destroyed much of what remained, including the church. Shortly thereafter, a New England-style steepled church was erected over the old foundations. In the 1950s, the Sons and Daughters of the Golden West launched a restoration campaign that resulted in archaeological and historical studies, and the subsequent reconstruction of the 1809 church. Begun in 1982 and dedicated on June 11, 1985, the reconstruction follows original foundations, flooring, and documented features. Carmel master craftsman Sir Richard Joseph Menn meticulously recreated the interior, including murals, gilded reredos, and side altars. Whereas the original altar screen was crafted by Mexico City master carpenter José María Uriarte in circa 1810, the side altars were created by carpenter Juan María Martin and painter Augustín Dávila in 1835. The most distinctive features of the fully restored church are the bell tower and *ochovado*, barrel-vaulted or octogonal, ceiling and redwood plank *toral* or triumphal archway over the chancel of the restored church of June 11, 1985.

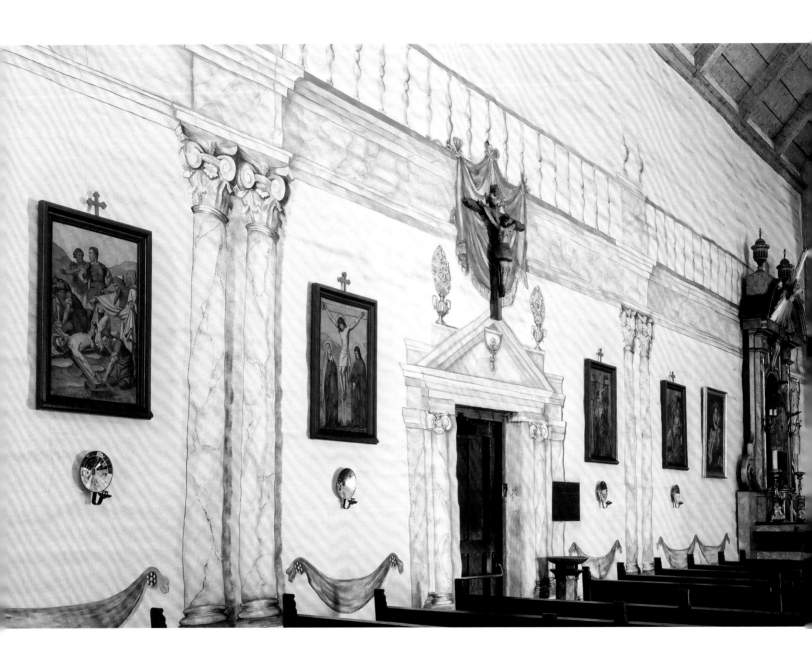

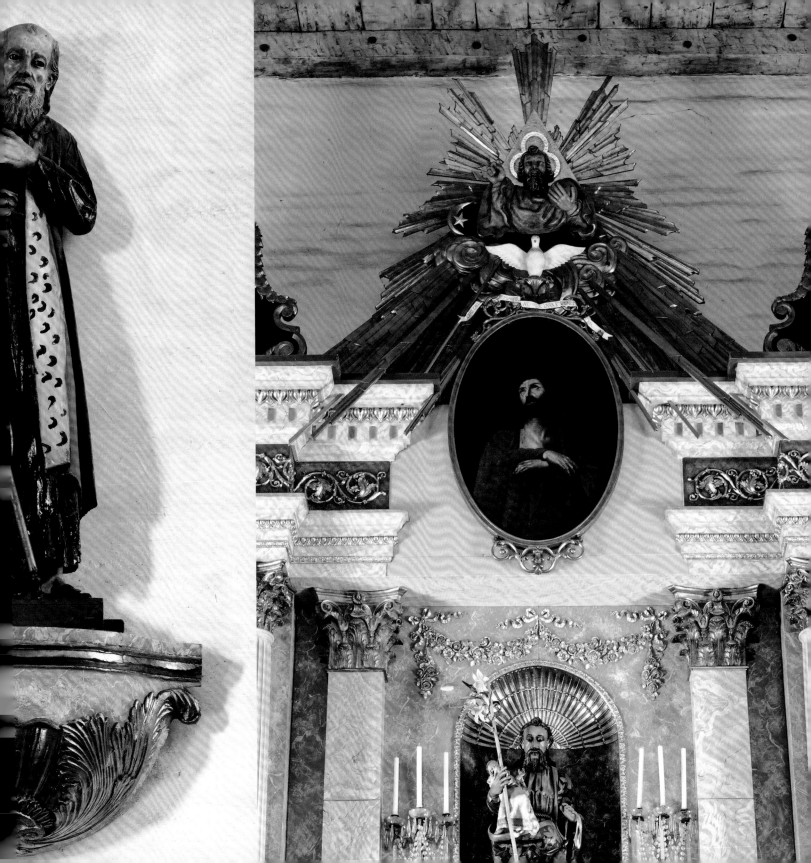

PREVIOUS PAGES, LEFT

Reconstructed on the basis of period prototypes and historical descriptions, the side altars of the nave were fabricated, painted, and gilded by Carmel master craftsman Sir Richard Joseph Menn in circa 1985. In this instance, the side altar features a surviving statue of San Buenaventura, or Saint Bonaventure, dated to 1808.

PREVIOUS PAGES, MIDDLE

Saint Joachim, the father of the Blessed Virgin Mary, constitutes the only period statue within the reconstructed church not identified with a side altar.

PREVIOUS PAGES, RIGHT

The main altar screen or reredos features a sculpted rendition of God the Father, the Holy Spirit in the form of a white dove, and a period painting of Christ. The original altar was crafted in the Mexico City workshop of master carpenter José María Uriarte in circa 1810.

RIGHT AND BELOW

Little remains of that portion of the two-story convento dormitory that once adjoined the south wall of the mission church. A simulated cobble foundation delineates the original footprint of the ruined convento building.

SAN JUAN BAUTISTA

Founded: June 24, 1797; Dedication: June 23, 1812
Founder: Fermín de Francisco Lasuén de Arasqueta, OFM

OPPOSITE
The hand-adzed redwood plank altar screen or reredos *was installed in 1818, and painted by Boston sailor Thomas Doak.*

FOLLOWING PAGES
The stark white facade or portada *of the Great Church of 1812 was intended to distinguish the desert of the human spirit from that of the blessings of the Heavenly Kingdom. Upon entering the church, the faithful beheld the brightly colored pigments used to evoke the Garden of Eden by way of murals depicting lush vegetation spanning the walls and columns of the nave and sanctuary.*

Known as the Mission of Music for its distinctively-crafted hymnals, San Juan Bautista was the fifteenth mission established in Alta California. Founded on June 24, 1797, and dedicated to Saint John the Baptist, this mission was one of four established that year by the second Father President of the California missions, Fray Fermín de Francisco Lasuén de Arasqueta, OFM. In anticipation of the founding ceremony atop the elevated west bank of the great San Andreas fault, Ygnacio Barrera, Second Carpenter of the frigate *Concepción*, Corporal Juan de Dios Ballesteros, and a detachment of soldiers from El Real Presidio de San Carlos de Monterey built a provisional chapel and missionaries' quarters. Mutsun villagers from Popeloutchom assisted the soldiers in building the first chapel and ancillary buildings. With the completion of a thatch-covered chapel, cloister, granary, and guardhouse, the missionaries redirected their efforts to stock raising, agriculture, water control, and a host of other tasks. With a rudimentary kiln in operation nearby, many of these same buildings were soon equipped with both roof and floor tiles.

The original quadrangle was leveled by a sizable earthquake and fire in October 1800. A formidable *convento* building was subsequently erected just beyond the east wall. Built atop a siltstone foundation, it featured hand-hewn redwood ceiling timbers (*vigas*), adzed and ship-lapped redwood floor and ceiling planks (*tablas*), and a flat-laid adobe block and lime-plastered roof and ceiling membrane (*torta*). A host of craftsmen contributed to the construction of the Padre's Quarters, including the soldier, blacksmith, and millwright José María Larios, soldier and master carpenter Manuel Rodríguez, the carpenter Leocadio Martínez, and José María Franco. Within a decade, a major expansion of the Padre's Quarters was undertaken, which doubled the residential space. In 1810, a mission kitchen or *pozolera* was added, and redwood doors carved with the iconic River of Life were installed throughout the complex. Moreover, the 1812 retrofit required that two freestanding adobe towers be dismantled in concert with the construction of the monumental fired brick arcade fronting the plaza.

Where the Great Church is concerned, the formal blessing and installation of a new church cornerstone convened on June 13, 1803, and participating dignitaries included Lasuén and Friars José Manuel de Martiarena and Domingo Iturrate, OFM. Spanish silver coins and a wax-sealed and inscribed scroll documenting the event was deposited within the cornerstone, and some nine years of almost continuous construction followed. Trenches were excavated to accommodate tons of mudstone boulders used to create foundation footings for the circa 4-foot-thick, and 32-foot-high walls of the three-aisled 72-foot-wide church, and lime was quarried from deposits in San Juan Canyon. In order to generate the 35-foot- to 40-foot-long beams needed to span the central nave, old growth redwoods were felled from ancient stands near Santa Cruz, and northeast of the mission. In 1809, side aisles were added to the church, and separated from the nave by two massive

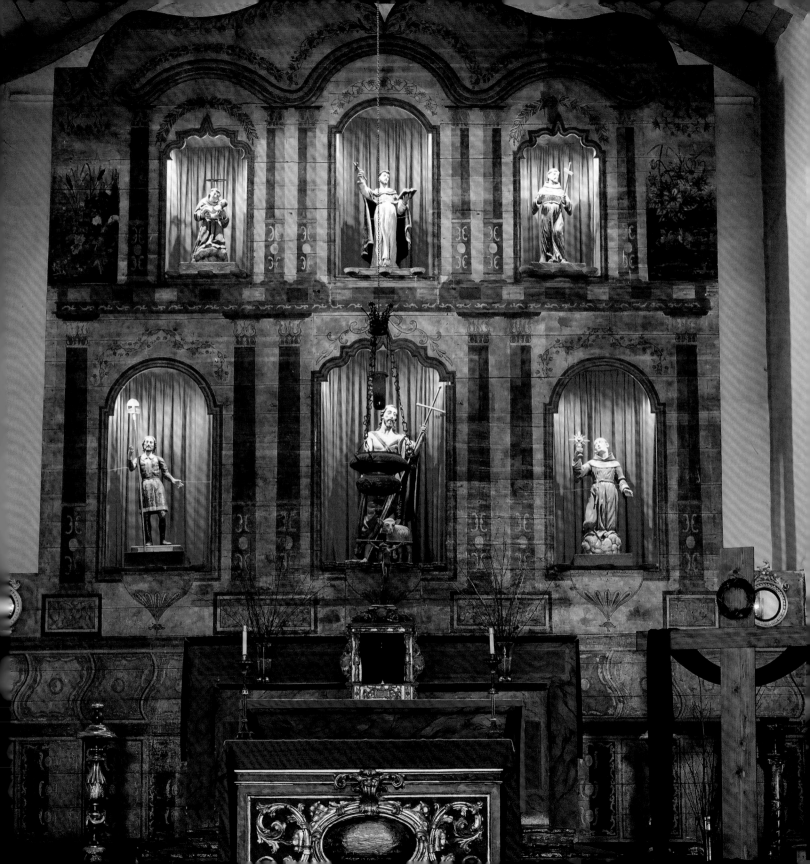

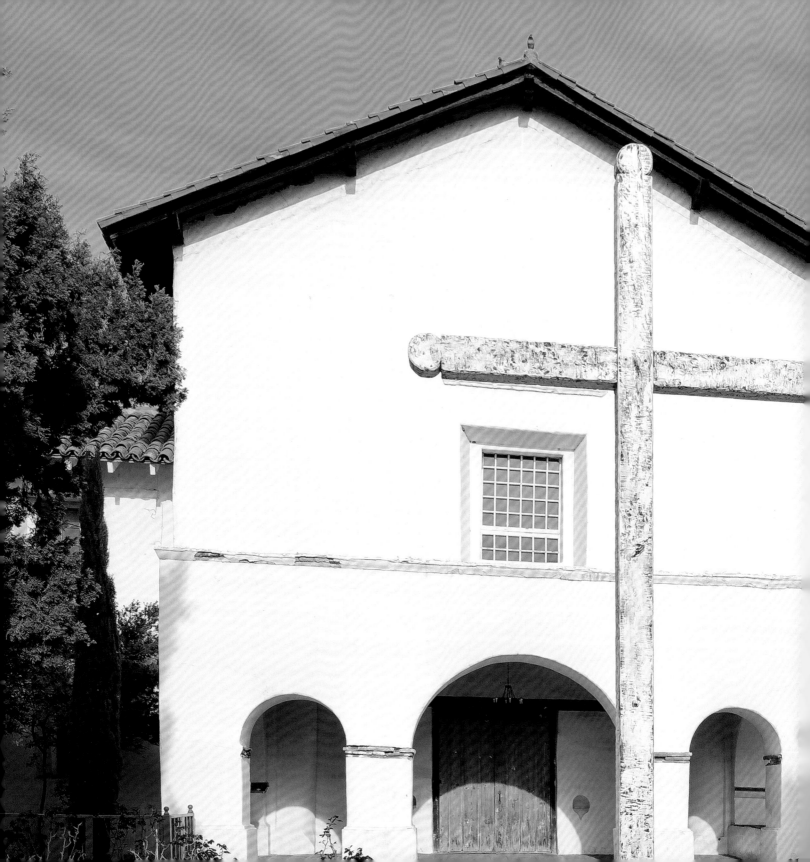

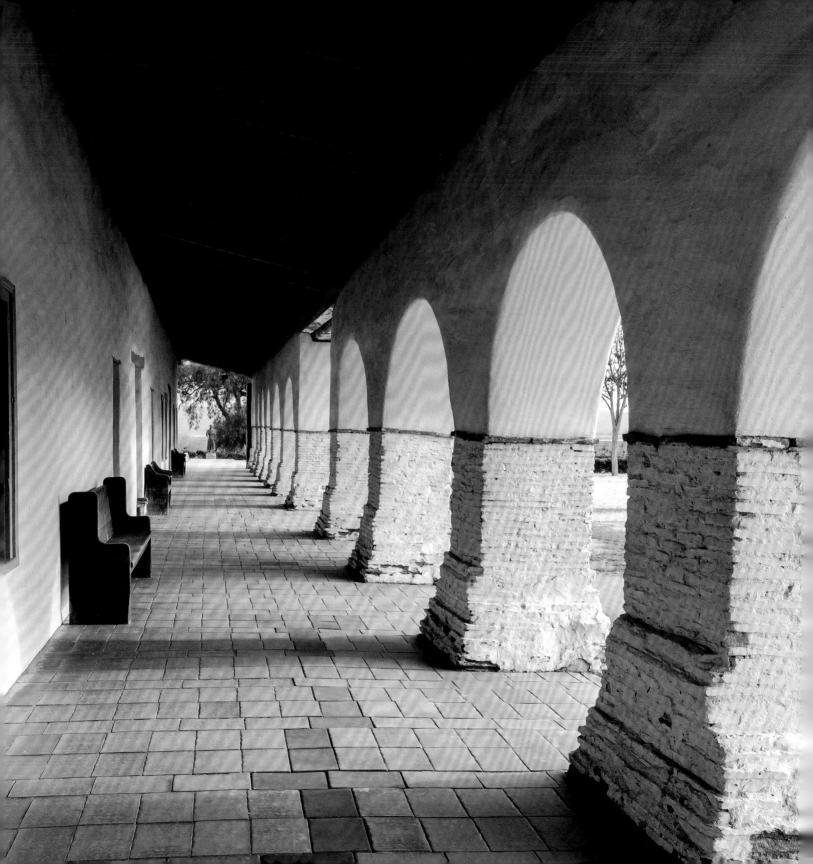

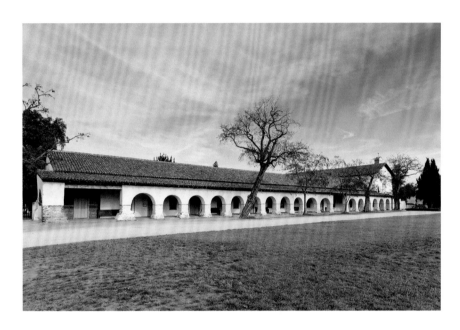

arcades with twelve piers forming fourteen arches, and a barrel-vaulted (*ochavado*) plank wood ceiling.

 Formal dedication of the church occurred on June 23, 1812. Among those officiating at the dedication of the Great Church were Governor Don José Joaquin de Arrillaga, Father President Fray Estévan Tápis, OFM, and resident Friars Felipe Arroyo de la Cuesta and Roman Fernández de Ullibarri, OFM. Clearly, the geometry and design represented required the skills of an accomplished architect, and it is no coincidence therefore that the mission's patron, Don Manuel Gutiérrez, the architect of San Buenaventura and San Fernando Rey, was present for the dedication. In 1818, a hand-adzed redwood plank altar screen or *reredos* was installed, and painted by Boston sailor Thomas Doak. In the aftermath of the 1812 earthquake, the archways were sealed with adobes, the original *ochavado* ceiling was dismantled, and clerestory windows were installed. In the final analysis, the Winter Solstice and Epiphany solar illuminations of the main altar saints and tabernacle remain telling features of the otherwise sophisticated solar geometry of the Great Church.

OPPOSITE *The monumental arcade consisting of 19 arches was constructed from thousands of fired bricks in 1812.*

LEFT *The Old Mission fronts the great square or* plaza mayor *of San Juan Bautista where religious processions, market days, bullfights, rodeos, and bull and bear fights were all the rage.*

FOLLOWING PAGES, LEFT *This side altar is devoted to La Virgen de Guadalupe, the "Indian Madonna" of Mexico.*

FOLLOWING PAGES, RIGHT *The Great Church of 1812 boasts the only three-aisle configuration in the California missions. As the largest remaining mission church, its arcade or* galería *is similarly unique. Sealed with adobes shortly after the earthquake of 1812, the movie* Vertigo *(1958) depicts Jimmy Stewart walking the nave with its walled-off arcade and side aisles.*

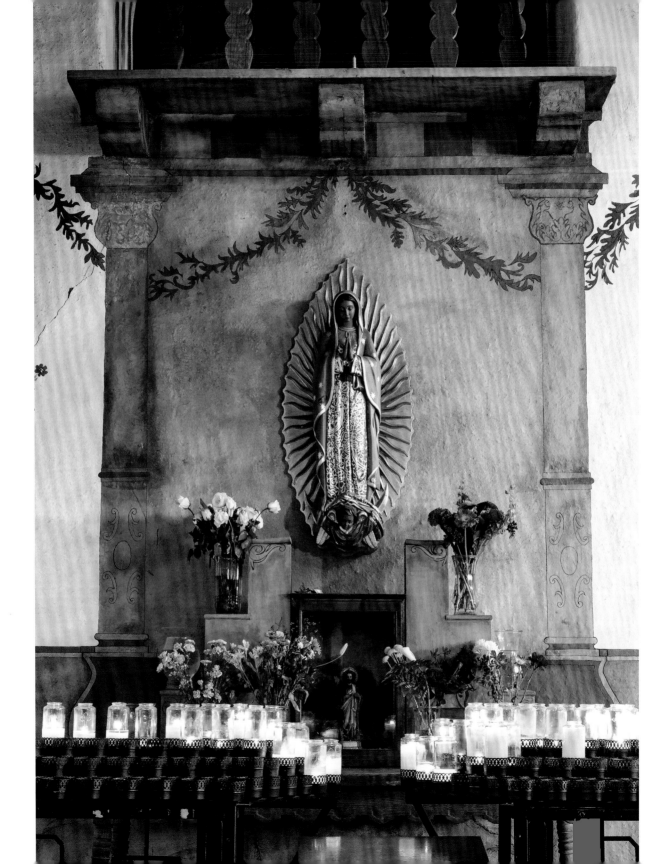

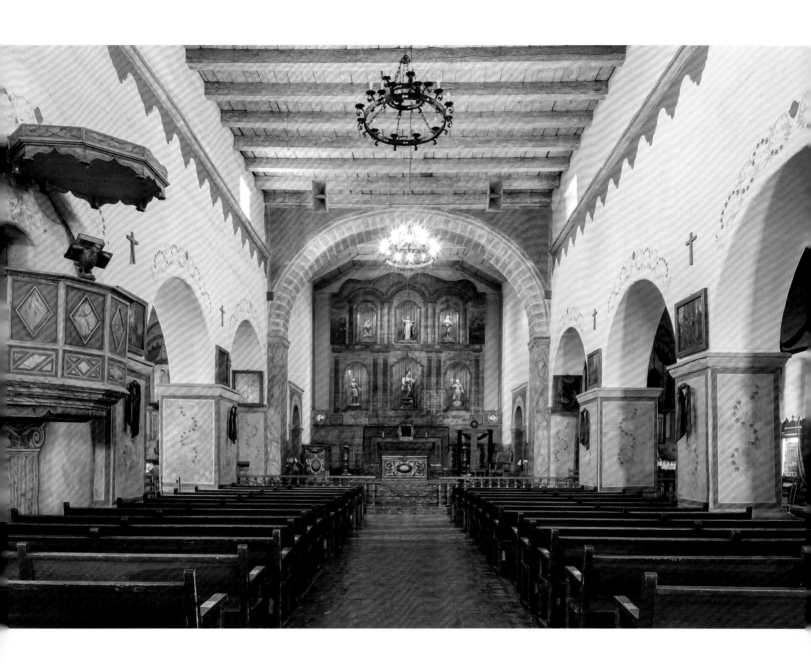

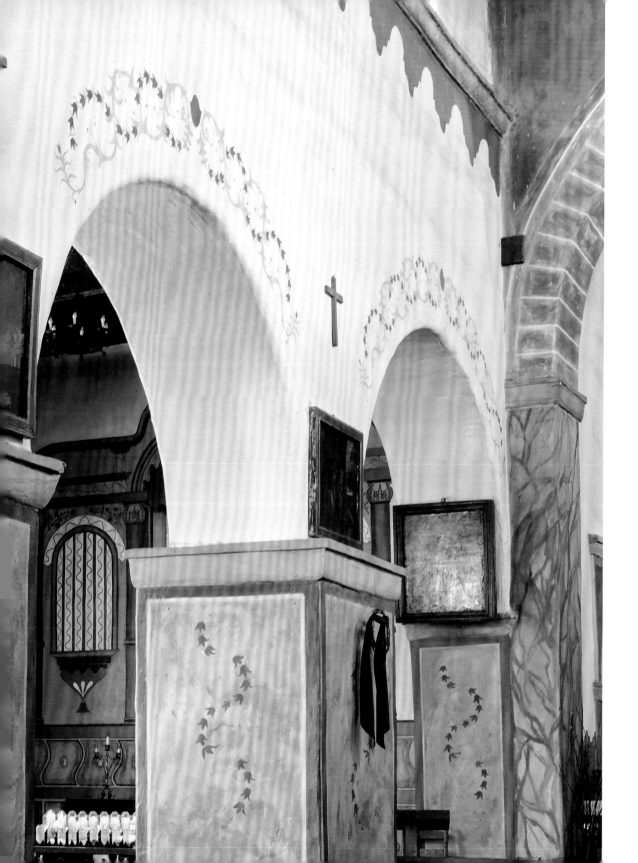

The beloved Friar Felipe Arroyo de la Cuesta, OFM, once delivered sermons in as many as thirteen distinct California Indian dialects from the pulpit or rostrum on the Gospel, or ambo side of the nave. This raised platform pulpit, or caja de púlpito, *was intended to emulate the stage upon which Christ delivered the Sermon on the Mount.*

The Padre's Quarters or Convento of 1800 was retrofitted, and thereby transformed into a double-barreled dormitory, in 1810–12. That portion of the building dated to 1800 replaced the ruined convento buildings destroyed in the earthquake of October of that year. Today, the whole of the convento serves as the Old Mission Museum and Gift Shop of the complex since dedicated to Fray Felipe Arroyo de la Cuesta, who oversaw the construction of the Great Church of 1812.

SAN MIGUEL ARCÁNGEL

Founded: July 25, 1797; Dedication: 1818
Founder: Fermín de Francisco Lasuén de Arasqueta, OFM

In a letter dated 27 August 1795, Fray Buenaventura Sitjar, OFM, reported the results of a scouting expedition for the future site of San Miguel Arcángel. In his report, the friar delineated water sources that would assure the agricultural viability of the new sixteenth mission of Alta California. With twenty-five years of experience at San Antonio de Padua, Sitjar was well acquainted with the potentials and pitfalls of the region. At the Salinan site of Vahiá or Cholame, Father President Fermín de Francisco Lasuén de Arasqueta, OFM, blessed holy water, the place, and a great Cross erected on July 25, 1797. Lasuén appointed Sitjar to serve as the resident missionary and administrator, and a garrison was assigned to the site. Given the multitude of California Indians who gathered at the dedicatory mass, Lasuén and Sitjar rejoiced. By the end of that first day, the Indians assembled offered fifteen children for baptism.

Known as the Mission of the Highway, San Miguel Arcángel was dedicated to the Archangel Michael, and represented the second of three churches devoted to the archangels in Alta California. The industrious Migueleños, or Salinan Indians of the region participated in the construction of a small clay-roofed adobe church and women's quarters (*monjerio*) added in 1798. An adobe house for the ministers, dwellings for the neophytes, and the retrofit and expansion of the church soon followed. At this time the quadrangle was enclosed. A system of canals (*zanjas*) were created to support the cropping of wheat and maize, an orchard, and vineyard. By 1805, roof tiles were produced for the church and other ancillary buildings, but fire destroyed much of the complex in 1806. Losses included workshops, storerooms, and granaries upon which 1,000 Salinan neophytes depended. The church of 1798 was damaged such that its roof and furnishings were destroyed. An elaborate, multi-component, and gilded neoclassical altar handcrafted by Mexico City master carpenter José María Uriarte survived the fire and is presently housed in the mission museum.

Area missions soon supplied provisions while San Miguel underwent repair and restoration. By 1808, a new women's quarters, warehouse or granary, sacristy, and both carpentry and weaving workshops were installed, and shortly thereafter a tile kiln and tannery. Fray Juan Martín, OFM, who mastered the Salinan language, initiated construction of a new church. Excavation of trenches or *trincheras* for a 12-foot-deep and 6-foot-wide shale and river-cobble church foundation footing began in 1814, and was completed in 1816. This herculean undertaking anticipated the construction of the existing adobe church, finished in 1818. The stockpiling of fired tile and sun-dried adobes after the 1806 fire facilitated the rapid construction of the church seen today. In the wake of the destructive earthquake of 1812, builders integrated earthquake-resistant construction techniques, including a seismic isolation system and elongated roof timbers (*vigas*) with wall ties (*clavijas*) needed to dampen seismic movement. Pine roofing timbers were harvested from the coast some 40 miles distant. Moreover, the austere and stark white lime or caliche-coated facade was designed to symbolically dis-

tinguish the sacred from the secular, the oasis from the desert of the human spirit. In 1821, Monterey merchant, diplomat, and artist Esteban Munras coordinated the embellishment of the painted nave and sanctuary, while the construction of the main altar *reredos* is attributed to Irish carpenter John Bones. The polychrome murals and altar screen are complimented by the All-Seeing Eye of God atop the reredos. As with San Juan Bautista, *portales*, or an arcade consisting of twelve arches in various shapes and sizes distinguishes the site, as does the use of American wallpaper designs for the painting of the sacristy by Salinan Indians. A particularly sophisticated solar geometry identified with the main altar spans the illumination of the statue (bulto) of San Francisco on his October 4 feast day through five-day intervals that illuminate in succession, the tabernacle, San Miguel, and San Antonio.

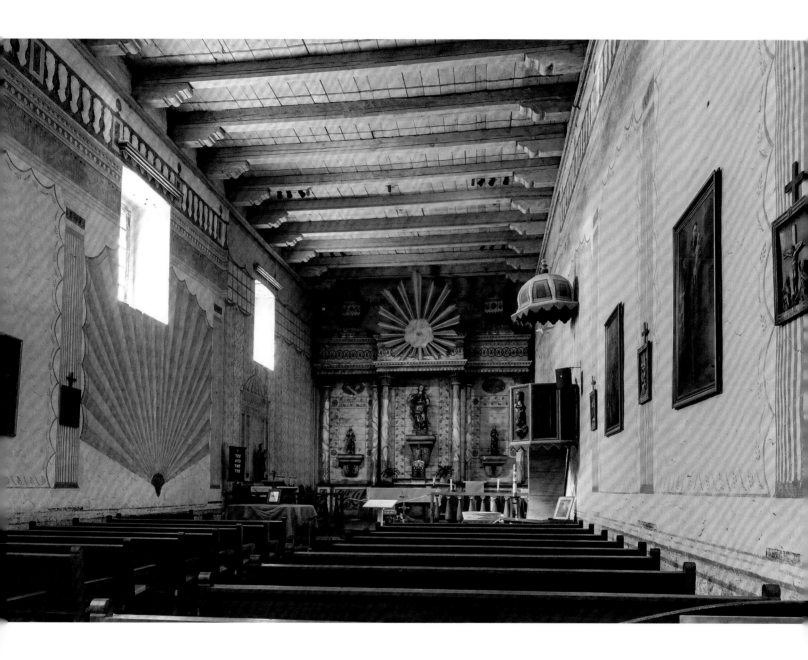

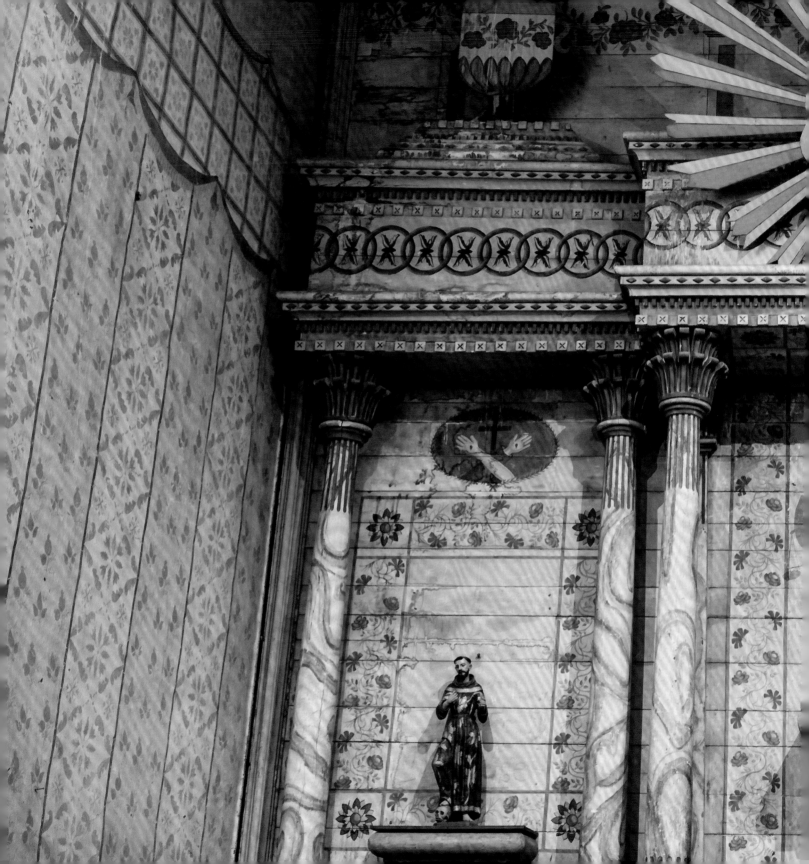

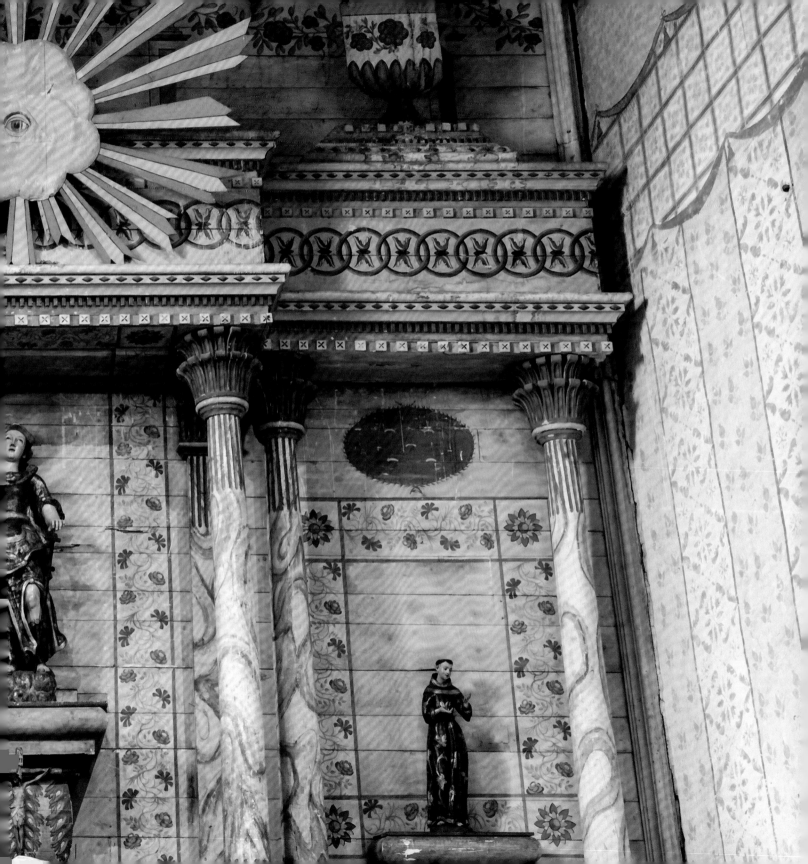

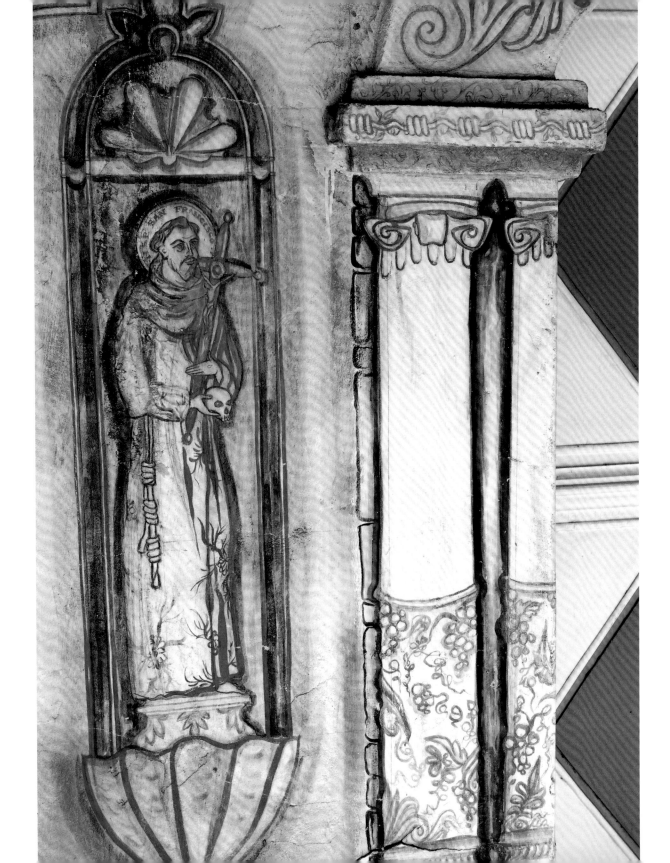

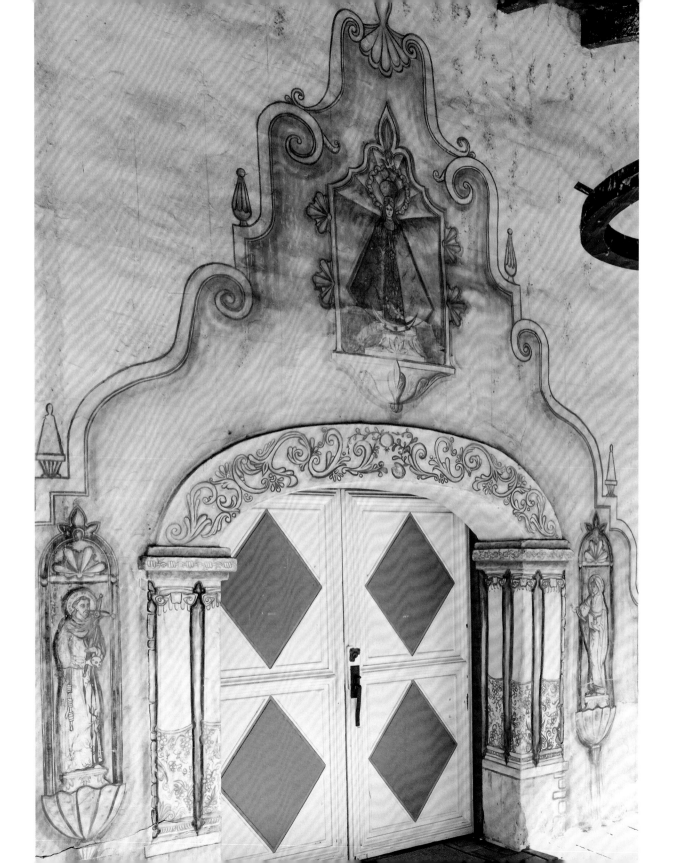

PREVIOUS PAGES
Today's ornate courtyard murals are the result of the handiwork of the novices of the Franciscan novitiate that maintained a presence here until relatively recently.

RIGHT AND BELOW
Cloistered or covered walk-ways provided shelter for transiting between the church and the dormitories of the convento quadrangle.

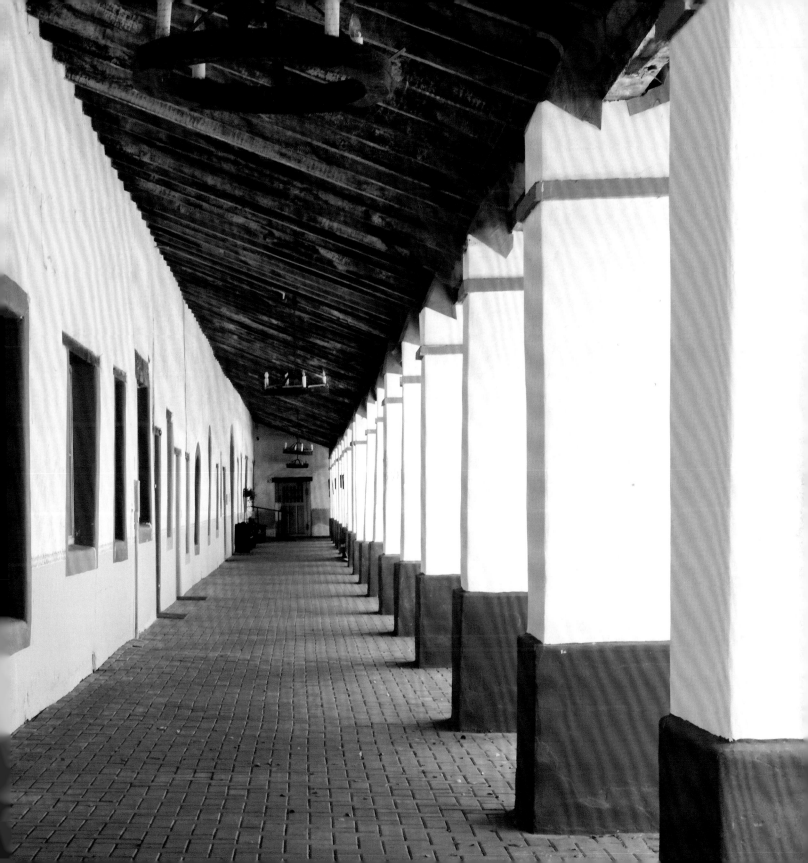

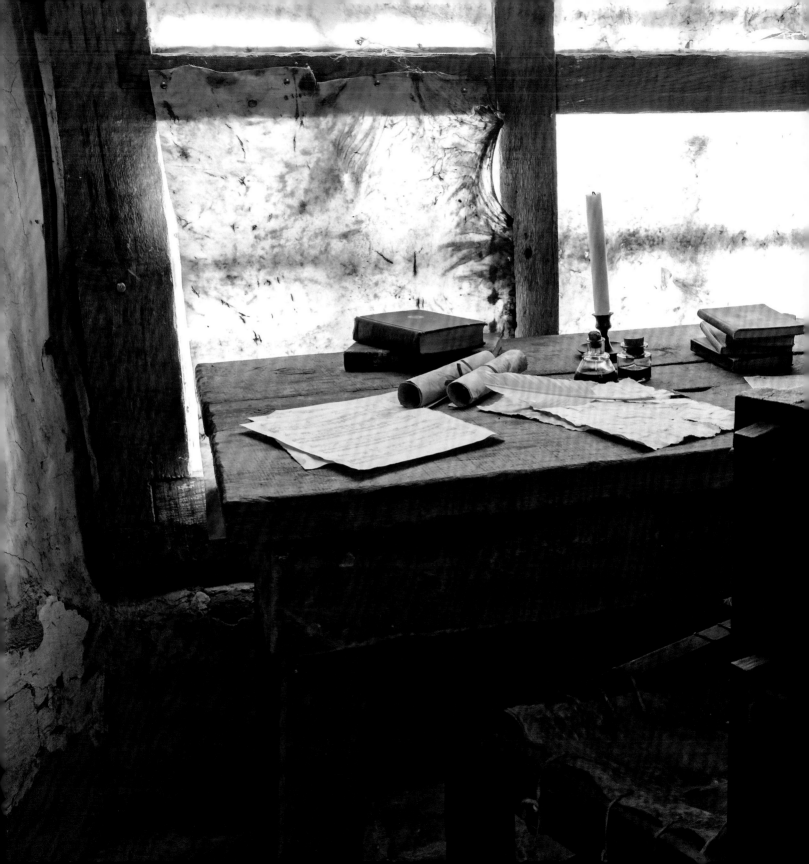

LEFT
*Processed rawhide was
sometimes used in lieu of
glass panes that were in
short supply in early
California.*

SAN FERNANDO REY DE ESPAÑA

Founded: September 8, 1797; Dedication: December 6, 1806
Founder: Fermín de Francisco Lasuén de Arasqueta, OFM

Once the second most agriculturally productive mission of Alta California, San Fernando Rey de España declined in the wake of the Secularization of 1834. In 1838, the population stood at 1,500, and the Fernandino (Chumash, Tongva, and Tataviam) neophyte community maintained 14,000 head of cattle, 5,000 horses, and 7,000 sheep. Moreover, they harvested 8,000 fanegas (12,640 bushels, or 445,600 liters) of grain annually, planted some 32,000 grapevines, 1,000 fruit trees, and produced 200 barrels of wine and brandy yearly. By 1842, the neophyte population plummeted to 400, and livestock numbers stood at 1,500 head of cattle, 400 horses, and 2,000 sheep. San Fernando's proximity to the thriving *paisano* or early *Californio* civilian population of Nuestra Señora de Los Ángeles del Río Porciúncula, or Los Angeles, posed a significant threat to the Mission and its landholdings. Despite the efforts of the padres, and those of Governor Don José Manuel Micheltorena, to defend San Fernando, the governor was ousted by Californio rancher and politician Don Pío de Jesús Pico and the paisanos of Los Angeles. They soon saw through the complete ruination of San Fernando. Contributing to the destruction and looting of the site was the first reported gold strike by the mission steward or *majordomo* and early Californio mining engineer Don Francisco Lopez at the mission rancho of San Francisquito in March of 1842. The placer deposits at San Francisquito spurred a Mexican era gold rush that anticipated Sutter's Mill by seven years, and prompted gold seekers to plunder mission lands believing that the friars had buried gold therein.

The "Mission of the Valley" was founded by Father President Fermín de Francisco Lasuén de Arasqueta, OFM, at the Tataviam or Tongva village of Achooykomenga/Pasheeknga on September 8, 1797. Lands of the seventeenth mission founding were originally apportioned to Mission San Gabriel Arcángel. Unlike other sites, this founding was fraught with conflict from the outset, as the land was also identified with the Spanish grazing concession of Rancho Los Encinos held by Don Francisco Reyes, the *alcalde* (mayor) of the Pueblo de Los Ángeles. Lasuén appointed Friars Francisco Dumetz and Juan Lope Cortés, OFM as the founding fathers at San Fernando. Dumetz oversaw the construction of the first buildings, Christian Indian village, as well as the first and second churches and quadrangle. Dumetz remained through 1804, and supervised initial construction on the third and final church which was completed, and dedicated on December 6, 1806.

Initial buildings, including the first church, were completed within two months of the founding. Dumetz and Cortés were afforded housing in the Reyes ranch house during construction. In 1799, a second larger adobe church was erected in order to accommodate the growing neophyte population, and by 1802, several granaries, weaving rooms, store rooms, padres' quarters, a *monjerío* (dormitory for single girls), guard barracks, and a carpentry shop were added. Within seven years, the neophyte population exceeded 1,000. As such, the friars prioritized the construction of seventy neophyte family housing units, as well as the

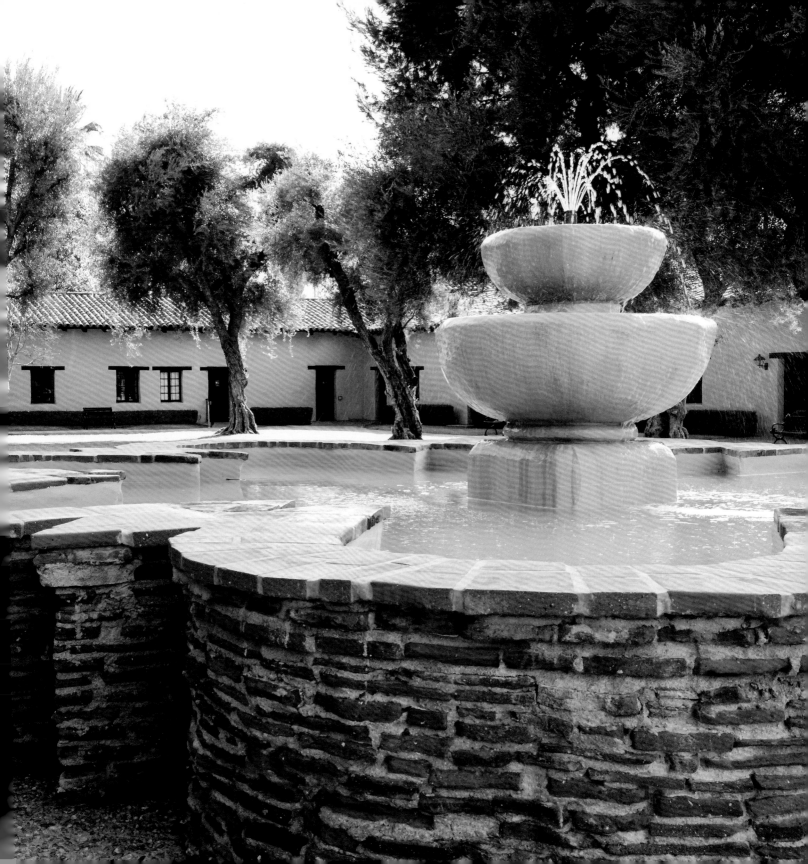

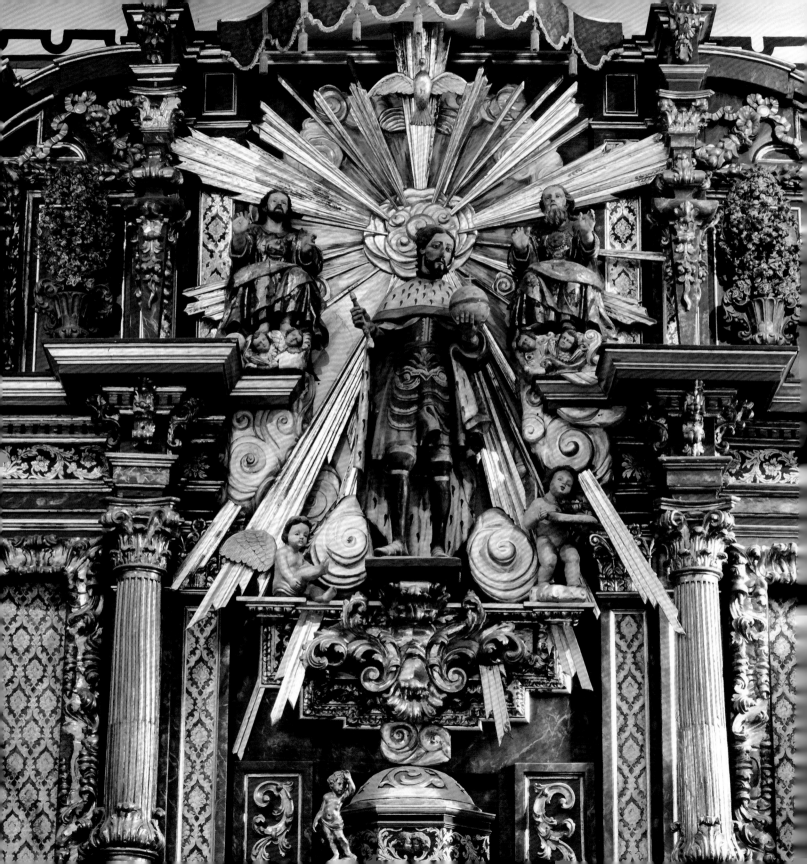

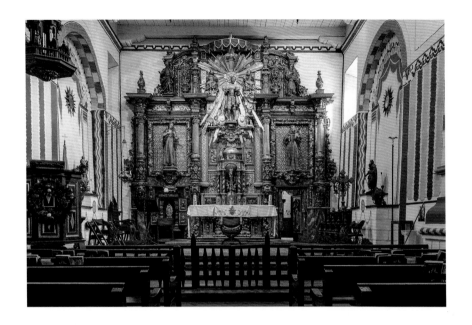

OPPOSITE
The main altar screen was once part of the much larger seventeenth-century Ezcaray Altar of the chapel of the Congregation of Saint Philip Neri, Ezcaray, Spain. In 1925 the altar was dismantled, sent to Los Angeles for use in the planned cathedral of that time, and finally sent to San Fernando for exhibition. In 1991, the altar was installed in the church by Diocesan curator and master craftsman Sir Richard Joseph Menn of Carmel.

LEFT
The hall or linear, as opposed to cruciform, floor plan of the main church was the standard in Alta California for much of the Mission era.

present church, a granary, and other rooms at one of three mission ranches, Rancho San Francisco Xavier. With the completion of the church in 1806, both a granary and a tack room were added. Construction between 1806 and 1812 encompassed the completion of a masonry dam in 1808, a new *convento* dwelling for the missionaries in 1810, a fountain and aqueduct in 1811, and an arcade corridor in 1812. The completed quadrangle enclosure then measured some 295 feet by 315 feet. On December 21, 1812, the Wrightwood earthquake so damaged the church that the friars retrofitted the building with 30 new roof beams (*vigas*) and a baked-brick buttress (*contrafuerte*). The year 1813 was dominated by efforts to rebuild, and the neophytes were relocated to a new *rancheria* or village site. A fountain was installed and a dwelling for the majordomo was erected in 1813, and a soap works and an additional 40 neophyte family houses were constructed in 1818. A hospital was added in 1821, and continued growth presaged the renovation of the *convento* of 1810. As such, between 1819 and 1822 the so-called Long Building was retrofitted with a second floor, and a new tiled roof. Said modifications, and the monumental proportions of the 243-foot-long-by-50-foot-wide adobe *convento* (replete with an expansive arcade consisting of 19 arches), produced the largest such adobe building in Alta California. With an upper floor, wine cellars, spacious offices and reception areas (*salas*), elaborately painted decor, and tiled roofs and floors, the Long Building was co-opted for use by both the Mexican and American military, politicians, and ranchers, and ultimately, ended its days as a hog farm.

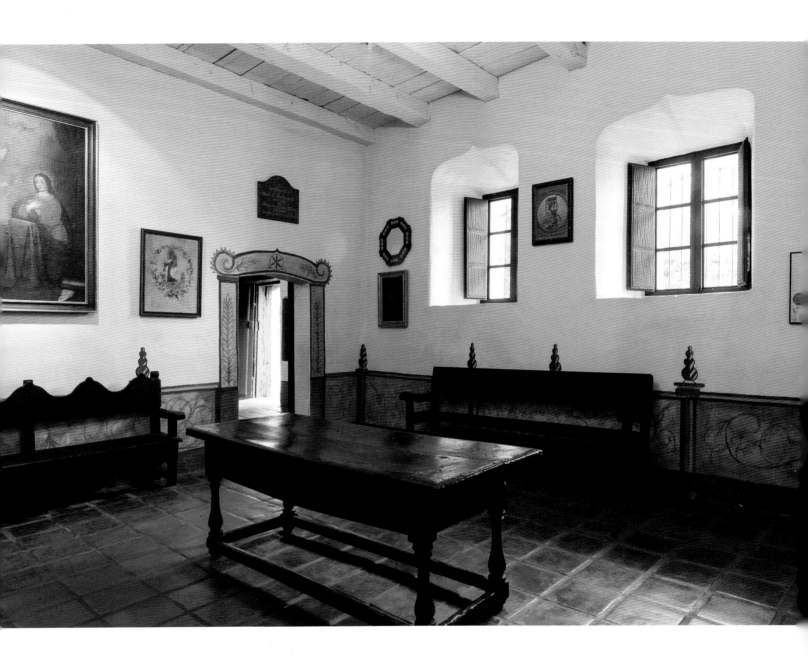

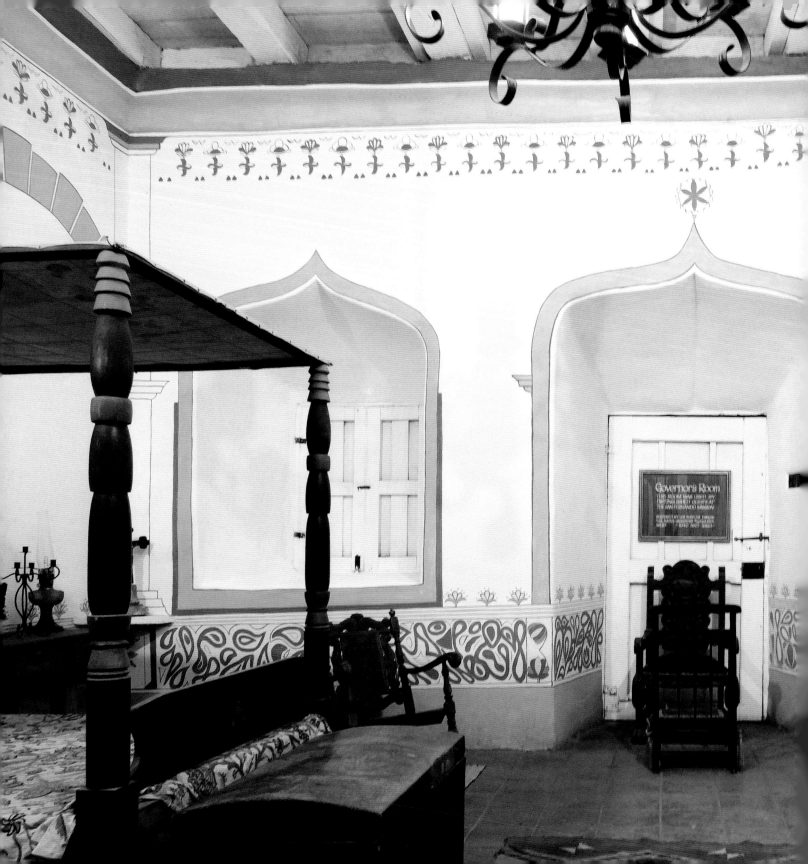

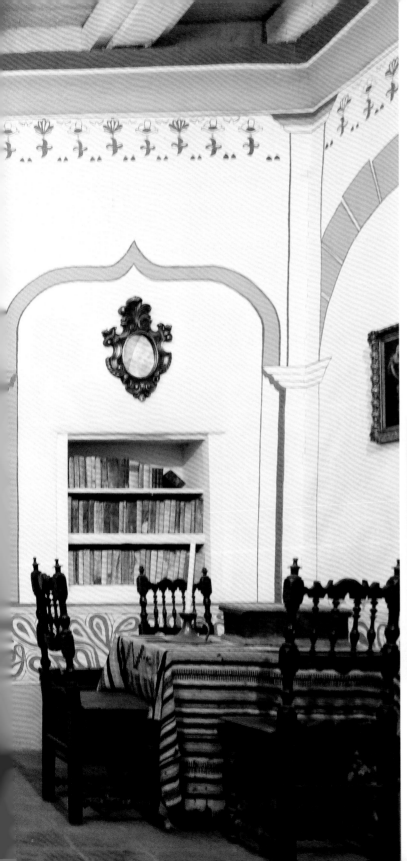

PREVIOUS PAGES
*One of the finest extant
adobe buildings at San Fer-
nando is that of the so-called
Long Building or* convento,
*which features a monumen-
tal arcade consisting of 21
brick arches, interior stair-
cases, tiled roofs and floors,
and a spacious wine cellar.*

OPPOSITE AND BELOW
Today, the convento *serves
as the mission museum, and
is replete with period
furnishings and artifacts.*

215

SAN LUIS REY DE FRANCIA

Founded: June 13, 1798; Dedication: October 4, 1815
Founder: Fermín de Francisco Lasuén de Arasqueta, OFM

OPPOSITE
A beautifully proportioned three-tiered and domed campanario *or bell tower stands just east of the main* portada *or entryway of the church. In one early nineteenth-century illustration, the artist depicted a second* campanario *to the west.*

FOLLOWING PAGES
The arched passageways between courtyards within the quadrangle were formed from fired brick and white lime-coated adobe walls.

In the early morning hours of January 17, 1832, the founding missionary of San Luis Rey de Francia, Fray Antonio Peyrí, OFM, secretly boarded the *Pocahontas* to sail for Mazatlán, México. Young Luiseño neophytes Pablo Tac and Agapito Amamix accompanied the friar and sought vocations in the priesthood at the Colegio de Propaganda Fide de San Fernando, México. Though Pablo and Agapito proceeded to Rome where they later succumbed to illness, Tac left behind a compelling firsthand account of the Luiseño people of San Luis Rey. Peyrí, whose tenure at the mission began years before with Fray Fermín de Francisco Lasuén de Arasqueta, OFM's dedication of June 13, 1798, ended in the wake of the Mexican expulsion of the Spaniards in 1827. Having devoted himself to building one of the largest and most prosperous Mission Indian communities of the Californias, Peyrí's clandestine departure anticipated the Mexican Secularization Decree of 1834. Although Peyrí tentatively embraced Mexican Independence from Spain after 1824, increased Mexican bureaucratic intervention in Mission affairs prompted him to abandon the Luiseño Indian community. As the Pocahontas departed, some 500 Luiseño men, women, and children waded into the waters hoping to dissuade Peyrí from abandoning the community. A decade later San Luis Rey was stripped of its assets, and its 2800 neophytes dispersed and dispossessed of lands and cattle. Within 30 years, the mission was in ruins.

As the eighteenth mission of Alta California, San Luis Rey was dedicated exactly one year after Lasuén's founding at San José. Identified after its royal namesake as the "King of the Missions," San Luis Rey was founded in the Quechia region of the Takic speaking Ataaxum (people), Payomkowishum (Westerners), or Luiseños of the village of Tacayme. Lasuén named Friars Peyrí and José Faura, OFM, as the founding missionaries, and though Faura only served until May 1800, Peyrí remained to administer the mission for 34 years. The continuity in leadership afforded San Luis Rey a modicum of stability unknown at other missions. Unlike the northern missions, San Luis Rey benefitted from its proximity to the Presidio Reál de San Diego, and the ready availability of resources and supplies. Initial buildings consisted of flat beamed earthen or tiled roofs (*terrado*) or thatched adobe structures, and included a church, missionaries' quarters, soldiers' barracks and storage areas. Construction was initially undertaken by presidio soldiers, craftsmen, and women. By 1802, most of the adobe buildings were tiled, and many new structures were erected, including a new granary, and additions to the first adobe church. Shortly thereafter, four additional granaries, two tanning vats, and a soap works were constructed, thereby enclosing the earliest quadrangle. By 1806, a sizeable *monjerio* or women's dormitory with enclosed patio was erected to form a second quadrangle.

In 1811, the field stone foundations of the present church were laid, and by the end of 1812, the walls rose to the height of the cornice. The main *convento* was expanded with the addition of a new room block in 1813. Construction continued such that the exemplary skills of church architect and master craftsman

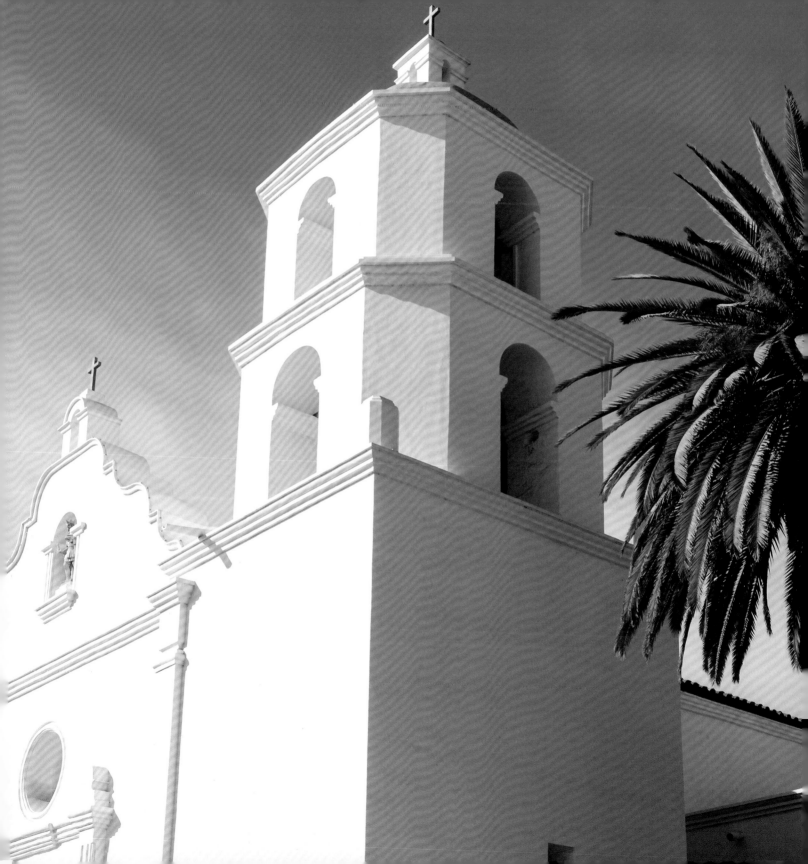

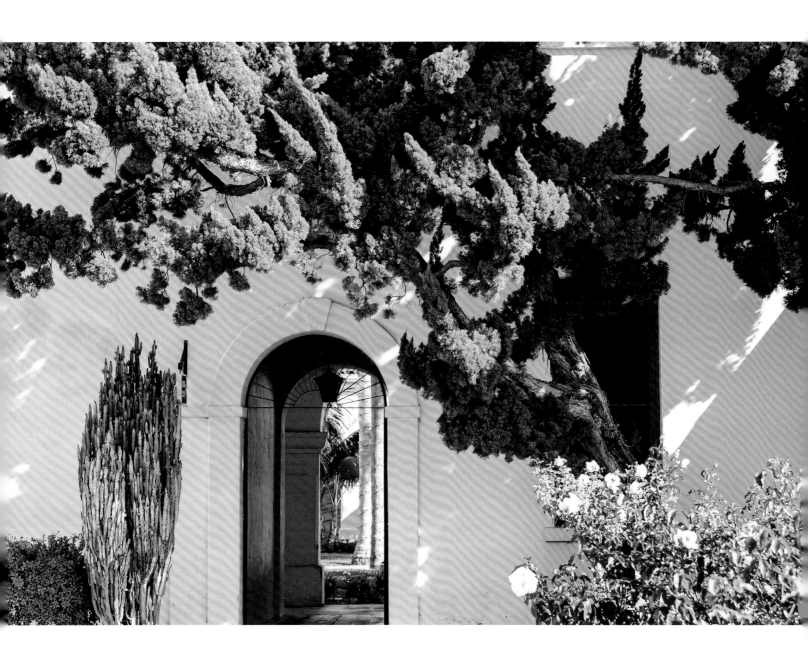

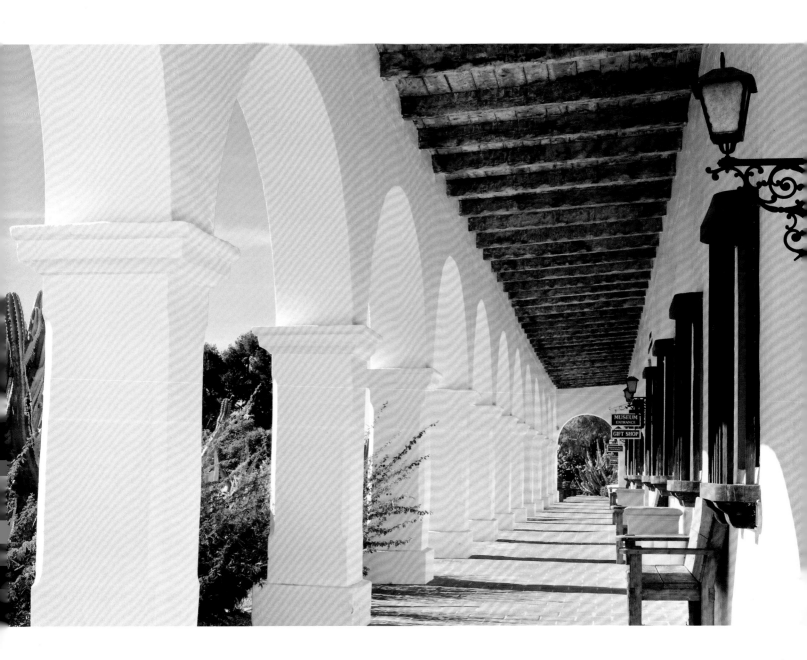

OPPOSITE
As with a host of other mission churches in Alta California, the adobe walls were reinforced with brick pilasters and moldings, and the adobe tower was wholly encased in a brick veneer.

FOLLOWING PAGES, LEFT
The Peyrí Court is situated between the convento courtyard and church, and features a fountain and a contemplative atmosphere for visitors. The staircase in the background features ladrillos *or floor tiles and bricks of the type used throughout the complex for the construction of archways, pavements, pilasters, and ornamental moldings.*

FOLLOWING PAGES, RIGHT
Holy water for personal devotion was dispensed via a host of pilas *or Holy Water stoups located at the main entryways of the church.*

José Antonio Ramírez of Jalisco, Mexico manifested in the fine lines and geometry of the sanctuary with its massive domed crossing and cruciform layout. Moreover, the church is distinctive given its monumental proportions, 5-foot-thick and 30-foot-tall adobe walls with baked-brick exterior surfaces or veneers, as well as for its mix of baroque and neoclassical elements, including the *espadaña* or bell gable-like *portada* of the main façade, and eastern *campanario* or bell tower. By 1829, an elaborate wooden dome was installed over the crossing, surmounted by an octogonal wooden lantern of eight columns and 144 glass panes. The transept was complemented by two ornately molded and painted neoclassically inspired side altars replete with Roman columns and niches for saints. As with the main altar, each of the side altars is spanned by *toral* masonry vaults, interior paintings, and features marbleized columns, pilasters, friezes, and cornices added prior to 1830. The adjoining complex includes a tiled arcade corridor with 32 baked brick arches, while the grounds featured a *cuartel* or soldiers' quarters, an extensive system of *zanjas* or canals, an open air *lavanderia* or communal wash basin replete with sculpted zoomorphic waterspouts, a charcoal water filtration system, lime kilns, and a sunken courtyard and garden. Such was the prosperity of San Luis Rey that several *asistencias* and *ranchos* were established to manage the 27,500 head of cattle, 26,100 sheep, 1,300 goats, 1,950 horses, and an annual average of 39 tons of wheat, and 2,500 barrels of wine.

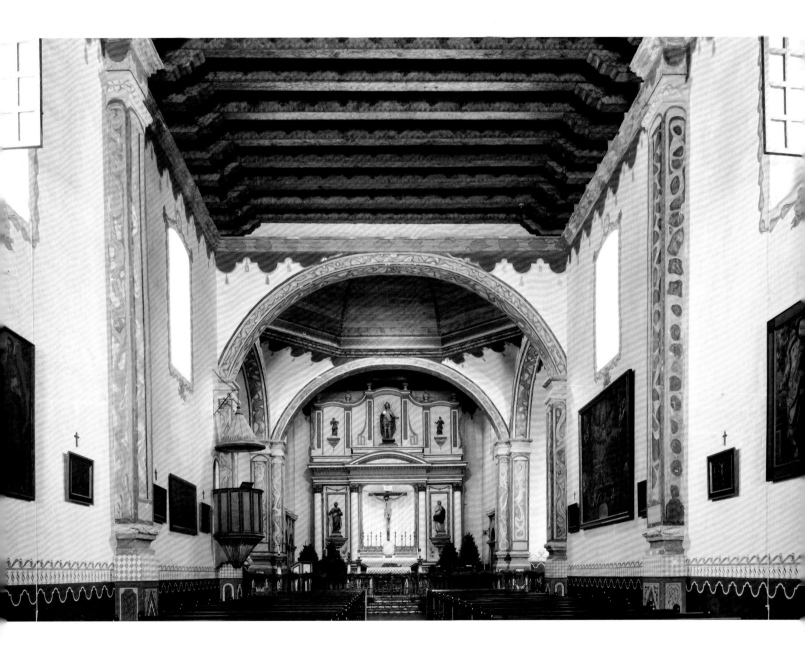

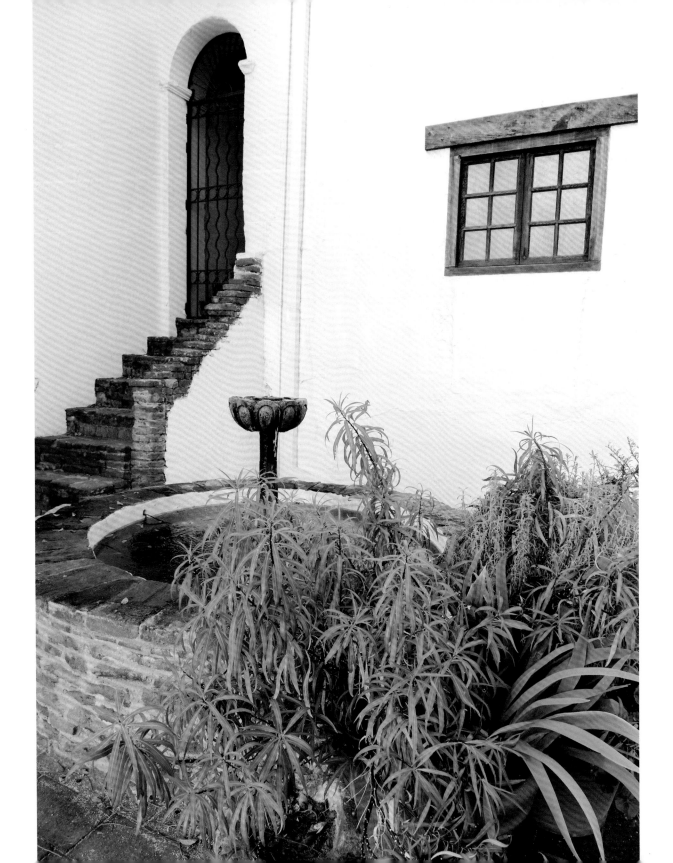

223

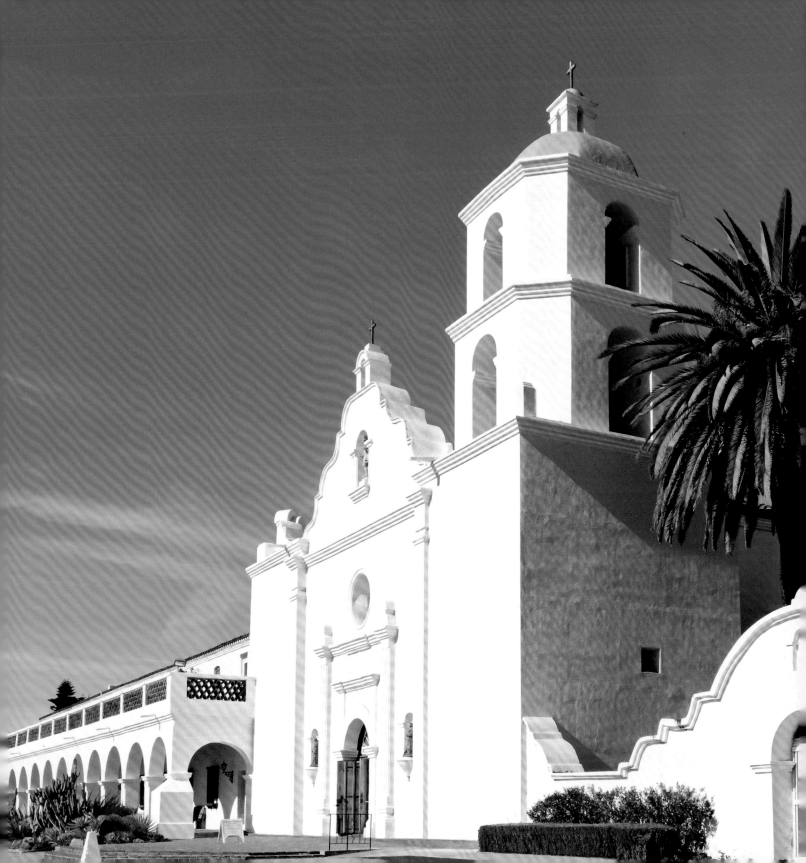

Dedicated on 4 October of 1815, and designed by master carpenter and stone-cutter José Antonio Ramírez of Jalisco, Mexico, the church of San Luis Rey stands as the only remaining cruciform sanctuary of the Mission era in Alta California.

PART 8: THE END

OF AN ERA

SANTA INÉS VIRGEN Y MÁRTIR

Founded: September 17, 1804; Dedication: July 4, 1817
Founder: Fr. Estevan Tapis, OFM

Santa Inés Virgen y Mártir was the nineteenth of 21 Spanish missions established in Alta California. Founded September 17, 1804 by Fray Estevan Tapis, OFM, the 3rd Father President of the California missions, Santa Inés evolved despite challenging times. Spain's Peninsular War with France (1807–14) set the stage for the decade-long War of Mexican Independence launched in 1810, Napoleon's intervention in Spain, and the installation of a French monarch on the Spanish throne, threatened New Spain and the missions of Alta California. As a result, funding by the Fondo Piadoso de las Californias (Pious Fund of the Californias) was curtailed by the shifting political currents. Santa Inés nevertheless weathered the changing fortunes in the land of the Chumash, in its capacity as the Misión de Alajulapu of the Santa Ynez valley.

Scouted by Captain Don Felipe Antonio de Goicoechea of the Presidio de Santa Barbara, and Tapis, in 1798, the site was selected as a buffer between the warring Tulare Indians and the Chumash. Intended for the conversion of the Eastern Coastal Chumash, neophytes from missions La Purisima Concepción and Santa Barbara were relocated to form the new Inézeño community. With Friars José Antonio Calzada, OFM, and Romualdo Gutiérrez, OFM, the mission community coalesced around an adobe range building that underwent initial construction six months prior to the mission's founding. Measuring 232 feet in length by 19 feet wide, the flat adobe-covered (*terrado*) single room-block structure incorporated an 86-foot-long provisional church, 14-foot-long sacristy, 29-foot-long missionaries' quarters, and a 103-foot-long granary. The walls measured the customary one *vara*, or 33-inch standard of the day. In 1805, a 145-foot-long-by-19-foot-wide and 19-foot-tall adobe room block was added to the complex, and its roof, was clad in *teja* roof files. By 1806, Calzada and Fray Luis Gil, OFM, supervised the construction of the third major row of tile-roofed adobe buildings to form the quadrangle, with the latter measuring 368 feet in length. In addition, a 75-foot-long-by-19-foot-wide tile-covered fired brick arcade (*galería*) was built to shield that portion of the convento fronting the forecourt. In the period spanning 1807 to 1812, a host of adobe structures were erected, including habitations for the padres and the soldiers, a guardhouse (*cuartel*), storehouse (*almacén*), Indian foreman's residence (*mayordomo*), and eighty dwellings for the neophytes. Asphaltum, and much later, asphalt, were used for the finishing of floors in the complex. Significantly, missions Santa Inés and La Purísima Concepción reported the completion of two 17.55 mile roads for travel and mail delivery between the missions.

On December 31, 1812, two sizeable earthquakes severely damaged the church, major portions of the quadrangle, and neophyte housing. By the end of 1813, reconstruction of a portion of the two-story convento fronting the forecourt resulted in the closure of both doors and windows in the upper floor, and the installation of a gabled roof. A tiled provisional church and sacristy with 4-foot-thick walls and stone buttresses were also constructed. In 1814, Friars Francisco

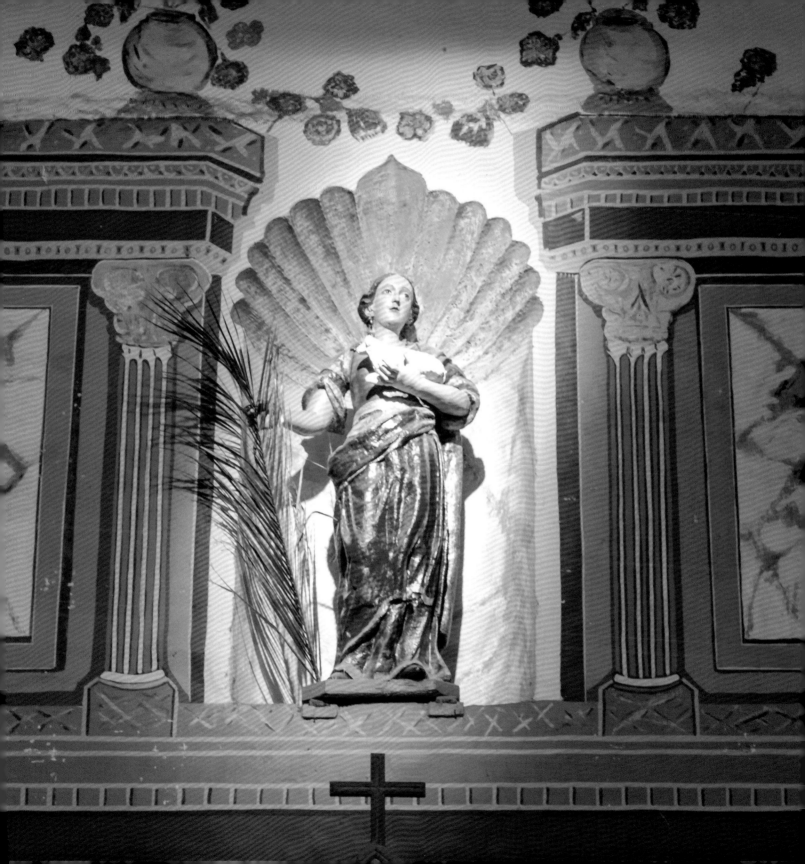

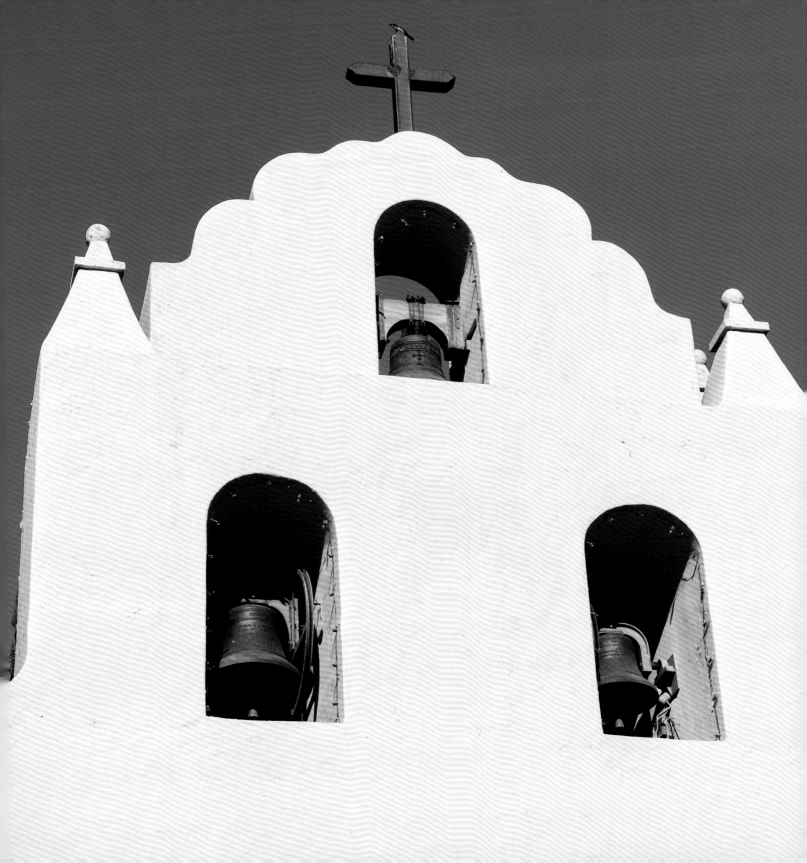

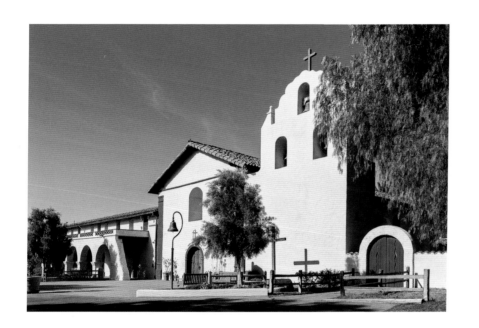

OPPOSITE
The belfry at Santa Inés was inspired by that of San Gabriel, which was in turn inspired by that of the 1781 church of the Santuario de Nuestra Señora de Guadalupe in Guadalajara, Mexico.

LEFT
Dedicated on July 4, 1817, the third church was inspired by that of San Gabriel Arcángel, while the convento *and arcade were largely completed between 1808 and 1812.*

Xavier de la Concepción Uría and Román Francisco Fernández de Ulibarri, OFM, oversaw the construction of the third church. By December 1816, construction was completed and Chumash builders plastered and decorated the interior of the new grand edifice. In that same year, the *campanario* or belfry was completed, and its design and that of the church was inspired by Fray Uría's prior assignment at Mission San Gabriel Arcángel. The interior of the 139-foot-long and 26-foot-wide gabled church reportedly resembled that of Santa Barbara. The new church was blessed on the July 4, 1817, Feast of the Anniversary of the Dedication of All the Churches of the Order of Friars Minor, and the provisional church was retasked as a commissariat for the Chumash community. One of the most distinctive features of the so-called Mission of the Passes includes an extensive waterworks system, consisting of an 1820 gristmill, an 1821 fulling mill, brick-lined reservoirs, neophyte bathing areas, and an aqueduct (*zanja*) extending from Cota Creek to the mission.

RIGHT AND BELOW
Despite the hardships occasioned upon the mission in the period after 1810, the church was well appointed with period artworks. The eighteenth century "Madonna of the Rosary" (below) was crafted with both estofado *(gold leaf) robes and* encarnacion *(incarnation) flesh tone painting.*

FOLLOWING PAGES
The original geometric and floral designs of the church nave were created by Chumash artisans, although the interiors have been recurrently whitewashed and repainted since the original dedication.

PAGES 236–237
The north wall of the church fronts the mission cemetery, and the massive pilasters were added to hedge against earthquakes.

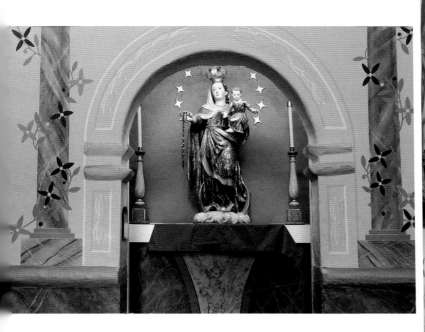

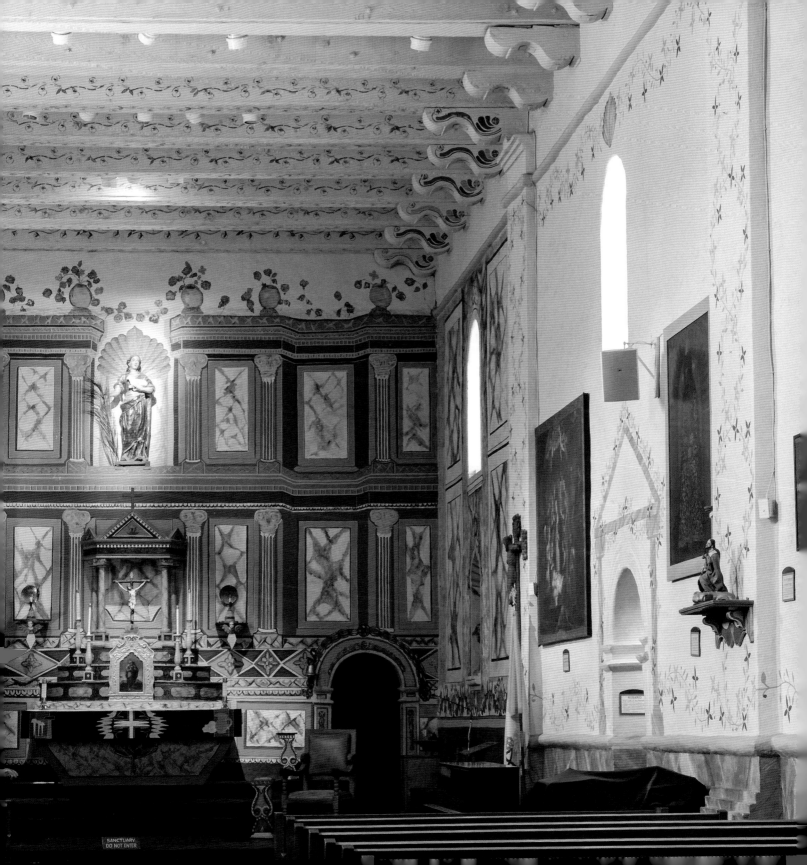

SANCTUARY.
DO NOT ENTER

SAN RAFAEL ARCÁNGEL

Founded: December 14, 1817; Dedication: April 18, 1824
Founder: Fr. Vicente Francisco de Sarría, OFM

On the eve of the founding of Mission San Francisco de Asís in 1776, inter-tribal warfare and raiding decimated the indigenous communities of the peninsula. Subsequently, Spanish soldiers and naval personnel were recruited to build the presidio stockade and the earliest mission buildings. Though largely devoid of indigenous settlement, the founding at Chutchui, and the growing neophyte community attracted other East Bay Ohlone or Chochenyo, and Bay and Coast Miwok, and Patwin converts. By 1817, respiratory illnesses identified with long-term exposure to the cold and fog-shrouded climate of the peninsula took their toll on the neophyte population. Exacerbated by water-borne enteric diseases such as dysentery coupled with growing infant mortality, the friars appealed for the founding of a sanitarium, or hospital sub-mission (*asistencia*), across the bay at the Coast Miwok village of Nana-guani. Fray José Ramón Abella, OFM, prompted the founding of a hospital for ailing neophytes in a letter to Spanish governor Don Pablo Vicente de Solá. Abella attributed the illness to young mothers inexperienced with child care on the peninsula and inadequate coping mechanisms in the face of culture change, which rendered the neophytes susceptible to European disease. After surveilling the surrounding countryside, the warmer inland clime would soon prove conducive to the convalescence of those neophytes relocated to the new site.

Founded as a medical sub-mission (*asistencia*) to San Francisco de Asís on December 14, 1817, by Commissary Prefect Fray Vicente Francisco de Sarría, OFM, the site was dedicated to Saint Raphael, the Healer of God. The learned Fray Luís Gil y Taboada, OFM, volunteered to serve the ailing neophytes, and was promptly appointed to the new asistencia. On December 13, 1817, friars Sarría, Gil y Taboada, Narciso Durán, and Ramón Abella departed the presidio by boat for the far shore in order to plant and bless the cross for the dedication the next day. The friars convened the dedication in the presence of two-hundred prospective neophytes and baptized twenty-six children. With an aptitude for medicine, indigenous linguistics, and a "dexterity" for Caesarian operations, Gil y Taboada was the ideal steward for San Rafael. The new asistencia was promptly transformed into a place of refuge featuring an adobe hospital ward as opposed to a standard mission quadrangle.

As the fifth of six *asistencias*, the site's prosperity and the growing number of converts led Sarría to elevate San Rafael to full mission status on October 19, 1822. By that time, much of the initial adobe complex had been expanded to address the growth of the sub-mission. The earliest adobe building consisted of an 87-foot-by-42-foot thatch- or tule-covered room block housing a chapel, padre's quarters, dispensary, dormitory for girls and single women, and visitor housing. By 1819, the main room block doubled in size with the addition of 55 linear feet of space. A thatched kitchen, additional dormitory for single women, weavery, housing for the site steward (*majordomo*), and carpentry and tack rooms were soon added. Ironically, in 1819 Gil y Taboada grew ill and was replaced by Fray Juan

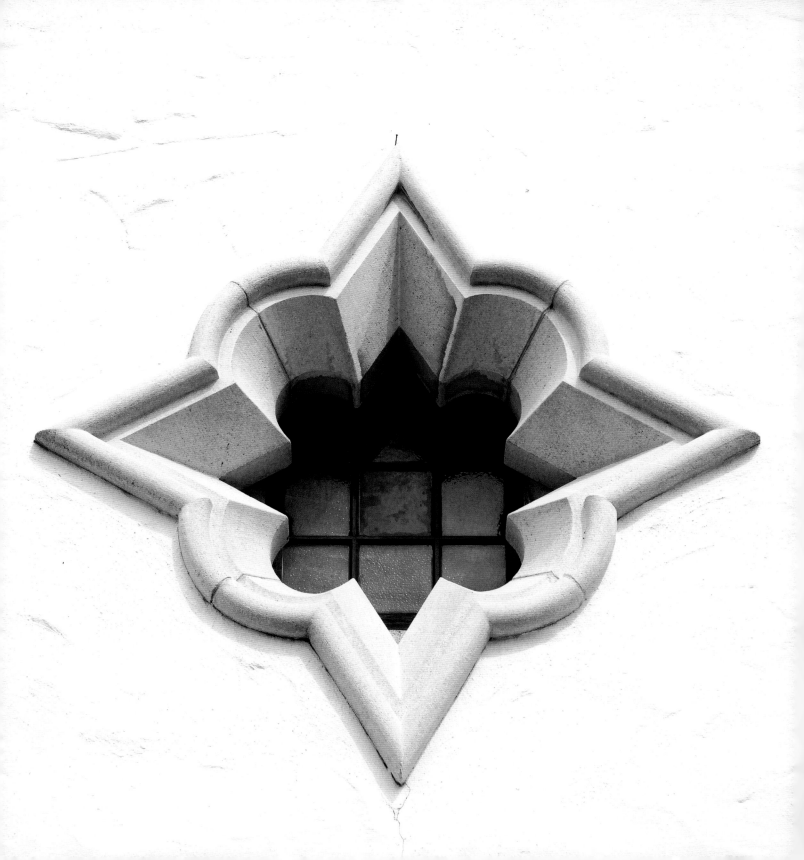

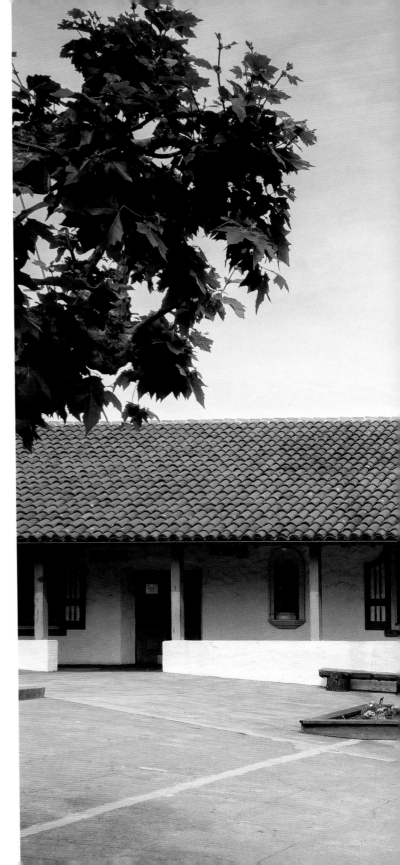

Dedicated on April 18, 1824, the original church was oriented to the southeast, as opposed to the west, as is the case with the extant church building replica constructed in 1949.

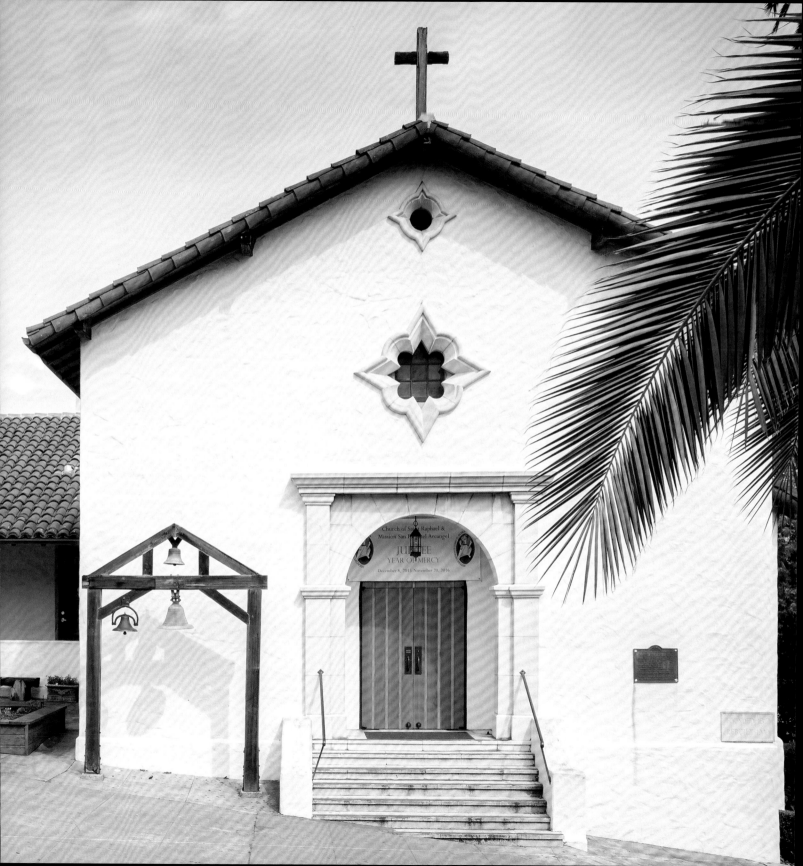

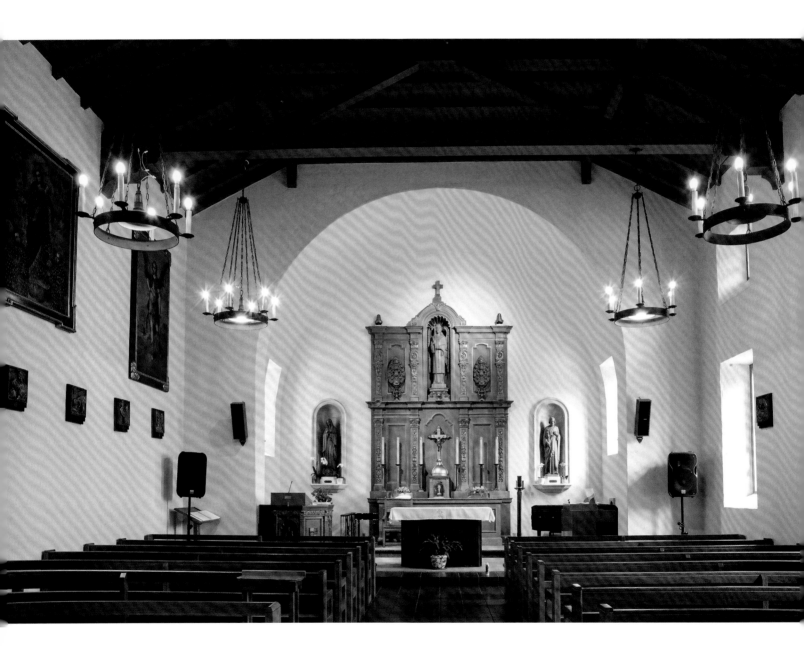

242 San Rafael Arcángel

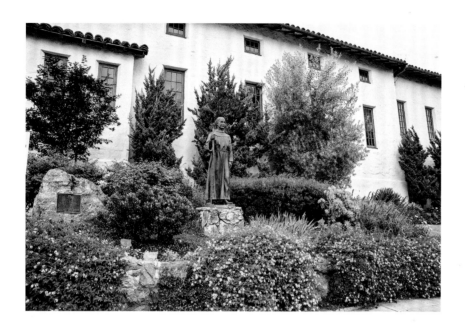

OPPOSITE
While the sanctuary arch or toral, *the timber roofing, and overall footprint of the church approximate the interior of the original church, little contemporary documentation exists to validate the current reconstruction.*

LEFT
Fronting 5ᵗʰ Avenue in the modern community of San Rafael, the statue of Fray Junípero Serra, OFM, was donated by the William H. Hannon Foundation, and represents the artistic contribution of noted sculptor Dale Smith.

Amorós, OFM, who was well liked by the Coast Miwok and Hispanic settlers. Amorós initiated the planting of vineyards, orchards that produced pears noted for their excellence, and a boat building enterprise.

The following year, tile roofs (*tejas*) were installed on all existing buildings including the chapel, and the granary (*troj*) was enlarged under Amorós in 1821. Between 1822 and 1824, the new church, replete with a Mudéjar star window, a *cuartel* or soldiers' quarters, a dormitory for neophyte recruits, and additional neophyte housing were built. The church was whitewashed in 1823 and dedicated on April 18, 1824. By 1828, the annual census reported a neophyte population of 1,140, and one of the most bountiful agricultural harvests of northern Alta California. San Rafael ultimately declined in the Mexican era, and by 1841, the church was largely ruined. The mission buildings were subsequently razed in 1870, and replaced with a parish church in 1919. The extant church constitutes a partial replica of the original chapel and down-sized room block, albeit, one reoriented to the west, as opposed to the southeast.

SAN FRANCISCO SOLANO

Founded: July 4, 1823; Dedication: April 4, 1824 / 1841
Founder: Fr. José Altamira, OFM

As the last of the missions founded in Alta California, San Francisco Solano was borne of the impulsive actions of a Mexican-era friar, and mounting fears of a Tsarist Russian advance. Russian officer Count Nikolai Rezanov set out for the Puerto de San Francisco in 1806 to meet with Lieutenant Commander Don José Darío Argüello of the Presidio de San Francisco. Rezanov sought provisions and the opening of trade relations with Spain. Soon thereafter, Ivan Kuskov was dispatched to scout sites north of San Francisco, and soon identified an agriculturally viable region on the Bodega Bay in 1812. Fort Rossiya or Ross was ultimately settled by Russian merchants, Alaskan native Aleut and Alutiiq trappers, and the indigenous Kahaya. The presence of the marginally successful Russian stockade just north of San Francisco prompted the Mexican authorities of 1824 to permit Friar José Altamira, OFM, to found a new mission.

Assigned to San Francisco de Asís between October 3, 1820, and July 25, 1823, Altamira soon pursued the idea of a mission founding in a more temperate climate. The cold, fog, and otherwise unhealthy conditions at San Francisco prompted the establishment of a sub-mission or medical asistencia at San Rafael Arcángel in 1817. Altamira presented his plan to relocate San Francisco de Asís to the region north of San Rafael to Acting Governor and Commandant Don Luis Antonio Argüello for formal consideration by the Mexican Territorial Assembly in 1823. The Assembly approved the proposal, but with the caveat that San Rafael would also be relocated to Nuevo San Francisco, or San Francisco Solano. Without formal approval from Father President Fray José Señán, OFM, on June 25, 1823, Altamira and a military escort set out to found the new mission. On July 4, 1823, Altamira raised the cross and convened mass, thereby founding Nuevo San Francisco de Asís. He returned to the site with soldiers and neophyte laborers to commence construction on August 25, 1823. Initial efforts entailed the construction of provisional buildings, a granary, canal (*zanja*), and corrals.

As Altamira acted without formal permission, the Father President contacted Vice-Prefect Fray Sarría, OFM, who intervened and negotiated a compromise that reached Altamira on August 31. The compromise required that missions San Francisco and San Rafael remain intact, although neophytes indigenous to the Sonoma area were welcome to return to the area. Altamira consequently chose to relocate to a site approximately 4 miles north of the original location. By December 1823, the majority of neophytes who relocated to Solano originated at San Francisco, San José, and San Rafael. By April 4, 1824, the new whitewashed mission church, measuring 105 feet by 24 feet and constructed entirely of hewn boards (*tablas*), was dedicated. Other buildings erected by that time included a wood-plank granary (*troj*), Padre's quarters (*convento*), and cuartel or guardhouse. The annual report of December 1824 documented the construction of a large tile-roofed adobe house replete with colonnaded gallery (*galería*) that today constitutes a defining feature of the remaining buildings. Ironically, the church bells of that time were gifted by the Russian's at Bodega Bay.

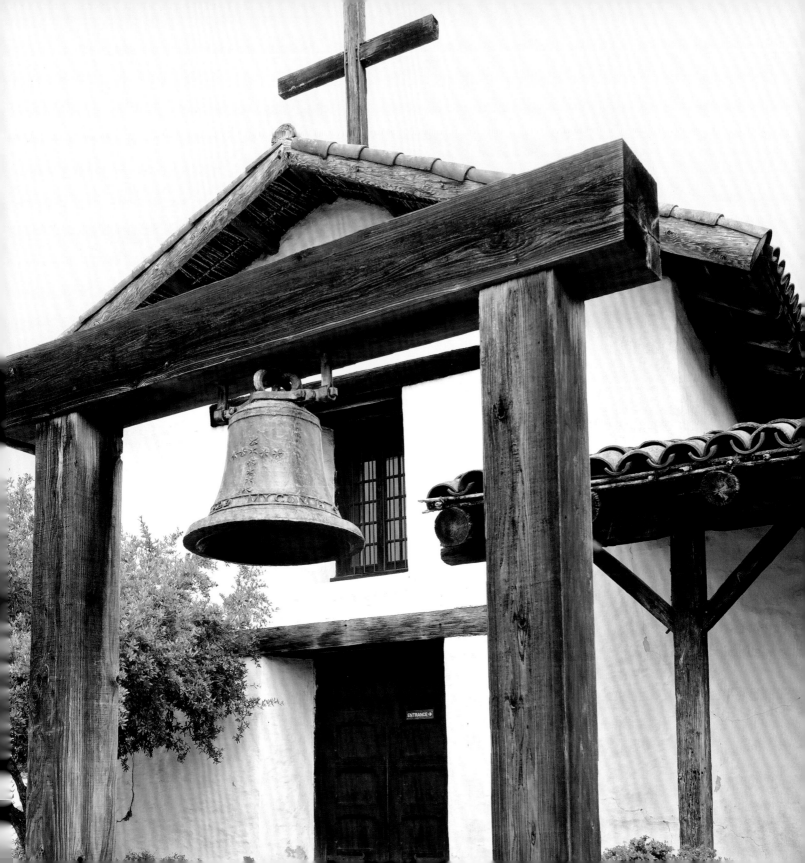

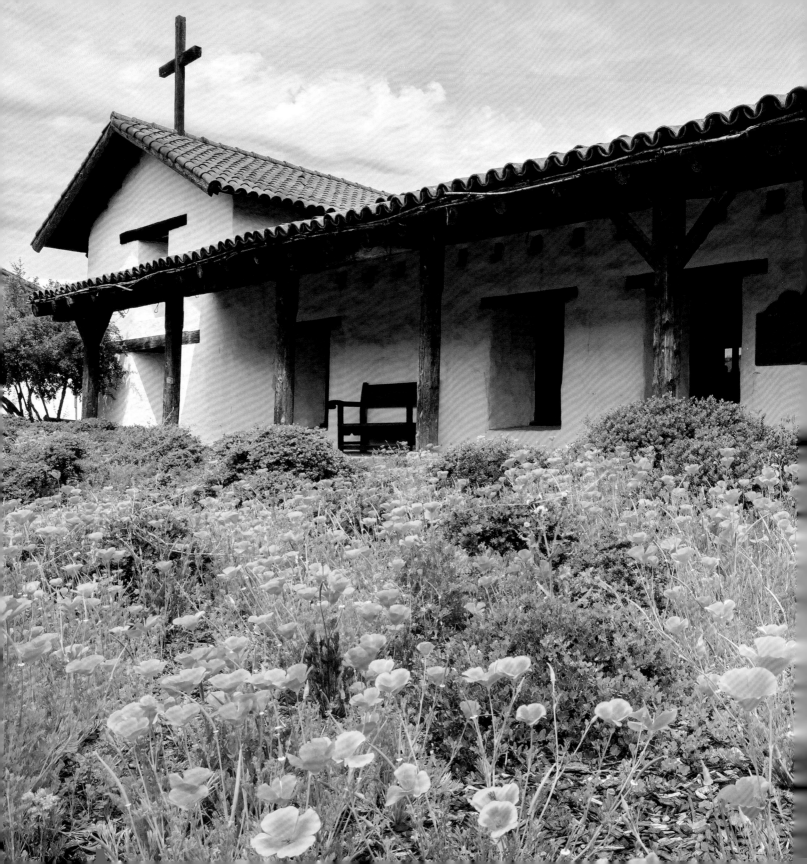

Given over to brash and untoward treatment of the neophytes, Altimira provoked an indigenous uprising that ousted him and resulted in the partial destruction of the mission in 1826. Consequently, Altimira was prohibited from missionary work in California, and was replaced by Fray Buenaventura Fortuny, OFM. During Fortuny's seven-year tenure ending in 1833, the majority of the provisional, fire-damaged, and wood-plank buildings were replaced with adobe structures, the convento was enlarged, the quadrangle was enclosed, and a large adobe church was erected at the east end of the complex. In sum, Fortuny oversaw the construction of thirty adobe buildings and the growing prosperity of the neophyte community. In that same fateful year, the Mexican Congress ratified the Secularization decree of August 9, 1834, and by November 3, 1834, Solano was dispossessed of its land, and a parish priest was assigned to the church. By 1835 Mexican Lieutenant Mariano Vallejo, the Commandant of the Presidio de San Francisco was appointed *comisionado* or administrator with oversight of the Secularization. Soon, the mission lands were dispersed, and the mission was dismantled. In 1841, Vallejo ordered the construction of a small parish church at the west end of the ruined quadrangle, and it remains the only structure devoted to worship in what is now a California State Park.

OPPOSITE
The gallery fronting the mission quadrangle was erected under the supervision of Fray José Altimira, OFM, as part of a much larger undertaking in 1824.

LEFT
The east wall of the adobe church of 1841 exemplifies the inherent simplicity or economy of design that characterized mission architecture throughout California and the West.

FOLLOWING PAGES, LEFT
The wood and iron chandeliers of the church of 1841 replicate a type that can be found in many a mission church from throughout the Californias and Mexico.

FOLLOWING PAGES, RIGHT
The reconstructed pulpit and tornavoz or sound board was inspired by those of sites such as San Juan Bautista and San Miguel Arcángel.

249

RIGHT
The painted reredos or altar screen was replicated with gray Corinthian columns and an elaborate lower wall dado or painting consisting of geometric patterns known from other mission sites.

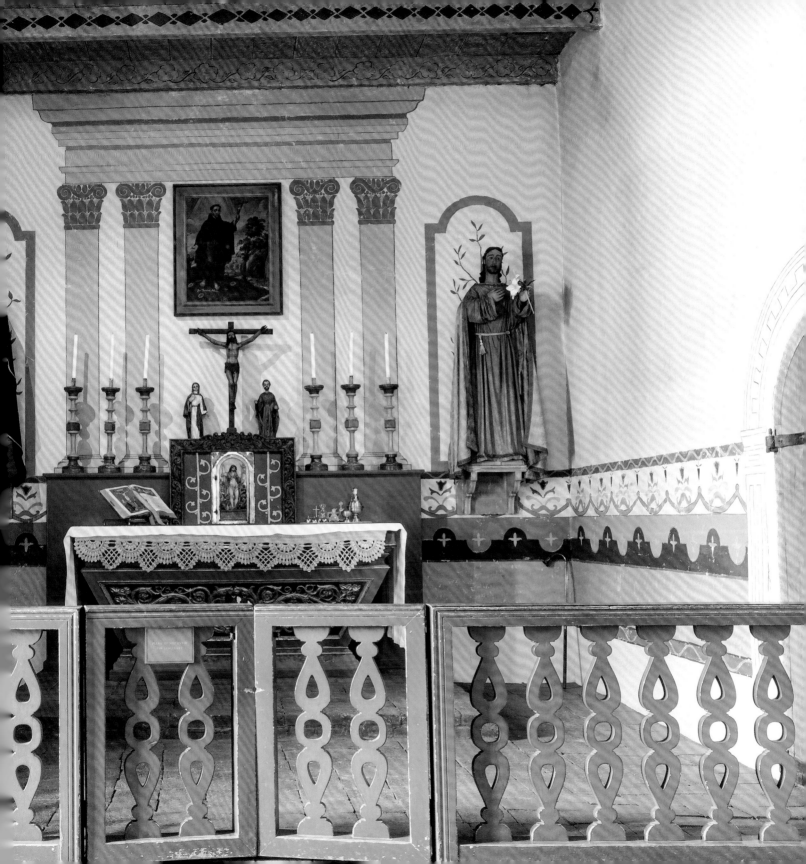

MISSIONS CONTACT INFORMATION

SAN DIEGO DE ALCALÁ, 10818 San Diego Mission Road, San Diego, CA 92108, (619) 283-7319, http://www.missionsandiego.org/

SAN CARLOS BORROMEO (CARMEL), 3080 Rio Road, Carmel, CA 93923, (831) 624-1271, https://carmelmission.org/

SAN ANTONIO DE PADUA, End of Mission Road, Jolon, CA 93928, (831) 385-4478, http://missionsanantonio.net/

SAN GABRIEL ARCÁNGEL, 428 S. Mission Drive San Gabriel, CA 91776, (626) 457-3035, http://www.sangabrielmissionchurch.org/

SAN LUIS OBISPO DE TOLOSA, 751 Palm Street, San Luis Obispo, CA 93401, (805) 781-8220, http://missionsanluisobispo.org/

SAN FRANCISCO DE ASÍS (MISSION DOLORES), 3321 16th St., San Francisco CA 94114, (415) 621-8203, http://www.missiondolores.org/64

SAN JUAN CAPISTRANO, 26801 Ortega Hwy, San Juan Capistrano, CA 92675 (949) 234-1300, https://www.missionsjc.com/

SANTA CLARA DE ASÍS, 500 El Camino Real, Santa Clara, CA 95053, (408) 554-4000, https://www.scu.edu/missionchurch/

SAN BUENAVENTURA, 211 E Main St, Ventura, CA 93001, (805) 643-4318, http://www.sanbuenaventuramission.org/

SANTA BÁRBARA, 2201 Laguna Street, Santa Barbara, CA 93105, (805) 682-4149, http://www.santabarbaramission.org/

LA PURISIMA CONCEPCION DE MARIA SANTÍSIMA, 2295 Purisima Road, Lompoc, CA 93436, (805) 733-3713, http://www.lapurisimamission.org/

SANTA CRUZ, 126 High Street, Santa Cruz, CA 95060, (831) 426-5686, http://www.holycrosssantacruz.com/

NUESTRA SEÑORA DE LA SOLEDAD, 36641 Fort Romie Road, Soledad, CA 93960, http://missionsoledad.com/

SAN JOSÉ, 43300 Mission Boulevard, Fremont, CA 94539, (510) 657-1797, http://www.missionsanjose.org/

SAN JUAN BAUTISTA, 406 Second Street, Old Mission San Juan Bautista, San Juan Bautista, CA 95045, http://www.oldmissionsjb.org/

SAN MIGUEL ARCÁNGEL, 775 Mission Street, San Miguel, CA 93451, (805) 467-3256, http://www.missionsanmiguel.org/

SAN FERNANDO REY DE ESPAÑA, 15151 San Fernando Mission Blvd., Mission Hills, CA 91345, (818) 361-0186

SAN LUIS REY DE FRANCIA, 4050 Mission Avenue, San Luis Rey, CA 92068, (760) 757-3651, (760) 757-3651, http://www.sanluisrey.org

SANTA INÉS, VIRGEN Y MÁRTIR, 1760 Mission Drive, Solvang, CA 93463, (805) 688-4815, http://www.missionsantaines.org

SAN RAFAEL ARCÁNGEL, 1104 5th Street, San Rafael, CA 94901, (415) 456-3016, http://www.saintraphael.com/

SAN FRANCISCO DE SOLANO, 114 East Spain Street (East Spain and 1st Street), Sonoma, CA 95476, (707) 938-9560

SELECTED SOURCES

Franciscan Friar Zephyrin Engelhardt, O.F.M., of Old Mission Santa Barbara penned some of the most thoroughgoing summaries of the California missions, and that based on his early readings and translations of Spanish missions primary documents. Beginning with his four volume treatment of *The Missions and Missionaries of California* (1908–1915), Fr. Engelhardt went on to publish the accounts of some 18 California missions. Those works deemed essential to our narrative include: *San Diego Mission* (1920), *San Luis Rey Mission* (1921), San Juan Capistrano Mission (1922), *Santa Barbara Mission* (1923), *San Francisco or Mission Dolores* (1924), *San Fernando Rey, the Mission of the Valley* (1927), *San Gabriel Mission and the Beginnings of Los Angeles* (1927), *San Gabriel, Pride of the Missions* (1927), *Mission Dolores (San Francisco de Asis), San Francisco* (1928), *Mission Nuestra Senora de la Soledad* (1929), *San Antonio de Padua: The Mission in the Sierras* (1929), *San Buenaventura, The Mission by the Sea* (1930), *Mission San Juan Bautista: A School of Church Music* (1931), *San Miguel, Arcangel* (1931), *Mission La Concepcion Purisima de Maria Santisima* (1932), *Mission Santa Inés, Virgen y Mártir, and its Ecclesiastical Seminary* (1932), *Mission San Luis Obispo in the Valley of the Bears* (1933), and *Mission San Carlos Borromeo (Carmelo): The Father of the Missions* (1934).

The meticulously recorded ethnohistorical works of archaeologist and architectural historian Mardith K. Schuetz-Miller were essential to identifying the artisans and craftsman documented in each mission's respective inventory. Three such works were invaluable, and include: *Building and Builders in Hispanic California 1769–1850*. Tucson: Southwestern Mission Research Center and Santa Barbara Trust for Historic Preservation Presidio Research Publication, 1994; *Biofile of Building Artisans who Worked on the Northern Spanish Borderlands of New Spain and Early Mexico*, National Park Service, n.d.; and *Architectural practice in Mexico City: A Manual for Journeyman Architects of the Eighteenth Century*, translated, with an introduction and annotation. Tucson: University of Arizona Press, 1987.

Other primary and secondary sources used to enhance our narrative include the following: Tibesar, Antonine, ed., *Writings of Junípero Serra*. Washington: Academy of American Franciscan History, 1955; Early, James. *Presidio, Mission, and Pueblo: Spanish Architecture and Urbanism in the United States*. Dallas: Southern Methodist University Press, 2004; McLaughlin, David, with Rubén G. Mendoza. *The California Missions Source Book*. Santa Fe: Pentacle Press and the University of New Mexico Press, 2012; Newcomb, Rexford. *Spanish-Colonial Architecture in the United States*. New York City: J. J. Augustin, 1937; Smilie, Robert S. *The Sonoma Mission, San Francisco Solano de Sonoma*. Fresno: Valley Publishers, 1975; Smith, Frances Rand. *The Mission of Nuestra Senora de la Soledad*. California Historical Society Quarterly. 23, no. 1 (1944): 1–18; Spearman, Arthur Dunning. *The Five Franciscan Churches of Mission Santa Clara 1775–1825*. Palo Alto: The National Press, 1963; Weber, Francis J., ed. *Queen of the Missions: A Documentary History of Santa Barbara*. Hong Kong: Libra Press, 1979; Weber, Francis J., ed. *The Precursor's Mission, A Documentary History of San Juan Bautista*. Los Angeles: Archives, Diocese of Los Angeles, 1983; and Weber, Francis J., ed. *Holy Cross Mission: A Documentary History of Santa Cruz*. Los Angeles: Archives, Diocese of Los Angeles, 1984.

ACKNOWLEDGMENTS

We gratefully acknowledge the many institutions, administrators, clergy, and mission curators, custodians, directors, parishioners, and staff who gave of their time and attention to accommodating our many editorial requests. Each of them stands as a faithful steward of the Hispanic and Indian Catholic heritage of the California missions. A particular thanks to Adriana Olivera de la Torre, for her guidance and support. This book would not have come to fruition without the vision and commitment of our publisher, Rizzoli International publications, and especially Vice President Charles Miers and our editor Douglas Curran. We are forever grateful to the Rizzoli team, and in particular to Douglas for his keen aesthetic eye, design contributions, unflagging leadership, and promotion of this labor of love. Mendoza is particularly indebted to CSU Monterey Bay Adjunct Professor Jennifer A. Lucido for her thoroughgoing critique and feedback for all content generated from the outset, and to architectural historian and archaeologist Mardith Schuetz-Miller for her lifelong contributions to California and Southwest mission studies. Her work and inspiration was central to advancing this undertaking. Mendoza was generously aided and abetted in his efforts to photo document the collections of the Father Junípero Serra Museum and Study Centre in Petra, Mallorca, Spain, by Bartomeu Bestard and Catalina Font of the Associació d'Amics de Fray Junípero Serra and the Fundació Pare Serra, and Bartomeu Bestard Cladera of the Ajuntament de Palma, Mayorca. For her part, Levick wishes to thank Matt Walla for his expert technical assistance. Finally, the co-authors acknowledge their respective families. To that end, Rubén Mendoza remains grateful for the loving support of his wife Linda Marie, and the infinite patience and understanding of his daughters Natalie Marie and Maya Nicole Mendoza. Melba Levick in turn wishes to acknowledge and thank her devoted husband Hugh Levick, without whose patience, assistance and support this book would not have been possible.